Rituals of the Way

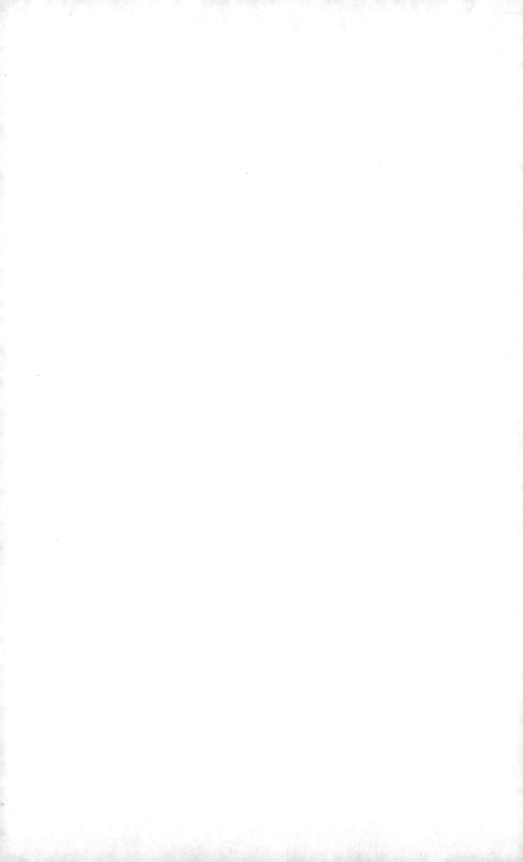

Rituals of the Way

The Philosophy of Xunzi

Paul Rakita Goldin

OPEN COURT
Chicago and La Salle, Illinois

To order books from Open Court, call 1-800-815-2280.

Open Court Publishing Company is a division of Carus Publishing Company.

© 1999 by Carus Publishing Company

First printing 1999

Printed and bound in the United States of America.

Library of Congress Cataloging-in-Publication Data

Goldin, Paul Rakita, 1972–
 Rituals of the way : the philosophy of Xunzi / Paul Rakita Goldin.
 p. cm.
 Includes bibliographical references and index.
 ISBN 0-8126-9400-7 (pbk. : alk. paper)
 1. Hsün-tzu, 340–245 B.C. Hsün-tzu. 2. Philosophy, Chinese—To 221 B.C. I. Hsün-tzu, 340–245 B.C. Hsün-tzu. Selections.
II. Title III. Title: Philosophy of Xunzi.
B128.H7G64 1999
181'.112—dc21 99–10654
 CIP

Contents

Preface

Since all translations in this book are my own, it is advisable to discuss some problems and procedures at the outset. For certain Chinese terms, it has proved difficult to find satisfactory English renderings. One crucial example is *junzi* 君子, which is usually translated as "gentleman." Literally, the term means "son of a lord," that is, a member of the hereditary aristocracy. Following Confucius, however, Xunzi uses the term aretaically to refer to *any* person who has attained a certain level of moral excellence by dint of self-cultivation. In order to highlight this critical moral dimension, some scholars have recently proposed such renderings as "profound person," "superior man," or "exemplary person." After all, when Confucius and Xunzi distinguish the *junzi* from the *xiaoren* 小人, or "small person," they are not referring to the *junzi*'s exalted social or political status, but to his exalted accumulation of virtue.

Nevertheless, I think a rendering along the lines of "profound person" is inadequate in two important respects. First, it is essential to preserve the allusion to the feudal patriarchy, because that is how the Confucian idea derives so much of its revolutionary power: by suggesting that political authority should be parceled out according to the criterion of moral attainment rather than that of birthright, the Confucians were using feudal terminology to challenge the very foundations of feudal society. The only *junzi* worthy of the name, in other words, were people who lived up to the highest moral standards, regardless of whether they were noble or base by birth.

There is a second problem—perhaps more disturbing to a modern reader—with renderings of *junzi* such as "exemplary person" or "superior person." Those terms are, as we say today, "gender-neutral," and can be applied equally to men or to women,

whereas *junzi*, even in the Confucians' innovative hands, is never used to refer to a woman. Their depreciating view of women is often cited as the greatest weakness of the traditional Confucian philosophers. They can imagine a man, however lowly, ultimately becoming a *junzi*, but the same cannot be said of women; indeed, in the only explicit statement that Confucius made about women (*Analects* 17.25), he compared them to *xiaoren*, or the antithesis of *junzi*, and even questioned their ability to grow.

Therefore, a just translation of *junzi* must reflect moralistic Confucian usage as well as its original sense as a designation of a member of the hereditary *male* ruling class. Anything else misrepresents both the originality and the limitations of the Confucian position. This is, *in nuce*, the justification of the translation "gentleman," which has similar sets of connotations in English: we speak of a "gentleman" (by birth) as opposed to a "commoner," but also a "gentleman" as a man morally superior to, say, a "boor." Nevertheless, I have been persuaded that "gentleman" is not quite right either, because it can evoke a sense of superficial conformity to insubstantial etiquette, and not the genuine moral transformation that Xunzi intends to convey. So I have tried to avoid this problem by translating *junzi* consistently as "noble man" (two words), hoping in the word "noble" to capture both the feudal and the moral senses of *junzi*.[1] (Xunzi's use of the term is taken up further at relevant points in this study.)

For the term *ren* 人, on the other hand, which need not refer solely to men, it is probably best to try to find words in English like "human" or "person." Other terms, such as *xing* 性 and *cheng* 誠, are discussed at length in the text, and sometimes left untranslated, since I believe the stock-translations ("human nature" and "sincerity," respectively) to be misleading. Finally, when the word *dao* 道 ("Way") is used as a verb (e.g. "make oneself *dao*"), I have sometimes kept the Chinese term.

*　*　*　*　*　*

References to the *Xunzi* will be noted in the text by an italicized "*X*," followed by the scroll (*juan* 卷), chapter (*pian* 篇), and page number in the well-circulated *Zhuzi jicheng* 諸子集成 edition of the *Xunzi jijie* 荀子集解 by Wang Xianqian 王先謙 (1842–1918).[2]

In addition, following my own translations I will indicate the corresponding chapter and section number of the complete translation of John Knoblock with a "K," although the rendering here will often differ significantly. Thus "*X* 17.23.289 = K 23.1a" means *juan* 17, chapter 23, page 289 in the *Xunzi jijie*, which corresponds to chapter 23, section 1a, in Knoblock's translation. I will also follow the same pattern for citations from other classical Chinese texts: references with three numbers indicate the *juan*, chapter, and page number; those with two numbers indicate simply the *juan* and page number (for example, "3.1a" means *juan* 3, page 1 *recto*). For purposes of concision, references to sources included by James Legge (1815–1897) in his *Chinese Classics* appear in the body of the text rather than in endnotes and are cited according to Legge's section divisions (e.g. "*Mencius* 4.2.19.1"). Full information on all works can be found in the bibliography.

All Chinese characters are Romanized according to Pinyin 拼音, because that system requires less frequent use of diacritical marks than the older Wade-Giles system. There is one exception: I do not alter the Romanizations that Chinese authors have chosen for their own names, even if the system they employ is idiosyncratic (e.g. "D.C. Lau" 劉殿爵). If they do not Romanize their names, I use Pinyin (e.g. "Liang Qichao" 梁啓超). Wade-Giles Romanizations of terms appearing in quotations from secondary material are converted silently to Pinyin.[3]

<p style="text-align:center">* * * * * *</p>

The illustration on the cover depicts a *gu* 觚, or ritual goblet. This seemed appropriate for two reasons. First, as a ritual implement, it is the kind of object that would have been on Xunzi's mind when he expounded his notion of *li* 禮 ("ritual"), which represents one of the cornerstones of his philosophy and is discussed in chapter 3. Moreover, the *gu* is the vessel that Confucius mentioned when he complained that people were not respecting the appropriate names of objects (*Analects* 6.23; see also chapter 4, below): the name *gu* should be reserved for goblets that conformed typologically to the *gu* model, and not used indiscriminately for vessels that properly went by other names. This Confucian idea was the foundation for Xunzi's notion of *zhengming* 正名 ("rectification

of names"), another cornerstone of his philosophy, discussed in chapter 4. This particular drawing is taken from the *Kaogu tu* 考 古圖, an eleventh-century work cataloguing ritual vessels that had survived from ancient times.

<p align="center">* * * * * *</p>

Finally, I must express my gratitude to my teacher, Tu Wei-ming 杜維明, without whom this book would never have been written. I would also like to thank other colleagues, friends, and former teachers who have read and commented on the entire manuscript at various stages: Victor H. Mair, Michael Puett, and Eric Hutton. Thanks to my student, Kenneth Holloway, for allowing me to revise the manuscript on his computer.

My thinking on Xunzi has been shaped by conversations with many people over the past few years: Robert Ashmore, Peter K. Bol, Scott Cook, Robert Foster, Bryan Hoffert, Philip J. Ivanhoe, Andrew Meyer, Stephen Owen, David W. Pankenier, Moss Roberts, Stephen F. Teiser. I have also benefited from discussions with other members of the Warring States Working Group and its two founding spirits, E. Bruce and A. Taeko Brooks. My friend Joshua Green, neuroscientist and philosopher, has been sharpening my way of looking at the world since the day we met in the old Quadrangle.

I would like to thank the staff at Open Court for the care with which they have handled this enterprise, and especially Kerri Mommer, who has pointed out to me some of the considerations involved in publishing a book at the end of the twentieth century.

I have derived much energy from the encouragement of my wife, Edilma.

Maximae tamen gratiae parentibus agendae, qui operibus numquam imperfectis satisfacti.

Introduction

This is a study of a Chinese text called the *Xunzi* 荀子, attributed to and named after Xun Kuang 荀況 (ca. 310–ca. 210 B.C.), about whom we know very little.[1] The work possesses "live philosophical interest" and will be of interest to participants in the philosophical forum of today.[2] With a distinct philosophical outlook and rhetorical character, the book addresses several interrelated and typically Confucian problems. What is the nature of a human being? How does one become civilized? What is our relation to other human beings, to Heaven, and to the cosmos? How should the ruler organize his state? What is the role of language in the enterprise of government and self-cultivation? The overarching preoccupation that binds together the diverse arguments and reflections in the text is the role of the *noble man*. The heart of Xunzi's vision is the perfectibility of the human being, the possibility of transforming the raw human animal into a noble man or sage. Xunzi's concerns are immanent, pragmatic, and humanistic. How do we make the world a better place for humanity? How do we make humans and the world conform to the pattern of the universe?

Xunzi has couched his questions in the idiom of his discourse, but the issues he considers are by no means alien to the Western philosophical tradition. Xunzi's deliberations wander across the plains of what we would call moral philosophy, civil philosophy, epistemology, philosophy of mind, philosophy of language, philosophy of science, and metaphysics. At turns in his journey he makes what a modern philosophical reader might consider dubious, if not far-fetched excursions; but in the effort of elucidating a unified theory of human life, Xunzi touches on many points that have attracted attention in Western circles, answering these at times in similar, at times in dissimilar, ways. These include, to name just a

handful of examples, game theory and its relevance to theories of government; the observation of the arbitrariness of the linguistic sign; the rejection of materialistic determinism; and the question of ontological relativity. Those labels are, to be sure, none that Xunzi ever used; I express his areas of interest in such terms only to suggest that a great, though neglected, philosopher of a distant time and place can produce writings of value not only to Sinologists or historians of Chinese philosophy, but to anyone who has dwelt with the questions he raises.

Further reason for the study of Xunzi involves his position in the Chinese tradition. In his day, Xunzi was respected as one of the greatest teachers alive, and two of his students were among the most influential people in their day: Han Fei 韓非 (d. 233 B.C.), a member of the ruling family of the state of Han 韓 and the supposed author of the *Han Feizi* 韓非子, a philosophical text; and Li Si 李斯 (d. 208 B.C.), Prime Minister of the first Chinese empire, Qin 秦 (221–206 B.C.). Xunzi's other students are responsible for having handed down some of the most influential redactions of and commentaries to the Confucian Classics. The *Guliang Commentary* 穀梁傳 to the *Springs and Autumns* 春秋 was transmitted to the scholar Shen Pei 申培 by Xunzi's student Fouqiu Bo 浮邱伯. The *Zuo Commentary* 左傳 to the *Springs and Autumns* was transmitted by Xunzi's student Zhang Cang 張蒼 (d. 162 B.C.). The Mao text of the *Book of Odes* 詩經 was compiled by Xunzi's student Mao Heng 毛亨 and his son Mao Chang 萇;[3] and the *Outer Commentary to the Han Odes* 韓詩外傳, as well as the *Record of Rites of Dai the Elder* 大戴禮記, attributed to Dai De 德 (fl. 1st cent. B.C.), borrow liberally from Xunzi.[4] A great proportion of the Confucian Classics thus passed through Xunzi to later generations.[5]

Xunzi's learning continued to be exalted after his death, and influenced in particular the new Confucian orthodoxy of the early Imperial age. But by the medieval period, when the *Mencius* became one of the most revered philosophical texts in China, Xunzi's unabashed criticism of that thinker damaged his own reputation, and his demotion to secondary status continued in China into this century. In recent years the trend has reversed itself, as scholars

both on the Mainland and in Taiwan praise Xunzi's philosophy as "materialist" and "scientific"[6]—this at a time when in the West, especially since Thomas S. Kuhn,[7] "science" has earned a questionable reputation. But the irony is that such modern encomia are often as unsophisticated and unilluminating as the unjust criticisms of earlier times. It is not at all clear that Xunzi is a materialist[8]—even less so whether it would be an attribute worth applauding if he were; and in any case he did not conceive of himself within that kind of category. Much recent scholarship, therefore, is as flimsy and one-sided as literature from when Mencius held sway.

The first published commentary did not appear until A.D. 818—an entire millennium after Xunzi's death—by Yang Liang 楊倞. This delay has much to do with the difficulty of the text, which employs a technical, though consistent, philosophical vocabulary. Still, the work is far from inaccessible. Yang Liang's commentary is thorough, and the many commentaries that have been compiled since Yang Liang's time are helpful.[9] We are likewise fortunate that we do not face the problem of variant traditions associated with more fluid texts such as the *Laozi* 老子.[10] Anyone who expends the effort to read the text will find himself rewarded abundantly, for Xunzi's writing is succinct and lucid, his philosophical positions original and reasoned.

* * * * * *

Of the figure himself, we can say almost nothing. There is a good amount of biographical information on Xunzi in the pages of the book bearing his name, but we cannot interpret any of this material as factual, and, indeed, should not assume that these references were even intended to be understood as such. We know that it was fashionable in ancient times to compose artful retellings of legendary or quasi-historical events involving famous personages.[11] We believe that Xun Kuang was born in the central Chinese state of Zhao 趙 well before 279 B.C., probably around 310 B.C., or more than two centuries after Confucius 孔子 (551–479 B.C.). He died very old, after 238 B.C.[12] At the age of fourteen, or possibly thirteen, he journeyed to the northeastern state of Qi 齊, a dominant philosophical center, in order to pursue his studies.[13] He held official posts, and was known by the epithets Xun Qing 卿,

"Chamberlain Xun," and Xunzi, "Master Xun." He taught at the so-called Jixia 稷下 Academy in Qi, but cannot be identified with any putative "Jixia" School, because he had intellectual differences with almost all the other scholars.[14]

It is possible that the book bearing Xunzi's name might not be entirely the work of Xun Kuang.[15] It was a common practice in ancient China to ascribe one's book to the teacher of a famous personage. Two well-known examples of this phenomenon are the *Heguanzi* 鶡冠子, named after the recluse who is said to have taught the successful general Pang Xuan 龐煖 (fl. 240 B.C.); and the *Laozi* (or *Daode jing* 道德經), attributed to Lao Dan 老聃, the obscure figure from whom, as legend has it, Confucius himself sought instruction.[16] There is a widespread consensus that neither of these texts was written by Heguanzi or Lao Dan—if such persons even existed. Unknown philosophers who wished instant credibility for their writings could hardly have found a better ploy than to name their books after Xun Kuang, whose students, as we have mentioned, included two of the most important men in late third-century China.

One would never know from two famous references to Xun Kuang outside the *Xunzi* that he was one of the greatest geniuses in the history of Chinese philosophy. The first is an epistle that Xun Kuang reportedly wrote to his former patron Huang Xie 黃歇, Lord Chunshen 春申君 (d. 238 B.C.), after the latter had asked him to return to his service. Xun Kuang declined forcefully, and listed several standard and semi-legendary examples of calamities that were said to have befallen participants in politics. The whole letter is a quilt of platitudes, adopting the familiar tone of the superior man unwilling to sully himself in the political arena. The message sounds almost Yangist: politics is bad for one's health.[17] The second reference is a citation from Li Si at a banquet. At the height of his power, the new Prime Minister, apprehensive, is recorded as having quoted Xun Kuang during a toast: 物禁大盛 ("Prevent things from flourishing greatly")—or, in other words, it's all downhill after the zenith.[18] That too was a hackneyed aphorism in Xunzi's age. How did Xun Kuang come to be associated with such trite maxims? Perhaps those who did not understand

the intricacies of Xunzi's philosophy, knowing that he was a man of great renown, circulated apocryphal stories about him in which he played the role of Authority, the voice of (received) "wisdom." Or perhaps the historical Xun Qing was but a Polonius, and the author of the *Xunzi* someone else.

The question is ultimately idle, since there is no conclusive evidence either way. But it highlights a knotty problem of interpretation: How are we to read a work that is attributed to a man who lived over two millennia ago, about whom we know only what the legends tell us, and who, in any case, may not even have written what appears under his name? The *Xunzi* challenges us to interpret a text with very little help from context. My method will be to focus on ideas.

Our problem is similar to one faced continuously by judges who must interpret the law and hand down decisions within a finite amount of time. One legal scholar, Ronald Dworkin, has named his ideal interpreter "Hercules."[19] This hero adjudicates hard cases—that is, cases in which both parties offer credible arguments—by establishing a set of candidate principles that "fit" the common law record, and choosing from that set the one principle that shows the law in its best light. The interpretation must "fit" precedent cases so that inane rulings may be cast out of bounds. The judge is granted the flexibility, however, to choose from among the possible interpretations the one which embodies the tenor of the judicial tradition most completely. This is what Dworkin calls "law as integrity." Naturally, different judges will have different conceptions of the law's best light, and no decision will square with every lawyer's sensibilities. But Hercules, or a mortal who imitates his practice, can claim in his defense that his reading has integrity. Hercules does not make things up; he tries to hand down decisions that will promote the good principles of the law.

The Herculean commentator would engage the challenges of reading the *Xunzi* by considering the possible variants and choosing the one which best exemplifies the spirit of the work. This entails referring to other thinkers, regardless of their context, where their ideas elucidate the problem at hand. It is a habit shared by Xunzi himself. Xunzi considered ideas from all the known philosophical

fronts: Mohism, Nominalism, Legalism, Huang-Lao, and especially Confucianism. Had he been aware of other traditions, he would have immersed himself in their ideas too; for if we know anything about Xunzi at all, we know that he loved ideas. Xunzi is concerned from start to finish with ideas. They are largely practical ideas, but he continuously justifies his pragmatism as he justifies all his other claims: on philosophical grounds. A commentary that focuses on ideas is the kind of commentary that Xunzi would have wanted—a commentary that places him in his best light.

Chapter 1

Self-Cultivation and the Mind

The philosophical issue with which Xunzi's name was identified most closely in the centuries after his death is his contention that *xing* 性 is *e* 惡. Xunzi's phrase *xing e* can be translated provisionally as "Human nature is evil"; the complexities of the terms *xing* and *e* will be taken up presently.

A century before Xunzi, Mencius (372–289 B.C.) had laid down his theory that human nature is good 善. The difference between people and beasts, Mencius argued, is that a person has a mind (heart) 心:

孟子曰：人之所以異於禽獸者，幾希，庶民去之，君子存之. (4.2.19.1)

Mencius said: That by which people are different from the beasts is slight. Common people abandon it; the noble man preserves it.

孟子曰：君子所以異於人者，以其存心也. (4.2.28.1)

Mencius said: That by which the noble man is different from other people is the preservation of his mind.

The special function of this mind is to think 思:

曰：耳目之官不思，而蔽於物，物交物，則引之而已矣. 心之官則思，思則得之，不思則不得也. (6.1.15.2)

He said: The organs of the ear and eye do not think, and are blinded by objects. When an object meets an object, it leads it. The organ of the heart

thinks. If it thinks, it apprehends it; if it does not think, it does not apprehend it.

Furthermore, by "thinking" Mencius appears to mean *moral* thinking. The mind is, by nature, ordered and righteous:

曰:口之於味也,有同嗜焉,耳之有聲也,有同聽焉,目之於色也,有同美焉.至於心,獨無所同然乎?心之所同然者,何也?謂理也,義也.聖人先得我心之所同然耳,故理義之悦我心,猶芻豢之悦我口. (6.1.7.8)

He said: Mouths have the same taste with respect to flavor; ears have the same hearing with respect to sound; eyes have the same beauty with respect to color [i.e. they perceive the same colors as beautiful]. Are minds alone without something in common? What is it that minds have in common? It is called order and righteousness. The sages were the first to apprehend what my mind has in common [i.e. with other minds]. Thus order and righteousness please my mind as the meat of grass- and grain-fed [beasts] pleases my mouth.

Beyond its inherent order and righteousness, the mind in Mencius's view is endowed with what he calls the Four Incipiences 四端 of goodness. To justify his claim, Mencius makes use of what was to become one of the most famous examples in the history of Chinese philosophy, that of one's instinctive reactions to the sight of a child about to fall into a well:

孟子曰:人皆有不忍人之心,先王有不忍人之心,斯有不忍人之政矣,以不忍人之心行不忍人之政,治天下可運之掌上.所以謂人皆有不忍人之心者,今人乍見孺子將入於井,皆有怵惕惻隱之心,非所以內交於孺子之父母也,非所以要譽於鄉黨朋友也,非惡其聲而然也.由是觀之,無惻隱之心,非人也,無羞惡之心,非人也,無辭讓之心,非人也,無是非之心,非人也.惻隱之心,仁之端也,羞惡之心,義之端也,辭讓之心,禮之端也,是非之心,智之端也.人之有是四端也,猶其有四體也. (2.1.6.1–6)

Mencius said: All people have commiserating minds. The Former Kings had commiserating minds; thus they had a commiserating government. By using a commiserating mind to put into practice a commiserating government, ruling all under Heaven is like rolling it in one's palm. [To show that] what are called people all have commiserating hearts, suppose a person suddenly saw a child about to fall into a well. Everyone [in such a situation] would

have a frightened, compassionate mind, not in order to ingratiate themselves with the child's parents, not because they want praise from their neighbors and friends, not because they hate the sound [i.e. a bad reputation].[1] From this we see: who does not have a commiserating heart is not a person. Who does not have a heart of shame is not a person. Who does not have a heart of deference is not a person. Who does not have a heart of right and wrong is not a person. The heart of commiseration is the incipience of humanity. The heart of shame is the incipience of righteousness. The heart of deference is the incipience of ritual. The heart of right and wrong is the incipience of wisdom. People have these Four Incipiences as they have four limbs.

孟子曰:乃若其情,則可以為善矣,乃所謂善也.若夫為不善,非才之罪也.惻隱之心,人皆有之,羞惡之心,人皆有之,恭敬之心,人皆有之,是非之心,人皆有之.惻隱之心,仁也,羞惡之心,義也,恭敬之心,禮也,是非之心,智也.仁義禮智,非由外鑠我也.我固有之也. (6.1.6.5–7)

Mencius said: As far as their essence[2] is concerned, people can become good; this is what is called good. Becoming not good is not the fault of the endowment. All people have a heart of compassion, a heart of shame, a heart of reverence, and a heart of right and wrong. [The principle of] the heart of compassion is humanity; of the heart of shame, righteousness; of the heart of reverence, ritual; of the heart of right and wrong, wisdom. Humanity, righteousness, ritual, wisdom—these are not infused into me from outside. I have them originally.

Mencius adds here that some people may be better than others, but that this is because they have made better use of their endowment, not because some minds are good and others not.

At this point Mencius takes pains to make clear that the Four Incipiences alone are not sufficient to make a person good. The Four Incipiences represent the *potential* for good; if they are not tended, they will wither, and the mind will be seduced by evil:

凡有四端於我者,知皆擴而充之矣,若火之始然,泉之始達.苟能充之,足以保四海,苟不充之,不足以事父母. (2.1.6.7)

Since everyone has the Four Incipiences within themselves, [if] they know to develop and fill them all, it is like a fire beginning to burn, a spring beginning to rise. If they are able to fill them, it is enough to protect the four seas; if they are not able to fill them, it is not enough to serve their parents [i.e. they will not be able even to serve their parents].

Mencius clarifies this notion through the parable of Ox Mountain. By nature, the mountain is luxuriant with growth, but if it is attacked with axes, it will be denuded. Mencius compares people's abandonment of their original, good minds to the chopping down of trees on the mountain. If people nurture their minds, they will grow; if they do not nurture them, they will die. The force of Mencius's analogy is augmented by the close relation between the two terms *cai* 材, "wood, timber," and *cai* 才, "talent, material"—as in someone's "raw material":

孟子曰:牛山之木嘗美矣.以其郊於大國也,斧斤伐之,可以為美乎?是
其日夜之所息,雨露之所潤,非無萌蘖之生焉.牛羊又從而牧之,是以
若彼濯濯也.人見其濯濯也,以為未嘗有材焉,此豈山之性也哉?雖存
乎人者,豈無仁義之心哉?其所以放其良心者,亦猶斧斤之於木也,旦
旦而伐之,可以為美乎?其日夜之所息,平旦之氣,其好惡與人相近也
者,幾希,則其旦晝之所為,有梏亡之矣,梏之反覆,則其夜氣不足以存,
夜氣不足以存,則其違禽獸不遠矣.人見其禽獸也,而以為未嘗有才焉
者,是豈人之情也哉?苟得其養,無物不長,苟失其養,無物不消.
(6.1.8.1–3)

Mencius said: The trees on Ox Mountain were once beautiful. On the outskirts of a great state, with axes attacking it, could it [remain] beautiful? Rested by the days and nights, moistened by the rain and dew—it is not true that no shoots grew on it. Then oxen and sheep came and grazed upon it; this is why it is so bare. People see its bareness, and think that there never was wood on it. Is this the nature of the mountain? And so also what is preserved within a human being—is there not a mind of humanity and righteousness? Abandoning the true mind is also like the axes with respect to the trees: if it is attacked every day, can it be beautiful? One [may be] rested by the days and nights and invigorated by the early morning, [but if] the correspondence between one's likes and dislikes and those of other people is slight, then what is achieved during the day is fettered and destroyed. If the fettering and destruction continues, then one's nocturnal invigoration [i.e. the restoration gained from sleep] is not enough to preserve [the true mind]. If one's nocturnal invigoration is not enough to preserve it, then one is not far from a beast. Other people see one's bestiality, and think that there never was an endowment inside. Is this the essence of a human being? If it obtains its nourishment, nothing will not grow; if it loses its nourishment, nothing will not be obliterated.

We should pause here to consider Mencius's argument before we move on to Xunzi's reaction to it. The notion that the mind 心

represents the slight 幾希 difference between people and beasts is one that most of us can probably accept, since we are all likely to agree that there exists at least *some* such difference. Likewise, the contention that the mind is ordered and righteous 理義 presents few problems as long as Mencius defines order and righteousness as vaguely as he does. But the next two steps pose some difficulty. Is it really true that all people, regardless of milieu, will feel anxious if a child is about to fall into a well? We must take care not to let Mencius beguile us with his dazzling imagery. For when we set aside the child and the well, Mencius's argument becomes far less persuasive.

Consider an example from the latter Confucian tradition. Lu Jiuyuan 陸九淵 (1139–1192), who considered himself an honest interpreter of Mencius, varied the example for the benefit of one of his students: Lu stood up suddenly and unexpectedly; when his student also stood up, without thinking, Lu pointed out that he had just demonstrated the mind's innate humanity and compliance with ritual. It would have been improper to remain sitting while the teacher was standing.[3] We may observe today, however, that Lu Jiuyuan's student had merely internalized an unspoken, but influential code of behavior in effect in his time and place. It is likely that a contemporary American student would *not* have stood up in the same situation. What is the provenance of the Confucian student's "humanity"—his original mind, or an imbued sense of decorum?[4]

This is no insignificant point, for it is the parable of the well that provides Mencius with his only evidence that the mind is by nature good. Were it not for this sole example, one would be free to say that the mind contains incipient *evil*—or even no inherent moral orientation whatsoever. Such theories are said to have been expounded even before Mencius, for example, by Shi Shi 世碩, a disciple of Confucius.[5] According to Mencius, the vigilance with which a person strives for perfection stands in proportion to the goodness that that person may attain, and the Four Incipiences alone are insufficient to determine someone's moral character one way or the other. Yet Mencius insists that the mind is not morally indeterminate, but originally good. Mencius ignores the menace of counterexample by refusing to consider the possibility that a

person might prove unmoved by the sight of a child about to fall into a well. To him, the effect must be universal. Therefore, it is more constructive perhaps to understand the story of the well as an illustration rather than a demonstration, and to accept the Mencian doxology of the "true mind" as a matter of axiom.[6] Mencius argues by analogy rather than by syllogism.

Xunzi viewed Mencius as one of the twelve leading thinkers whose ideas he intended to refute (*X* 3.6.59), and took issue with his teachings explicitly. Xunzi writes:

> 人之性惡,其善者偽也.今人之性,生而有好利焉,順是,故爭奪生,而辭讓亡焉,生而有疾 [=嫉] 惡焉,順是,故殘賊生,而忠信亡焉,生而有耳目之欲,有好聲色焉,順是,故淫亂生而禮義文理亡焉.然則從人之性,順人之情,必出於爭奪,合於犯分亂理,而歸於暴. (*X* 17.23.289 = K 23.1a)[7]

Human nature is evil; what is good is artifice. Now, human nature is as fol-lows. At birth there is fondness for profit in it. Following this, contention and robbery arise, and deference and courtesy are destroyed. At birth there is envy and hatred in it. Following this, violence and banditry arise, and loyalty and trust are destroyed. At birth there are the desires of the ear and eye, there is fondness for sound and color in it. Following this, perversion and chaos arise, and ritual, morality,[8] refinement, and order are destroyed. Thus obey-ing human nature, following one's essence, must result in contention and robbery. This is in accordance with the violation of [social] division and dis-ruption in the natural order, and a return to turmoil.

What Xunzi means by artifice 偽 will become clearer as we pro-ceed. Social division 分, as we will also see, is good in Xunzi's eyes. Xunzi continues, arguing that we can improve our behavior by being taught:

> 故必將有師法之化,禮義之道,然後出於辭讓,合於文理,而歸於治.用此觀之,然則人之性惡,明矣,其善者偽也. (*X* 17.23.289 = K 23.1a)

Thus there must be the transformation [brought about by] the methods of a teacher, and the Way of ritual and morality; then the result will be deference and courtesy, in accordance with refinement and order, and a return to gov-ernment. Using this to see it, it is clear that human nature is evil; what is good is artifice.

今人之性惡,必將待師法,然後正,得禮義,然後治,今人無師法,則偏險
而不正. (*X* 17.23.289 = K 23.1b)

Now human nature is evil, and must await the methods of a teacher before it
is upright, must obtain ritual and morality before it is governed. Now a person
without the methods of a teacher is partial, malicious, and not upright.

Having set forth his point of view, Xunzi thereupon claims that
even the Sage Kings of prehistoric times knew human nature to be
evil, and established conventions of conduct in order to straighten
this perverse inborn nature:

古者,聖王以人之性惡,以為偏險而不正,悖亂而不治,是以為之起禮
義,制法度,以矯飾人之情性而正之,以擾化人之情性而導之也,始出
於治,合於道者也. (*X* 17.23.289f. = K 23.1b)

In ancient times, the Sage Kings took human nature to be evil, and thought
people were partial, malicious, and not upright; shiftless, chaotic, and not
governed. For this reason they established for them ritual and morality. They
instituted laws and norms in order to reform and adorn human essence and
nature, and straighten it; in order to tame and transform human essence and
nature, and guide it. Only then did order ensue, in accordance with what is
the Way.

Thus human beings may transcend their brutish natures through
the guidance of the norms handed down by the Sage Kings, for
these rituals accord with the Way. However vile their initial dispo-
sitions, if people attune themselves to the Way unceasingly, they
may become Sages themselves. The process, however, is by no
means easy.

今之人化師法,積文學,道禮義者,為君子,縱性情,安恣睢 [= 睢],而違禮
義者,為小人.用此觀之,然則人之性惡,明矣,其善者偽焉. (*X* 17.23.290
= K 23.1b)

People today who are transformed by the methods of a teacher, who accumu-
late refinement and learning, who take ritual and morality as their Way, become
noble men; those who indulge their nature and essence, are at peace in lust
and staring, and are far from ritual and morality, become small men. Using
this to see it, it is clear that human nature is evil; what is good is artifice.

Small men can become noble men, and noble men can revert to being small men. The difference is that neither is willing to become the other. A noble man has made himself into a noble man; a small man has not. In his antonomastic style, Xunzi writes that even a person in the street can become the equivalent of Yu 禹, a famous sage, although such a transformation would require an accumulation of learning which would be difficult to accomplish:

故聖人者,人之所積而致也.曰:聖可積而致.然而皆不可積.何也?曰:可以,而不可以使也.故小人,可以為君子,而不肯為君子.君子,可以為小人,而不肯為小人.小人,君子者,未嘗不可以相為也,然而不相為者,可以,而不可以使也.故塗之人,可以為禹,則然. (*X* 17.23.296 = K 23.5b)

Thus the Sage is a person who has achieved this through accumulation [sc. of learning]. It was asked: One can accumulate to achieve sagehood, but all [of us] cannot accumulate. Why is this? I answered: We can, but cannot be forced. Thus a small man can become a noble man, but is not willing to become a noble man. A noble man can become a small man, but is not willing to become a small man. Small man, noble man—it was never so that one could not become the other; but they do not become each other, not because they cannot, but because they cannot be forced. Thus it is like this that a person in the street can become Yu.

At this point Xunzi elaborates: it is *possible* to walk across the world, although no one has done it; but the fact that no one has done it does not mean that it is impossible. Likewise, it is *possible* for a person in the street to become the equivalent of Yu, although, ostensibly, no one has done it recently; but the fact that it is so difficult does not mean that it is impossible. It is difficult because it requires unceasing self-cultivation and vast accumulation of learning.

Xunzi takes up the same theme in a different essay:

材性知能,君子小人一也,好榮惡辱,好利惡害,是君子小人之所同也.若其所以求之之道則異矣.......凡人有所一同,飢而欲食,寒而欲煖,勞而欲息,好利而惡害,是人之所生而有也,是無待而然者也,是禹桀之所同也.目辨白黑美惡,耳辨音聲清濁,口辨酸鹹甘苦,鼻辨芬芳腥臊,體膚理辨寒署疾養 [=癢],是又人之所生而有也,是無待而然者也,

是禹桀之所同也. 可以為堯禹, 可以為桀跖, 可以為工匠, 可以為農賈,
在注錯習俗之所積耳. 是又人之所生而有也, 是無待而然者也, 是禹桀
之所同也.......堯禹者, 非生而具者也, 夫起於變故, 成乎修, 修之為
待盡而後備者也. 人之生固小人. (*X* 2.4.38ff. = K 4.8ff.)

In endowment, nature, knowledge, and ability, the noble man and small man
are one. They like glory and hate shame; they like profit and hate harm. This
is what is alike in noble men and small men. It appears that the Way with
which they seek things is different. . . . All people are alike in one respect:
hungry, they desire food; cold, they desire warmth; working, they desire
rest; they like profit and hate harm. This is what is in human beings from
birth; this is what is so without waiting. This is what is alike in Yu and Jie
[prodigal last king of the mythical Xia 夏 dynasty].[9] The eye distinguishes
white, black, beautiful, and ugly; the ear distinguishes the clarity and muddi-
ness of tones and sounds; the mouth distinguishes sour, salty, sweet, and
bitter; the nose distinguishes fragrant and foul; the bones and skin distin-
guish cold, heat, pain, and itching. This is what is in human beings from
birth; this is what is so without waiting. One can be Yao [a sage ruler] or Yu;
one can become Jie or Zhi [a legendary robber]; one can become a mechanic
or artisan; one can become a farmer or merchant. [The difference] lies in the
accumulated [benefit] of noting faults and practicing habits. This is also what
is in human beings from birth; this is what is so without waiting; this is what
is alike in Yu and Jie. . . . Yao and Yu were not born whole: they arose by
transforming their former selves; they completed themselves through culti-
vation. When they cultivated themselves exhaustively, they became prepared.
Human nature is originally a small person's nature.

The language of the last portion of this passage may be intended
to remind the reader of Mencius's famous aphorism, "The myriad
things are all prepared in me" 萬物皆備於我矣 (7.1.4.1), to which
Xunzi's position here is unmistakably opposed. Mencius holds that
the possibility of attaining sagehood lies originally within one's
mind, Xunzi that this possibility can be brought about only through
the transformation effected by exhaustive self-cultivation. Else-
where Xunzi challenges Mencius directly:

孟子曰: 人之學者, 其性善. 是不然, 是不及知人之性, 而不察乎人之性
偽之分者也. 凡性者, 天之就也, 不可學, 不可事. 禮義者, 聖人之所生
也, 人之所學而能也, 所事而成者也. 不可學, 不可事, 而在人者, 謂之
性. 可學而能, 可事而成之在人者, 謂之偽, 是性偽之分也. (*X* 17.23.290
= K 23.1c)

Mencius said: Since one can learn, one's nature is good. This is not so. This does not reach knowledge of human nature, and does not investigate into the division between one's nature and artifice. Nature is what is spontaneous from Heaven, what cannot be learned, what cannot be acquired. Ritual and morality arise from the Sages. People become capable of them through learning; they complete themselves by acquiring them. What cannot be learned, what cannot be acquired, and is in human beings, is called "nature." That in human beings, of which they can become capable through learning, which they can acquire to perfect themselves, is called "artifice." This is the division between nature and artifice.

Here Xunzi explains his distinction between nature 性 and artifice 偽. Human *nature* is not good, as Xunzi has repeated a number of times; what is good is *artifice*. By nature people are gluttons; the transformation that they may undertake in order to become noble men—or even Sages—is their own project, and hence artificial. Artifice is not inferior to nature; on the contrary, it is one's artifice that *completes* 成 one's nature. We will take up this matter shortly.

孟子曰：人之性善,曰：是不然.凡古今天下之所謂善者,正理平治也,所謂惡者,偏險悖亂也,是善惡之分也.今誠以人之性固正理平治邪?則有惡用聖王,惡用禮義矣哉? (*X* 17.23.293 = K 23.3a)

Mencius said: Human nature is good. I say: This is not so. From ancient times until the present, all that has been called good under Heaven is rectitude, order, peace, and government. What is called evil is partiality, malice, perversion, and chaos. This is the division between good and evil. Now can one sincerely believe that human nature is originally upright, ordered, peaceful, and governed? Then what use for the Sage Kings, what use for ritual and morality?

Xunzi's point here is similar to what we have seen above: human nature cannot be good, because if it were, there would have been no need for the Sage Kings to have governed with ritual. Were people moral by nature, the Sage Kings could not have improved upon their innate morality by implementing their rituals. Note that this does not contradict Mencius's argument: Mencius agrees that people must cultivate their incipient goodness to remain good. Without constant nourishment, goodness decays. Little indeed of Xunzi's essay, for all its eloquence, can be said strictly to refute

Mencius's position. The two thinkers arrive, in fact, at remarkably similar points of view. Both agree that people can perfect themselves; both agree that such an achievement requires great exertion and self-motivation.[10] And both agree that without such self-cultivation, people are evil.[11]

These similarities have led some commentators to suggest that Xunzi's objections "are not quite to the point."[12] What prompted Xunzi to dissent vigorously from Mencius's characterization of human nature as good, if his own theory was to be, from a pragmatist point of view, so difficult to distinguish from the one he criticizes so keenly?[13] Much of the difference between Mencius and Xunzi, as has been observed, lies in the uses to which the two thinkers put the term that we have until now provisionally translated as "nature" 性. There is little consensus among scholars regarding the precise classical "meaning" of *xing* 性. Some suggest that it indeed carries a meaning comparable to that of our "human nature," while others disagree; some point out that the term may mean a number of different things among different authors and in different contexts—to the point that it may mean almost anything.[14] And it is certainly true that Mencius and Xunzi cannot mean the same thing by *xing*.

Xing 性 has a manifest graphemic connection with *sheng* 生 "life" in addition to an alluring semantic bond, although phonologically it is unclear how or whether the two terms are related.[15] Nevertheless, the organic dimension to Mencius's conception of *xing* is made clear by a telling line in the parable of Ox Mountain: "If it obtains its nourishment, nothing will not grow; if it loses its nourishment, nothing will not be obliterated" 苟得其養, 無物不長, 苟失其養, 無物不消. A person's *xing* is, in other words, like a tree: it will grow if it is nourished; it will wither if it is not. The *xing* represents the natural course of development which an organism may be expected to undergo given nourishing conditions.[16] There is abundant classical evidence for such a sense:

彼民有常性, 織而衣, 耕而食.[17]

The people have a constant *course of life*: they weave to clothe themselves and plow to feed themselves.

全性保真, 不以物累形.[18]

Keep intact your *natural course of life* and protect your integrity; do not burden the form [of the body] on account of [other] things.

Mencius, therefore, is telling us what we may become if there is no interference with our natural course of life. In this sense, it is a tree's *xing* to become leafy and offer shade; it is no refutation to observe that trees die without leaves if they are denied their proper nourishment. A person's *xing*, similarly, is to be humane, moral, and so on—in other words, good—and the cultivation of one's incipient virtue is as essential to one's moral development as water and soil are to the tree's growth. It is not a flaw in his argument, therefore, that one's *xing* may be good and yet one's actual behavior not good.[19]

By contrast, there is no organic or dynamic element to Xunzi's *xing*:

生之所以然者, 謂之性. (*X* 16.22.274 = K 22.1b)

What is so by birth is called *xing*.

Xing is what we have from birth—in other words, different forms of desire. These desires are not merely appetitive; to Xunzi, human beings desire virtually everything, and engage in all manner of unscrupulous conduct in order to gain satisfaction of their desires. To our *xing* belong also our senses and our faculties. *Xing* encompasses everything which we possess without having exerted any effort to obtain it.

While Xunzi uses *xing* to denote what all members of a certain species hold in common, Mencius emphasizes that *xing* in his parlance indicates what distinguishes the members of a certain species from all other species:

犬之性, 猶牛之性, 牛之性, 猶人之性與? (6.1.3.3)

Is a dog's *xing* like an ox's *xing*; is an ox's *xing* like a person's *xing*?

To Mencius, this is a rhetorical question; the dog's *xing* is obviously *not* the same as an ox's *xing*. Each species has its own *xing*.[20] But, deliberately or not, Xunzi misrepresents Mencius's use of *xing*.[21] The Mencian *xing* can grow and change; to Xunzi it is immutable. In Mencius, *xing* embodies the unique characteristics of human beings, while in Xunzi's work, it signifies only the characteristics that all people share from birth. For, as we shall see, Xunzi has a separate term for the unique characteristics of human beings: *ren zhi suoyi wei ren zhe* 人之所以為人者 ("that by which humans are human").[22]

We can thus feel secure in eliminating the commonplace but superficial reading of the debate between Mencius and Xunzi: Mencius argued that human nature is good, Xunzi that human nature is bad.[23] Mencius and Xunzi were not even talking about the same thing, and if we refer to *xing* as "human nature," we may do so only as a sort of stock translation, since "nature" cannot capture the nuances of *xing*.[24] The power of Xunzi's essay must lie elsewhere.

An appealing line of exegesis that has been followed by many scholars is to consider Xunzi's use of the term *e* 惡 as hyperbole.[25] The meaning of *e* certainly lies close to that of "evil"—though not necessarily evil *for its own sake*; Xunzi makes this much clear when he defines *e* as "partiality, malice, and lack of uprightness; rebelliousness, chaos, and anarchy" 偏險而不正；悖亂而不治 (*X* 17.23.293). Xunzi's villain steals the pears, in other words, for the pleasure of eating them, not for the pleasure of having stolen them.[26] But it is worth considering the argument that Xunzi deliberately overstates his case in order to emphasize a point that Mencius may have overlooked. Suppose that, far from "missing the point," Xunzi *intended* the consequences of his theory to match those of Mencius as closely as they do. The force of such a move would be aesthetic. Mencius may assert as he wishes that the *xing* is good—so Xunzi might be telling us—I can argue as cogently that the *xing* is evil, and arrive at virtually the same conclusions. "Good" and "evil," in other words, are inadequate terms; the complexity of *xing* is such that it defies facile characterization.

It is useful in this regard to consider Xunzi's discussions of the nature of the state 國：[27]

有亂君，無亂國......故明主急得其人，而闇主急得其埶.急得其人，則
身佚而國治，功大而名美，上可以王，下可以霸.不急得其人，而急得其
埶，則身勞而國亂，功廢而明辱，社稷必危.故君人者，勞於索之，而休於
使之. (*X* 8.12.151 = K 12.1)

There are chaotic lords; there are no chaotic states. . . . Therefore, an enlightened ruler hastens to obtain [the support of] his people, and a benighted ruler hastens to obtain his stature. If he hastens to obtain his people, then his body may be at leisure, yet the state governed; his accomplishments will be great and his name admired. At best, he can be a king; at worst, he can be a hegemon. If he does not hasten to obtain his people, but hastens to obtain his stature, then his body may toil, yet the state will be in chaos; his accomplishments will be frustration, his name shame. The altars of grain and soil will be imperiled. Thus the lord toils at choosing him, and relaxes as he commands him.

The state is morally indeterminate; its fate rests in the disposition of its ruler. The ruler who concentrates on ordering the state through the employment of ministers obtains admiration and a measure of spiritual success. The benighted ruler seeks stature 埶, but finds only the instability of the hearth.

Xunzi discloses his point of view further in the following passage:

刑 [=形] 范正，金錫美，工合巧，火齊得，剖刑而莫邪已.然而不剝脫，不
砥厲，則不可以斷繩，剝脫之，砥厲之，則劙盤盂，刎牛馬忽然耳.彼國
者，亦 [有] 彊國之剖刑已.然而，不教誨，不調一，則入不可以守，出不可
以戰，教誨之，調一之，則兵勁城固，敵國不敢嬰也.彼國者，亦有砥厲，
禮義節奏是也. (*X* 11.16.194 = K 16.1)

If the mold is exact, the metal auspicious,[28] the workmanship and casting skillful, and the fire and alloying appropriate, then cut open the mold and there will be a Moye [a mythical sword].[29] But if one does not pare and expose it [when it becomes rough], does not sharpen it with a whetstone, then it will not be able to cut a rope. If one pares and exposes it, sharpens it with a whetstone, then it can slice a pan or basin, and slash an ox or horse instantly. As for the state—there is also a "cutting open of the mold" for a

strong state. But if one does not teach and instruct, does not tune [i.e. harmonize] and unify, then one cannot defend against invasions or wage war outside [i.e. on other states]. But if one teaches and instructs them, tunes and unifies them, then the soldiers will be firm and the fortress secure; enemy states will not dare enclose. As for the state—there is also a "sharpening with a whetstone." This is ritual, morality, restraint, and report.

The fortune of the state lies in its execution of the rituals. The ruler who does not "sharpen" his state is helpless against attack; the ruler who implements the rituals presides over an orderly domain. There are no intrinsic tendencies to the state: the pattern that it demonstrates is impressed upon it by the ruler.

君者儀也, 儀正, 而景正, 君者槃也, 槃圓, 而水圓, 君者盂也, 盂方而水方. (*X* 8.12.154 = K 12.4)

The lord is the sundial. If the sundial is straight, the shadow is straight. The lord is the bowl. If the bowl is round, the water is round. The lord is the basin. If the basin is square, the water is square.

The whetstone passage contains language remarkably similar to that describing a person's process of self-refinement:

君子曰: 學不可以已. 青, 取之於藍, 而青於藍, 冰, 水為之, 而寒於水. 木直中繩, 輮以為輪, 其曲中規, 雖有槁暴, 不復挺者, 輮使之然也. 故木受繩, 則直, 金就礪, 則利. 君子博學而日參省乎己, 則知明而行無過矣. (*X* 1.1.1 = K 1.1)[30]

The noble man says: Learning cannot cease. Blue dye is gained from the indigo plant, but is bluer than the indigo. Ice is made of water, but is colder than water. Wood as straight as a plumbline, if bent into a wheel, [can become] as round as a compass. Though it be dried or heated, it will not return to its straightness because the bending has made it that way. Thus wood set to the plumbline is straight; metal put to the grindstone is keen. The noble man learns broadly and examines himself trebly everyday,[31] so that his knowledge is bright and his conduct without transgression.

直木, 不待櫽栝而直者, 其性直也, 枸木, 必將待櫽栝烝矯然後直者, 以其性不直也. 今人之性惡, 必將待聖王之治, 禮義之化, 然後皆出於治, 合於善也. 用此觀之, 然則人之性惡明矣, 其善者偽也. (*X* 17.23.294 = K 23.3c)

> Straight wood need not await the bevel and press-frame to be straight, because
> its *xing* is straight. Warped wood must await the bevel and press-frame and
> be steamed before it is straight, because its *xing* is not straight. Now a person's
> *xing* is evil; it must await the governance of the Sage Kings, the transformation
> of ritual and morality, then [people] all develop with governance accompanied
> by goodness. Using this to see it, it is clear that a person's *xing* is evil, what is
> good is artifice.

The recurrent artisan's metaphors—of warped wood placed before the bevel, of metal whetted by the stone—bring to the fore the central difference between Xunzi and Mencius. Xunzi proposes a bipartite model of the fortune of a polity. The state possesses an initial set of features—it may be large, small, prosperous, depressed, desirable, or undesirable—but these features are immaterial to the state's ultimate shape, for, however small, a state may yet serve as the foundation for global dominion:

百里之國, 足以獨立矣. (X 6.10.127 = K 10.14)[32]

A state of one hundred *li* is sufficient to establish independent rule [over the earth].

Thus it is the second variable that is critical: the management of the state. The state may be nurtured into the demesne of a king, or cast to perdition at the hands of its enemies. There are furthermore two constitutive elements to the process of transformation. First, transformation requires a method; this involves following the rituals handed down by the Sage Kings. But the process requires moreover a conscious spirit, a decisive agent, who wills that the transformation take place. This element is the lord who causes the rituals to be followed, or causes them to fall into disuse.

This claim can bear repeating; it is essential to the rest of the argument. The state is made up of two parts: its resources and its policies. Success or failure rest with the policies; the resources play no appreciable role in the determination of the state's ultimate fate. Policy-making is further composed of two parts: method and agent. The only effective method, Xunzi asserts, is that of the Sage Kings; we shall discuss the implications of this tenet in chapter 3. The agent chooses the method freely; the agent is the lord.

There is a fundamental parallel in Xunzi's conceptions of polity and personhood. People, too, are made up of two parts: their *xing*, or their initial state, and their conduct, or, in Xunzi's language, their artifice 偽. Their initial state is evil, but this evil does not preclude their subsequent development. Through their conduct they may transform themselves; or they may just as easily remain evil. Personal conduct, the analogue of policy in the case of the state, contains the same two sub-elements: method and agent. Here again, according to Xunzi, the only effective method of self-cultivation is to follow the rituals of the Sage Kings. The agent chooses to adopt or reject that method: the agent is the mind 心.

To investigate the consequences of this point of view, let us begin with Huang Baijia's 黃百家 (fl. 1680–1695) famous objection: If one's *xing* is evil, how can one desire to become good 安有欲為善乎?[33] Xunzi offers two answers. The first is that evil desires what it has not, or in other words good:

> 凡人之欲為善者,為性惡也.夫薄願厚,惡願美,狹願廣,貧願富,賤願貴,苟無之中者,必求於外.故富而不願財,貴而不願埶,苟有之中者,必不及於外.用此觀之,人之欲為善者,為性惡也. (*X* 17.23.292 = K 23.2b)

All people desire to become good because their *xing* is evil. Thin yearns for thick, ugly yearns for beautiful, cramped yearns for spacious, base yearns for noble. If they do not have it in them, they must seek it from outside. Thus the rich person does not yearn for wealth, the aristocrat does not yearn for stature. If one has it in one, one does not need to reach outside. Using this to see it, one seeks to become good because one's *xing* is evil.

This is an ineffectual response, which only lends fuel to Huang Baijia's criticism. If it is in fact the evil—that is, the lack of goodness—in one's *xing* that leads one to seek good, can it not be said that one's *xing* possesses an intrinsic impetus towards good?[34] This road is best left untravelled. For Xunzi is armed with a far more trenchant explanation of the urge to goodness. It is *prudent*:

> 禮起於何也?曰:人生而有欲,欲而不得,則不能無求,求而無度量分界,則不能不爭,爭則亂,亂則窮.先王惡其亂也,故制禮義以分之,以養人之欲,給人之求,使欲必不窮乎物,物必不屈於欲,兩者相持而長,是禮之所起也. (*X* 13.19.231 = K 19.1a)[35]

Whence did rituals arise? I say: One is born with desires; if one desires and does not obtain [the object of one's desires], then one cannot but seek it. If, in seeking, people have no measures or limits, then there cannot but be contention. Contention makes chaos, and chaos privation. The Former Kings hated such chaos, and established ritual and morality in order to divide them [i.e. people], in order to nourish people's desires and grant what people seek. They brought it about that desires need not be deprived of objects, that objects need not be depleted by desires; the two support each other and grow: this is where rituals arise.

夫貴為天子,富有天下,是人情之所同欲也.然則從人之欲,則埶 [=藝] 不能容,物不能贍,故先王案為之制禮義以分之. (*X* 2.4.44 = K 4.12)

To be honored as the Son of Heaven [i.e. the ruler on earth], and to possess richly all under Heaven—this is the common desire of human essence. But if people follow their desires, then boundaries cannot contain [them] and objects cannot satisfy them. Thus the Former Kings restrained them and established for them ritual and morality in order to divide them.

今使人生而未嘗睹芻豢稻粱也,惟菽藿糟糠之為睹,則以至足為在此也,俄而粲然有秉芻豢稻粱而至者,則瞲然視之,曰:此何怪也!彼臭 [=嗅] 之,而無嗛於鼻,嘗之,而甘於口,食之,而安於體,則莫不棄此而取彼矣.今以夫先王之道,仁義之統,以相群居,以相持養,以相藩飾,以相安固邪?以夫桀跖之道,是其為相縣也,幾 [=豈] 直夫芻豢稻粱之縣糟糠爾哉? (*X* 2.4.40f. = K 4.10)

Now if one were made to live without having gazed upon [the meat of] grass- and grain-fed [animals], or rice and millet, having gazed upon only beans, pulse, dregs, and chaff, then he would consider highest sufficiency to be in this. But if suddenly a sumptuous platter were to arrive with [the meat of] grass- and grain-fed [animals], and rice and millet, then one would behold it staring, and say: What strange thing this is! That [delicacy]—when one smells it, it is not disturbing to the nose; when one tastes it, it is sweet to the mouth; when one eats it, it is peaceful to the body—thus no one does not reject this [old food] and choose that [new food]. Now take the Way of the Former Kings, the principles of humanity and righteousness—are they not that by which societies live together, by which we support and nourish each other, by which we screen and adorn each other, by which we are peaceful and secure with each other? Does it not contrast with the Way of Jie and Zhi just as [the meat of] grass- and grain-fed [animals], rice, and millet contrast with dregs and chaff?

One observes that it is *in one's best interest* to follow the rituals. A world of unbridled contention prevents the fulfillment of everyone's desires. The Former Kings established the rituals in order to regulate one's associations with others, to bring into existence a regulated society in which one's trust in one's neighbors allows for everyone's continued enjoyment. One cedes one's absolute freedom today in exchange for greater goods tomorrow, in accordance with a calculus that is rational and hedonistic; the mode of argument is reminiscent of the utilitarian principle of prudence propounded by Henry Sidgwick (1838–1900).[36] Why do we have an urge towards goodness? Because we reckon that we are simply better off good than evil.

Conformity with the principles of ritual is the essence of goodness, as Xunzi makes clear in what may be an early passage displaying Mencian influence:[37]

君子養心,莫善於誠,致誠則無它事矣.唯仁之為守,唯義之為行.誠心守仁則形,形則神,神則能化矣.誠心行義則理,理則明,明則能變矣.變化代興,謂之天德. (*X* 2.3.28 = K 3.9a)

For the noble man to nourish his mind, there is nothing better than *cheng*. If one has attained *cheng*, then there is no other matter [of concern]. Only humanity is defended, only righteousness is practiced. If one *cheng* one's mind to defend humanity then there is form, with form there is spirit, with spirit one can transform [one's *xing*]. If one *cheng* one's mind to practice righteousness, then there is order, with order there is illumination, with illumination one can change [one's *xing*]. When change and transformation prosper for ages, this is called the power of Heaven.

The character *cheng* 誠 is often translated as "integrity" or "sincerity." This is the modern meaning, and the classical sense certainly contains these nuances. But the effective meaning of *cheng* is conformity with the Way 道.[38] The root meaning lies close to our English "fulfillment" or "perfection." Phonologically *cheng* 誠 is indistinguishable in all periods of the language from *cheng* 成 "to complete" (as well as *cheng* 城 "to fortify," hence "wall, fortress"; and *cheng* 盛 "to fill, to pack"). *Cheng* 誠 is thus a graphic variant indicating a particular sense of *cheng* 成. The *Zhong yong* 中庸

(*Application of the Mean*), a text with a philosophical orientation not dissimilar to that of Mencius, expands upon the concept.

誠者, 自成也, 而道自道 [=導] 也. (25.1)

Cheng is self-completion, and the Way is self-guidance.

誠者, 天之道也, 誠之者人之道也. 誠者不勉而中, 不思而得, 從容中道, 聖人也. 誠之者, 擇善固執之者也. (20.18)

What is perfect is the Way of Heaven; the perfection of the self is the Human Way. One who is perfect hits upon [the right] without effort, apprehends without thinking, naturally and easily hits upon the Way, is a Sage. One who perfects oneself is one who chooses goodness and firmly holds to it.

Cheng means self-completion, and self-completion means hitting upon 中 the Way.[39] While it would be inaccurate to say that the philosophy of the *Zhong yong* is the same as that of Xunzi—the understanding of *xing*, for example, is entirely different—it is nevertheless the case that Xunzi incorporates into his philosophy a notion of *cheng* quite compatible with this text. Our *xing*, our natural *donnée*, is evil, and it is our task to complete 成 our development by *transforming* 化 our nature. This completion is called *cheng* 誠, let us say, "perfection," and perfection entails following the rituals. Unfulfilled *xing* is evil; transformed *xing* is good. This is why Xunzi insists repeatedly that it is artifice which is good, and not *xing*: self-perfection lies within the realm of conduct rather than that of initial nature. It is in this light that we are to interpret Xunzi's apophthegm:[40]

天地生之, 聖人成之. (*X* 6.10.118 = K 10.6)

Heaven and Earth give birth to it; the Sage completes it.

But this view of human development rests throughout upon the basic assumption that one's actions represent one's own choices. We may attempt to complete ourselves and transform our *xing*, and enjoy the benefits, both material and spiritual, of a good life— or we may equally freely decline the effort, and suffer the consequences of imprudent reasoning. To complement such an outlook,

Xunzi must postulate a conscious agent within us, directing our paths between the alternatives that we face. Xunzi needs a concept of mind.

人何以知道?曰:心.心何以知?曰:虛壹而靜.心未嘗不臧也,然而有所謂虛,心未嘗不滿[=兩?]也,然而有所謂一,心未嘗不動也,然而有所謂靜.人生而有知,知而有志,志也者,臧也,然而有所謂虛,不以所已臧害所將受,謂之虛.心生而有知,知而有異,異也者,同時兼知之,同時兼知之,兩也,然而有所謂一,不以夫一害此一,謂之壹.心臥則夢,偷則自行,使之則謀,故心未嘗不動也,然而有所謂靜,不以夢劇亂知,謂之靜. (*X* 15.21.263f. = K 21.5d)

How does one know the Way? I say: the mind. How does the mind know? I say: emptiness, unity, and tranquillity. The mind never stops storing, but it has something called emptiness. The mind never stops being filled [or 未嘗不兩 "never lacks duality"], but it has something called unity. The mind never stops moving, but it has something called tranquillity. From birth humans have knowledge; with knowledge come thoughts; thoughts are stored. But it has something called emptiness: it does not take what has been stored to harm what is to be received; this is called emptiness. From birth the mind has knowledge; with knowledge comes [perception of] difference; different things are known at the same time. Knowing different things at the same time is duality. But it has something called unity: it does not take one thing to harm another; this is called unity. The mind dreams when it sleeps; it moves by itself when it relaxes; it plans when it is commanded. Thus the mind never stops moving, but it has something called tranquillity: it does not take dreams and fancies to bring chaos to knowledge: this is called tranquillity.

Xunzi here elucidates three paradoxes concerning the mind. The mind stores thoughts incessantly, but always allows for the storage of new information. This feature he calls emptiness. The mind also knows different things, but retains its essential unity. We speak, for example, of *one* Abraham Lincoln, although through his intellectual life Abraham Lincoln's mind projected any number of disjunct and discrete thoughts. Xunzi dubs this property unity. The third paradox involves the subconscious (or unconscious) and conscious aspects of the mind. The mind dreams and fantasizes when we do not control it; and yet when we direct it, it ceases its wandering and separates its fancies from reality. Xunzi calls this feature tranquillity.

All three of the mysterious mental functions that Xunzi outlines—storage, unity, and consciousness—represent issues as unsettled in the philosophical scene today as they were over two thousand years ago.[41] The conundrum of identity has occasioned numerous enquiries in the West. Is the reformed Scrooge the same man as Scrooge the miser? The physical aspect of the problem is no less perplexing: how can we consider ourselves the same beings as when we were born, when every atom in our bodies is replaced over the course of a few years?[42] There lies likewise a puzzling paradox beneath the characteristic of tranquillity: what body is it that employs the mind if not the mind itself? On the one hand, it seems impossible to deny the existence of a conscious spirit directing the mind—for it appears to be an antinomy for the mind to control itself—but on the other hand, the ontic manifestation of such a spirit defies observation. Along such lines rages the monist-dualist debate even now.

We have reached now an intricate topic; it will be useful to set aside for the moment our inquiry into the difference between Mencius and Xunzi, and examine at some length Xunzi's concept of mind. Our observations here will aid us in our original purpose, and help us answer Huang Baijia's question. It has been observed that in the succinct passage on the mind Xunzi borrows terms from other schools while simultaneously rejecting the philosophical views from which he has severed them.[43] That this is so can be demonstrated by a comparison with influential texts representing other traditions.

The *Zhuangzi* 莊子, for example, also recommends that one make one's mind empty:

無為名尸,無為謀府,無為事任,無為知主,體盡無窮,而遊無朕,盡其所
受乎天,而無見得,亦虛而已,至人之用心若鏡,不將不迎,應而不藏,故
能勝物而不傷.[44]

Do not be a medium possessed by fame; do not be the storehouse of plans; do not be the undertaker of affairs; do not be the proprietor of knowledge. Embody exhaustively what has no limit and wander where there is no trail. Use what you have received from Heaven, but do not see or apprehend. Be empty—that is it. The consummate person employs his or her mind as a

mirror, without leading or welcoming, responding but not storing. Thus he or she can win over things without injury.

But Zhuangzi's admonition not to store 藏 is merely one indication that his conception of emptiness 虛 is not at all the same as Xunzi's. Emptiness for Xunzi refers to the mind's capacity to store unlimited information; to Zhuangzi it represents a state of perfect impartiality. The mirror is therefore a favorite motif of Zhuangzi: continuously reflecting, it has no absolute substance or direction of its own. Zhuangzi expresses his suspicion of resolute minds in a passage that reveals further the fundamental schism between him and Xunzi:

夫隨其成心而師之, 誰獨且無師乎? 奚必知代而心自取者有之? 愚者與有焉.[45]

[If one] follows one's completed mind and makes it one's guide, who will not have a guide? Why must one know the succession [sc. of time] and make one's own choices with one's mind to have [a guide]? Idiots also have one.

The "completed mind" 成心 here refers to what are often called in legal philosophy "conscientiously held private beliefs": a completed mind is a mind that has been made up, with its own opinions and prejudices, and anyone from a genius to an imbecile can have one. Indeed, if we replace "completed mind" with "conscience," we find before us an argument that could well have come from the mouth of Hobbes:

When two, or more men, know of one and the same fact, they are said to be CONSCIOUS of it one to another; which is as much as to know it together. And because such are fittest witnesses of the facts of one another, or of a third; it was, and ever will be reputed a very Evil act, for any man to speak against his *Conscience*; or to corrupt or force another so to do: Insomuch that the plea of Conscience, has been always hearkened unto very diligently in all times. Afterwards, men made use of the same word metaphorically, for the knowledge of their own secret facts, and secret thoughts; and therefore it is Rhetorically said, that the Conscience is a thousand witnesses. And last of all, men, vehemently in love with their own new opinions, (though never so absurd,) and obstinately bent to maintain them, gave those their opinions also that reverenced name of Conscience, as if they would have it seem

unlawfull, to change or speak against them; and so pretend to know they are true, when they know at most, but that they think so.[46]

"Conscience," in other words, is a grand name for opinion, which everyone has in abundance. It is central to Hobbes's philosophy that a situation in which everyone follows his conscience is one in which virtually no one profits and is in all respects inferior to that brought about by a commonwealth under the rule of a sovereign.[47] Similarly, Zhuangzi believes that there are as many ways to "complete" a mind as there are people with minds to complete. But Xunzi holds, as we have seen, that there is only one legitimate form of self-completion: *cheng*, or diligent conformity with the Way.[48] Xunzi partook of no Hobbesian skepticism of right reason: there is one correct Way, knowable, and practicable. We have encountered here the first of what will be many attacks by Xunzi upon nascent attitudes of *relativism*.

Xunzi's rigid and uncompromising distinction between conscious and unconscious psychic activity may likewise be interpreted as an attempted refutation of Zhuangzi, who took up the issue of dreaming in a famous passage:

昔者,莊周夢為胡蝶,栩栩然胡蝶也,自喻適志與,不知周也,俄然覺,則蘧蘧然周也,不知周之夢為胡蝶與,胡蝶之夢為周與.周與胡蝶,則必有分矣.此之謂物化.[49]

In the past Zhuang Zhou dreamt he was a butterfly. The fluttering butterfly was aware that its intentions were gratified, but did not know [Zhuang] Zhou. When suddenly he awoke, Zhou, startled, did not know whether Zhou was dreaming he was the butterfly, or the butterfly was dreaming it was Zhou. There must be a distinction between Zhou and the butterfly. This is called the Transformation of Things.

And similarly:

且汝夢為鳥而厲乎天,夢為魚而沒於淵,不識今之言者,其覺者乎,其夢者乎.[50]

You dream you are a bird and soar unto Heaven; you dream you are a fish and dive into a pool. But I do not know whether the present speaker is awake or dreaming.

Xunzi would counter that the dreamer Zhuangzi was probably confused only in jest, and was in any case confused only *temporarily*: as soon as he commanded his mind 使心, the clouds receded. But here Xunzi may well have missed the point. The heart of Zhuangzi's (pre-Cartesian) argument is epistemological: How can we know whether what we experience is real?

夢飲酒者,旦而哭泣,夢哭泣者,旦而田獵.方其夢也,不知其夢也,夢之中又占其夢焉.覺而後知其夢也.且有大覺而後知此其大夢也,而愚者自以為覺,竊竊然知之,君乎,牧乎,固哉!丘也,與女皆夢也.[51]

Who dreams of wine weeps in the morning; who dreams of weeping hunts in the morning. While one is dreaming, one does not know that it is a dream, and in the middle of the dream one [may] even divine one's dream. Only after waking does one know that it was a dream. Soon there will be a Great Awakening, after which we will know that this is a Great Dream. And fools think themselves awake, confident that they know things—this is a lord, this a shepherd—blockheads! Confucius and you are all dreaming.

Though he may assert that the mind distinguishes waking from dreaming, Xunzi cannot be said to have refuted *this* point; for by "dreaming" Zhuangzi actually meant *sensory delusion*, and there is indeed no way to distinguish reality from our perception of it. Zhuangzi comes down to us, in other words, as an ancient proponent of phenomenalism.[52]

Xunzi's doctrine of unity 壹 similarly stands in direct opposition to Zhuangzi's teaching that the mind should reflect like a mirror and engage in no purposive action. Xunzi argues, by contrast, that only focused effort can bring about any results:

積土成山,風雨興焉,積水成淵,蛟龍生焉,積善成德,而神明自得,聖心備焉.故不積蹞步,無以至千里,不積水流,無以成江海.騏驥一躍不能十步,駑馬十駕.功在不舍,鍥而舍之,朽木不折,鍥而不舍,金石可鏤.蚓無爪牙之利,筋骨之強,上食埃土,下飲黃泉,用心一也. (*X* 1.1.5 = K 1.6)[53]

If one accumulates enough earth to complete a mountain, the wind and rain prosper on it. If one accumulates enough water to complete a pool, serpents and dragons are born in it. If one accumulates enough goodness to complete virtue, then numinous illumination is obtained of itself, and a Sagelike mind is prepared within one. Thus without accumulating half-paces and paces,

there is no way to reach a thousand *li* [a standard unit of measurement comparable to, but shorter than, our mile]. Without accumulating waters and streams, there is no way to complete rivers and oceans. Qiji [a legendary thoroughbred][54] cannot [advance] ten paces in one prance, but in ten yokings a nag [can]. Accomplishment rests in not desisting. If one carves but desists, rotten wood will not be broken. If one carves and does not desist, metal and stone can be engraved. The earthworm has not the benefit [or keenness] of claws and teeth, the strength of muscles and bones. Above it eats dust and earth; below it drinks from the Yellow Springs [the mythic subterranean realm].[55] It employs its mind to one [purpose].

The assiduous earthworm focuses itself upon its solitary goal, and can, as a result, construct tunnels through layers of earth. Accomplishment is attained through accumulation, single-minded and unrelenting attention to a particular task.[56] An unengaged mind accumulates nothing and accomplishes nothing.

Unity is also a crucial notion in mystical traditions.[57] The *Laozi* contains a number of passages—some of them enigmatic and nearly inscrutable—expounding on unity or the One:[58]

載營魄裹一, 能無離乎? 專氣致柔, 能如嬰兒乎? 滌除玄覽, 能無疵乎?[59]

Keeping the souls,[60] carrying the One in your bosom, are you able never to leave it? Concentrating the *qi* and achieving softness, are you able to [be like] an infant? Polishing and cleaning your dark insight, can you make it without blemish?

聖人裹一, 為天下式.[61]

The Sage carries the One in his bosom and becomes the model for all under Heaven.

昔之得一者: 天得一以清, 地得一以寧, 神得一以靈, 谷得一以盈, 萬物得一以生, 王侯得一以為天下貞, 其致之一也.[62]

These obtained the One in ancient times: Heaven obtained the One to become clear. Earth obtained the One to become settled. Spirits obtained the One to become numinous. Valleys obtained the One to become full. The myriad things obtained the One to be born. Kings and counts obtained the One to become the [most] virtuous under Heaven.[63] What makes them so is the One.

道生一, 一生二, 二生三, 三生萬物, 萬物負陰而裹陽.[64]

The Way bore the One. The One bore the Two. The Two bore the Three. The Three bore the myriad things. The myriad things carry *yin* and bear *yang* in their bosoms.

Yin and *yang* are the complementary aspects of matter and its processes. They are not poles, for one has no manifestation without the other; and they have no physical existence, though they reside in all material.[65] The One is a cosmological force, borne of the Way and composed of *yin* and *yang*; the text deliberately leaves the rest obscure. Through what may be yogic practices, one can embrace the One and attain some transcendent state. Bodies including Heaven on high and kings among us have obtained the One and owe their character to it.[66]

The place of the One is more explicit in another text from the third century B.C., the *Heguanzi*.[67] According to this work, matter is made up of numerous complementary aspects, including *yin* and *yang*. The cosmographic arrangement here is similar to that in Laozi:

有一而有氣, 有氣而有意, 有意而有圖, 有圖而有名, 有名而有形, 有形而有事, 有事而有約, 約決而時生, 時立而物生. 故氣相加而為時, 約相加而為期, 期相加而為功, 功相加而為得失, 得失相加而為吉兇, 萬物相加而為勝敗. 莫不發於氣, 通於道, 約於事, 正於時, 離於名.[68]

There is the One and hence the *qi* [undifferentiated substance], the *qi* and hence the idea, the idea and hence the picture, the picture and hence the name, the name and hence the form, the form and hence the affair, the affair and hence the covenant. The covenant decided, time is born; time established, objects are born. Thus *qi* added together makes time; covenants added together make projects; projects added together make accomplishment; accomplishments added together make gain and loss; gains and losses added together make auspiciousness and inauspiciousness; the myriad things added together make victory and defeat. Everything emerges from *qi*, interpenetrates the Way, is covenanted by affairs, is regulated by time, and corresponds to its name.

故東西南北之道踹 [=耑/專?], 然其為分等也, 陰陽不同氣, 然其合同也, 酸鹹甘苦之味相反, 然其為善均也, 五色不同采, 然其好齊也, 五聲不同均, 然其喜一也.[69]

Thus the ways of east, west, south, and north are specific [or "roads are trod" in the four directions], but are of the same rank as portions [i.e. they are all quarters]. *Yin* and *yang* are not the same *qi*, but their harmony is the same. The tastes of sour, salty, sweet, and bitter oppose each other, but are on a par in goodness [i.e. all tastes are good]. The Five Colors are not the same hues, but their charms are equal. The Five Sounds are not the same pitch, but their delights are one.

All matter is composed of a protean One. The senses may detect different manifestations of this One as different colors, sounds, or tastes, but all the different aspects must correlate since they are all products of the same universal Origin. The *Heguanzi* cosmology is different from that of the *Laozi* in that the One is *not* born of the Way; it operates in tandem with the Way as one of two aspects of the cosmos,[70] as *yin* and *yang* act in concert as aspects of matter:

空之謂一,無不備之謂道,立之謂氣,通之謂類,氣之害人者,謂之不適,味之害人者,謂之毒.天 [=夫?] 社不刺,則不成霧.氣故相利相害也,類故相成相敗也.[71]

The Void is called the One; [that by which] there is never no instantiation is called the Way. What establishes [a thing] is called *qi*, what interpenetrates it is called kind. When *qi* harms people, it is called inappropriateness. When taste harms people, it is called poison. When the Heavenly earth-altar [or: "When the earth-altar"] is not stabbed [i.e. exposed to the right kind of *qi*] then mist is not completed.[72] Thus *qi* benefits or harms; kind succeeds or fails.

This difficult passage appears to tell us that the One represents primal substance, the Way the order into which that substance is put. By "kind" 類 the text means the manipulation of situations. Thus the instantiation of the One is *qi*, substance; the instantiation of the Way is kind. The One and the Way interact through *qi* and kind to yield *effects*: thus mist appears when the appropriate form of *qi* is conjoined to the hearth in the proper way. The scheme is hylomorphic: effects are made of matter and form.

As we have read in the *Laozi*, moreover, the One can be apprehended, with beneficial results.

故物無非類者,動靜無非氣者,是故有人將.得一,人氣吉,有家將,得
一,家氣吉,有國將,得一,國氣吉,其將兇者,反此.[73]

Thus since no object is without its kind, no action or quietude without its *qi*, there is human contingency. When the One is apprehended, human contingency is auspicious. There is familial contingency. When the One is apprehended, familial contingency is auspicious. There is national contingency. When the One is apprehended, national contingency is auspicious. If the contingency is inauspicious, it is opposite to this [i.e. the One is not apprehended].

But this One is not Xunzi's One. Knowing well the history of his terms and the contexts in which they appeared before him, Xunzi wishes the reader to avoid all such mystical associations when he counts unity among the faculties of the mind. Xunzi's unity is a mental property rather than a cosmic force or presence, and need not be the object of a lifelong meditative quest, for it is ever present in the mind. If Xunzi's phraseology recalls texts like the *Laozi* or *Heguanzi*, it does so only to the end of emphasizing what his conception of unity is *not*.

There is one other contemporary text to which Xunzi may have been alluding in his discussion on the mind—or in any case a philosophical line of which he must have been aware. This is the *Neiye* 內業 (*Internal Enterprise*), included in the well-known miscellany *Guanzi* 管子, which derives its name from the famed Qi minister Guan Zhong 管仲 (d. 645 B.C.). In typical proleptic fashion, the chapters attributed to Guan Zhong were written during the fourth century B.C. and later, and did not coalesce until Han times. The *Neiye*, however, apparently dates to the late fourth or early third century.[74] Unity is an important concept in this text as well:

一物能化,謂之神,一事能變,謂之智.化不易氣,變不易智,惟執一之
君子能為此乎.執一不失,能君萬物,君子使物,不為物使.得一之理,治
心在於中.[75]

The ability to transform in unity with objects is called spirit; the ability to change in unity with affairs is called wisdom. Transforming without altering the *qi*, changing without altering wisdom—only the noble man holding unity

can do this! By holding unity and not losing [it], he can be the lord of the myriad things: the noble man employs objects; he is not employed by objects. The plan by which he obtains unity is ruling the mind within.

Ruling the mind means returning it to its original state; for at birth the mind is full and complete, and degenerates only through the indulgence in desire:

> 凡心之刑 [=形], 自充自盈, 自生自成, 其所以失之, 必以憂樂喜怒欲利, 能去憂樂喜怒欲利, 心乃反濟. 彼心之情, 利安以寧, 勿煩勿亂, 和乃自成.[76]

The form of all the mind is, of itself, full and replete, perfect of itself from birth. That by which it loses [this state] must be through sorrow, happiness, joy, anger, desire, and profitseeking. If one can leave sorrow, happiness, joy, anger, and profitseeking, the mind will be complete again. The essence of the mind is benefitted by peace and quiet;[77] without perturbation or chaos, harmony will be perfect of itself.

This "peace and quiet" is otherwise called tranquillity 靜, the same term that Xunzi uses for his third faculty.

> 彼道之情, 惡音 [=意?] 與聲, 修心靜音 [=意?], 道乃可得.[78]

The essence of the Way hates tones [or "intentions"?] and sounds [i.e. since they disturb the original peace]; if one cultivates one's mind and makes tranquil one's tones [or "intentions"], the Way can be obtained.

> 四體既正, 血氣既靜, 一意搏心, 耳目不淫, 雖遠若近.[79]

When the four limbs are correct and the blood and *qi* are tranquil, if one concentrates the mind with a singular intention, the ears and eyes will not be skewed, and though it [sc. the Way] be far, it will seem near.

The salubrious effects of returning to one's original mental tranquillity, so the *Neiye* has it, manifest themselves both internally and externally. The object of the internal training is to attain perfection 成, but both the end and the means of this process differ from that of the Xunzian project. Indeed, the perfection of both

the *Neiye* and Xunzi is attunement to the Way, and in both systems this accomplishment requires the abjuration of desire. But while the *Neiye* addresses the task of transforming the *mind*, for Xunzi the undertaking is to transform the *xing* with the *aid* of the mind. Since the *Neiye*'s mind is originally perfect, the goal is to *return* to the exalted state through continuous refinement and quieting of emotion. Xunzi holds, on the contrary, that our original state is brutish; perfection entails continuous accumulation rather than diminution, and *progression* towards a sagely existence that transcends our basic pettiness. Tranquillity 靜, moreover, describes an ideal mental state in the *Neiye*, while Xunzi employs the term simply to denote the ability of the mind to distinguish reality from fantasy. We have examined the contextual significance of Xunzi's use of the terms "emptiness" and "unity"; "tranquillity" is now the third example of Xunzi's skill in choosing wording to call our attention to other schools, and through the sharp contrast between his use of the terms and that of his contemporaries, in calling attention to what is distinctive about his philosophy of mind.[80]

Let us return now to the question that furnished the occasion for the previous discussion: If Xunzi holds that our *xing* is evil, what reason is there for anyone to become good? We noted that people prefer life under the rituals to life without them, for the rituals allow for the greater fulfillment of their desires while preventing the depredation of the limited supply of resources available. But what mechanism is there in us that allows us to consider alternatives, and to act according to our own will? The mind is able to deliberate, and having decided what it approves, is able to command the organs of the body to obey.

心知道,然後可道,可道,然後能守道,以禁非道. (*X* 15.21.263 = K 21.5c)

The mind can approve the Way after it knows the Way; it can defend the Way after it approves the Way by prohibiting what is contrary to the Way.

心者,形之君也,而神明[81] 之主也. 出令而無所受令,自禁也,自使也,自奪也,自取也,自行也,自止也. 故口可劫而使墨 [=默] 云,形可劫而使詘申,心不可劫而使易意,是之則受,非之則辭. (*X* 15.21.265 = K 21.6a)

> The mind is the lord of the body and the master of spiritual illumination. It issues commands but does not receive commands. It prohibits on its own; it employs on its own; it considers on its own; it takes on its own; it acts on its own; it ceases on its own. Thus the mouth can be forced to be silent or to speak; the body can be forced to contract or expand; the mind cannot be forced to change its intention. If it accepts [something], it receives it; if it rejects, it forgoes it.

We have read of the three faculties of the mind; here we learn of its two functions. The mind issues commands to the body and serves as the locus of deliberation. The mind determines what it will do and what it will not, thereupon sending the relevant commands to the rest of the body. Now the rituals, as we have seen, bring about a situation that benefits people, and people, by virtue of the power of their minds, are able to perceive the advantages of following the rituals, and command their bodies to act in accordance with them. The mind, therefore, must be able to observe dispassionately the conduct of the self. It observes that the *xing* is self-destructive because it does not conform to the rituals, and directs the self to begin the arduous process of transformation.[82] Self-reflection is the key to Xunzi's entire vision: we can see ourselves, and change what we see if we do not like it.[83]

But this tension between *xing* and mind is utterly absent from Mencius, who, at times, seems to speak of the two interchangeably.[84] The mind is the property by which our *xing* is good, and our *xing* is good because the mind contains the Four Incipiences within it. Mencius's view is illustrated well by his discussion with Gaozi 告子, a contemporary figure who tried to argue for a forerunner of the position that Xunzi later defended with incomparably greater sophistication.[85]

The crux of the debate between Mencius and Gaozi is the question of the source of morality—is it internal or external? Gaozi opens the debate with the contention that humanity and righteousness are fashioned from human *xing* as cups and bowls are made of the wood of the willow.

告子曰：性猶杞柳也，義猶桮棬也，以人性為仁義，猶以杞柳為桮棬. (6.1.1.1)

Gaozi said: *Xing* is like a willow; righteousness is like cups and bowls. Making our *xing* humane and righteous is like making a willow into cups and bowls.

But Gaozi's recurrent obstacle in the discussion is his inability to marshal his images; he is outwitted at every turn by Mencius, who employs analogies as skillfully as any thinker in Chinese history.

孟子曰：子能順杞柳之性而以為桮棬乎？將戕賊杞柳而後以為桮棬也，
如將戕賊杞柳而以為桮棬，則亦將戕賊人以為仁義與！率天下之人，而
禍仁義者，必子之言．(6.1.1.2)

Mencius said: Can you accord with the willow's *xing* and [still] make it into cups and bowls? You must injure and pillage the willow before you can make it into cups and bowls; if you must injure and pillage the willow before you can make it into cups and bowls, then [by your account] you must also injure and pillage people in order to make them humane and righteous! Your speech will by necessity lead people under Heaven to treat humanity and righteousness as calamities.

The understanding of *xing* here is familiar: *xing* signifies the process of development that an organic being may be reasonably expected to undergo, given nurturing conditions. A willow does not turn into so many cups and bowls *naturally*; one must chop the tree and work its wood to *create* cups and bowls. From the point of view of the willow, this is hardly a favorable scenario. Mencius then extends the model to cover humans: if a person's *xing* must be violated to make it righteous, then we will think of this conversion to morality as a misfortune. Gaozi may well have meant to say that the transformation of our *xing* is an unnatural or even violent process—such was precisely Xunzi's point—but Mencius here paints this position in such an unfavorable light that assenting to it appears ludicrous.

So Gaozi tries again.

告子曰：性猶湍水也，決諸東方，則東流，決諸西方，則西流，人性之無分
於善不善也，猶水之無分於東西也．(6.1.2.1)

Gaozi said: *Xing* is like a torrent of water. Open it to the east, and it will flow towards the east; open it to the west, and it will flow towards the west. Human

xing is not divided into good or not good, just as water is not divided into east and west.

孟子曰：水信無分於東西，無分於上下乎？人性之善也，猶水之就下也，人無有不善，水無有不下. (6.1.2.2)

Mencius said: Water is indeed not divided into east and west, but is it not divided into up and down? The goodness of human *xing* is like water's tendency to go downward. There is no person without goodness; there is no water that does not go downward.

Mencius has again succeeded in demolishing the image while avoiding the issue. Which way water runs is of course entirely irrelevant to the issue of human *xing*. Gaozi, however, chooses not to rehabilitate his analogy, but to take a different approach.

告子曰：生之謂性. 孟子曰：生之謂性也，猶白之謂白與？曰：然. 白羽之白也，猶白雪之白，白雪之白，猶白玉之白與？曰：然. 然則犬之性，猶牛之性，牛之性，猶人之性與? (6.1.3.1–3)

Gaozi said: What is inborn is called *xing*. Mencius said: Is it called *xing* as white is called "white"? [Gaozi] said: It is so. [Mencius said:] Is the whiteness of white feathers like the whiteness of white snow; is the whiteness of white snow like the whiteness of white jade? [Gaozi] said: It is so. [Mencius said:] But is the *xing* of a dog like the *xing* of an ox; is the *xing* of an ox like the *xing* of a person?

We are to understand Gaozi's silence after the last question as his tacit concession that his position has been refuted. Mencius has engaged here in a bit of legerdemain. There is even an element of sophistry in this argument.[86] But Mencius has a point to make: humans are not like the other animals. The whiteness of white feathers may be like the whiteness of white snow, but human *xing* is something unique, almost holy, for it is what separates people from the animal kingdom, what endows people with their original goodness.

The difference between Mencius and Xunzi becomes clear in the next section of the debate with Gaozi. Gaozi brings up the question of whether humanity and righteousness are internal or external:

告子曰：食色，性也．仁內也，非外也，義外也，非內也．孟子曰：何以謂仁
內義外也？曰：彼長而我長之，非有長於我也，猶彼白而我白之，從其白
於外也，故謂之外也．曰：異於白．[白][87] 馬之白也，無以異於白人之白
也，不識長馬之長也，無以異於長人之長與？且謂長者義乎？長之者義
乎？曰：吾弟則愛之，秦人之弟，則不愛也，是以我為悅 [=說] 者也，故謂
之內．長楚人之長，亦長吾之長，是以長為悅 [=說] 者也，故謂之外也．
曰：耆秦人之炙，無以異於耆吾炙．夫物，則亦有然者也，然則耆炙，亦有
外與？(6.1.4.1–5)

Gaozi said: Food and sex are the *xing*. Humanity is internal and not external;
righteousness is external and not internal. Mencius said: Why do you call
humanity internal and righteousness external? [Gaozi] said: That man is older
[than I] and I treat him as an elder; he does not have his age in me. Similarly,
if he is white and I treat him as white, it is because his whiteness is external
[to me]. Therefore I call it external. [Mencius] said: [Righteousness] is dif-
ferent from whiteness. A white horse's whiteness is no different from a white
man's whiteness. But I do not know: [do you consider] the age of an older
horse no different from the age of an older man? Moreover, do you call the
elder righteous? Do you call the one who treats him as an elder righteous?
[Gaozi] said: I love my younger brother but do not love the younger brother
of a man of Qin. Because of this, I am the explanation [i.e. a man's relation to
me determines my love of him], so I call it internal. I treat a Chu man's elder
as my elder, and also treat my elder as an elder. Because of this, age is the
explanation [i.e. a man's age determines my respect for him], so I call it exter-
nal. [Mencius] said: Relishing the roast of a man of Qin is no different from
relishing my roast. We can find other objects like this; but is there something
external about relishing a roast?

"But I do not know"—this is rhetorical aporia; Mencius knows
well how Gaozi will answer, for he cannot assent to the claim that
an old horse is like an old man. Gaozi's position, that the impulse
for certain emotions lies outside the self, while the impulse for
other emotions lies inside the self, is quite untenable. To defend
the proposition that righteousness is external, Gaozi attempts to
show that it is the *age* of an old man, and hence a source external
to the self, which engenders the reverence that a younger man will
show him. But in the course of justifying his view, Gaozi engages
in a tenuous hypostatization of "age." He is forced, in fact, to claim
that there is a knowable absolute reality of all objects—a *Ding an
sich*: for he is unable to answer the challenge that an aged horse
cannot incite in us the same emotions that we feel in the presence

of an aged man. The significance of age, in other words, is subjective. The younger man senses that age in people does not demand the same modifications of behavior as age in animals. Mencius is dealt the easier hand; in keeping with his own philosophical predilections, he argues that *both* humanity *and* righteousness are internal. For they are two of the Four Incipiences, which he supposes to be present in the mind from birth.

Xunzi argues, to the contrary, that morality is external. But in aligning himself with this position, Xunzi does not, like Gaozi, allege that perceptions of external reality stimulate our moral responses. That avenue, as Mencius has demonstrated, leads to quagmire. Instead, Xunzi claims that morality is external—or artificial—because the rituals are external and must be acquired:

今人之性,飢而欲飽,寒而欲煖,勞而欲休,此人之情性也.今人飢見長,而不敢先食者,將有所讓也,勞而不敢求息者,將有所代也.夫子之讓乎父,弟之讓乎兄,子之代乎父,弟之代乎兄,此二行者,皆反於性而悖於情也,然而孝子之道,禮義之文理也.故順情性,則不辭讓矣,辭讓,則悖於情性矣.用此觀之,然則人之性惡明矣,其善者偽也. (*X* 17.23.291 = K 23.1e)

Now the *xing* of human beings is that they desire satiation when hungry and warmth when cold, respite when toiling. This is the essence and *xing* of human beings. Now a person, when hungry, sees an elder, but does not dare to eat before him or her, because there is someone to defer to; when toiling, we do not seek rest, because there is someone we relieve. A son's deference to his father, a younger brother's deference to his older brother, a son's relieving his father, a younger brother's relieving his older brother—these two [forms of] conduct are both contrary to the *xing* and inimical to our essence. But it is the Way of the filial son and the ornament and pattern of ritual and morality. Thus [acting] in accordance with one's essence and *xing* is not to defer. Deference is inimical to one's essence and *xing*. Using this to see it, it is clear that human *xing* is evil; what is good is artifice.

Here, then, is the difference between Mencius and Xunzi: Mencius believes that the basis of morality lies complete within the self, Xunzi that it must be obtained from outside the self. To Mencius the mind is the seat of morality; to Xunzi it is the agent that incites us to *attain* morality. There is little potential for reconciliation between Mencius and Xunzi, for they disagree explicitly

on how human beings will behave in their savage or pristine state. It is Mencius's conviction that people will be moved by the sight of a child about to fall into a well, thereby proving their original goodness. Xunzi contends instead that it is our basic urge to satisfy ourselves, and that we control ourselves only after we have learned ritual. We all wish to eat first at a meal; our deference to our seniors is artificial.[88]

What prospects are there for a restoration of Gaozi's position along Xunzi's lines? Gaozi says that the *xing* can be made to flow in any direction, or, as Xunzi emphasizes, that one can determine one's moral character.[89] Gaozi has been called a "voluntarist," since human nature is essentially the product of each person's own choice: the *xing* is neither good nor evil, but nebulous.[90] Similarly, Xunzi's characterization of the *xing* as evil is empirical rather than apodictic; that is to say, evil will predominate if it goes unchecked, but it is not *inescapable* that a human will be evil.[91] We shall see Xunzi concede, in fact, that the essential character of a human being includes not only the base aspect of the *xing*, but also the incipience of civilization and the potential for redemption.[92] Herein lies the answer to the frequent, and obscurantist, criticism: How did the Sages attain goodness if there was no propaedeutic ritual for them to follow?[93] The Sages perfected themselves.

Moreover, the facile distinction between *xing* and *wei*, between inborn nature and creative artifice, will begin to break down as we consider other dimensions to Xunzi's vision. In the context of his criticism of Mencius, Xunzi resorts to the convenient dichotomy in order to emphasize his point that the gateway to morality lies in artifice—and hence in the *mind*. But where the utility of maintaining the distinction diminishes, Xunzi simply casts it aside. In this respect the refutation of Mencius is no refutation at all: it is a rhetorical trope designed to distance the audience altogether from the Mencian mode of thought, and introduce what proves in *other* respects to be a wholly new world view.

Chapter 2

Heaven

Imbedded in Xunzi's discussion of *xing* is a term to which we have heretofore not given much attention. This is *tian* 天, Heaven. What Heaven imparts is called *xing*, Xunzi tells us; but what is Heaven? The ancient Chinese philosophers provided no dearth of answers to this question. Indeed, though their opinions varied widely, thinkers from virtually every philosophical school agreed that Heaven was a subject worthy of discussion. One of the oldest cosmological conceptions, articulated in the *Shujing* 書經, or *Book of Documents*, postulated an unmediated and knowable connection between affairs in Heaven and affairs on Earth:

天聰明,自我民聰明,天明畏,自我民威,達于上下.敬哉有土! (2.3.4.7)[1]

Heaven hears and sees as our people hear and see. Heaven brightly terrifies; the people are brightly awed. [This connection] extends above and below [i.e. between Heaven and Earth]. Be reverent, O owners of the land!

Further examples of this belief in the readability of Heaven are common in the pages of the *Zuo zhuan*, the Zuo Commentary to the *Springs and Autumns*.[2]

秋宋大水,公使弔焉,曰:天作淫雨,害于粢盛,若之何不弔?對曰:孤實不敬天降之災,又以為君憂,拜命之辱.臧文仲曰:宋其興乎!禹湯罪己,其興也,悖焉,桀紂罪人,其亡也,忽焉. (Zhuang 莊 11=683 B.C., 87)

In autumn [there were] great floods in Song; Duke [Zhuang of Lu 魯, r. 693–662 B.C.], sent his condolences, saying, "Heaven has made excessive rains,

damaging the [sacrificial] millet vessels. How can I not condole with you?"
[Duke Min 閔 of Song, r. 691–682 B.C.] answered: "For this catastrophe
sent down [because of] my lack of reverence towards Heaven, and for the
grief that it has caused my Lord, I do obeisance to the condescension of your
embassy." Zang Wenzhong said: "How Song will prosper! Yu and Tang [semi-
legendary founder of the Shang 商 dynasty] blamed themselves, and their
prosperity was grand; Jie and Zhou blamed others, and their destruction was
sudden."

秋七月, 有神降于莘, 惠王問諸內史過, 曰: 是何故也? 對曰: 國之將興,
明神降之, 監其德也, 將亡, 神又降之, 觀其惡也. (Zhuang 32 = 662 B.C.,
119)³

In the autumn, in the seventh month, a spirit descended into Xin [a city in
the state of Guo 虢]; King Hui [of Zhou, r. 676–652 B.C.] asked Royal Sec-
retary Guo about this, saying: "What is the cause of this?" He answered:
"When a state is about to prosper, bright spirits descend into it, to survey its
virtue. When it is about to perish, the spirits also descend into it, to observe
its evil."

In the first passage, the Duke of Song's confession indicates his
belief that he himself was to blame for his state's misfortunes. In
his eyes, it was his irreverent behavior that prompted Heaven to
punish him with excessive rains. Let us note the unmistakable
assumption that Heaven interacts with Earth on two levels: it
observes the demeanor of a state's ruler, and responds in turn by
sending down prosperity or destruction. The relevance of the
second passage depends upon our interpretation of the origin of
the mysterious spirits; in any case the idea that supernatural hap-
penings may *portend* fortune or calamity is, as the following
examples show, not alien to the belief in a connection between
Heaven and Earth.

公曰: 詩所謂 "彼日而食 [= 蝕], 于何不臧" 者, 何也? 對曰: 不善政之謂
也. 國無政, 不用善, 則自取謫於日月之災. 故政不可不慎也. 務三而已,
一曰擇人, 二曰因民, 三曰從時. (Zhao 昭 7 = 535 B.C., 612)

Marquis⁴ [Ping 平 of Jin 晉 r. 557–532 B.C.] said: "When the *Odes* say, 'An
eclipse of the sun, O how it is not good,'⁵ what does this refer to?" [Shi
Wenbo 士文伯] answered: "It refers to bad government. When there is no
government in a state, and it does not employ good [men], then it acquires

its own fault with regard to the catastrophes of the sun and moon [i.e. the state can only blame itself for these catastrophes]. Thus government cannot be neglected. There are but three duties. The first is recruiting men; the second is considering the people; the third is following the seasons.

內蛇與外蛇鬥于鄭南門中,內蛇死,六年而厲公入. 公聞之問于申繻曰: 猶有妖乎? 對曰:人之所忌,其氣燄以取之,妖由人興也. 人無釁焉,妖 不自作,人棄常,則妖興. 故有妖. (Zhuang 14 = 680 B.C., 91)

[Two serpents], one inside and one outside, fought at the southern gate of Zheng. The snake inside died; six years later Duke Li [of Zheng, r. 700–697 and 679–673 B.C.] entered [i.e. was restored]. Duke [Zhuang of Lu] heard this and asked Shen Xu, saying, "[Does Duke Li's restoration come from] that portent?" He answered: "When people are afraid of something, their *qi* blazes and brings about [such things]. Portents arise because of people. If people [commit] no offenses, portents do not create themselves; if people depart from the ordinary, then portents arise. Thus there was this portent."

八年春,石言於晉魏榆. 晉侯問於師曠曰:石何故言? 對曰:石不能言, 或馮焉,不然民聽濫也. 抑臣又聞之曰作事不時,怨讟動民,則有非言 之物而言. 今宮室崇侈,民力彫盡,怨讟並作,莫保其性,石言不亦宜乎? (Zhao 8 = 534 B.C., 620)

In the spring of the eighth year, a stone spoke to Jin Weiyu. Marquis [Ping] of Jin asked Music Master Kuang,[6] saying: "How can a stone speak?" He answered: "Stones cannot speak; perhaps it was possessed, or else the people heard things that were not there. Still, your servant has heard it said that when things are done at the wrong time, discontent and complaints are stirred among the people, and objects that cannot talk talk nonetheless. Now palaces and mansions are lofty and extravagant; the strength of the people is carved to exhaustion. Discontent and complaints are created together; [the people think] they should not preserve their course of life. Is this not an appropriate time for stones to speak?"

Unusual things happen, in other words, when people on Earth, especially rulers, transcend the ritually prescribed limits to their behavior. And as the Duke of Song makes clear in his confession, the ultimate source of these portents is a watchful, willful, and vengeful Heaven.

Associated with this omenology is the notion that Heaven may throw its support behind particularly virtuous individuals.[7] With

Heaven on a person's side, nothing can stand in the way. A court official, for example, once indicated that the fugitive Prince Chonger 重耳—the future Duke Wen 文 of Jin (r. 636–628 B.C.)—enjoyed Heaven's favor. When Ziyu 子玉 (=Cheng Dechen 成得臣), the Chief Minister of Chu, thereupon asked King Cheng 成 of Chu (r. 671–626 B.C.) to kill Chonger, the king refused, saying, 天將興之, 誰能廢之, 違天必有大咎, "When Heaven is about to make a man prosperous, who can destroy him? Resisting Heaven must incur a great calamity" (Xi 僖 23 = 637 B.C., 185). Confucius himself once expressed his conviction that Heaven affirmed his cause:

子畏於匡. 曰 : 文王既沒, 文不在茲乎? 天之將喪斯文也, 後死者不得與於斯文也, 天之未喪斯文也, 匡人其如予何? (*Analects* 9.5.1–3)

The Master was besieged in Kuang. He said, "Since the death of King Wen [of Zhou], is [the cause of] culture not within me? If Heaven were to have destroyed this culture, then [I], a later mortal, would not have obtained a relation to this culture. Since Heaven has not destroyed this culture, what are the people of Kuang to me?

Heaven will sustain him, Confucius declares, because he is the guardian of the cause of culture.[8] This case is extraordinary because the claim of celestial approval was usually reserved for rulers of states. Heaven's Mandate typically manifested itself in the political arena, where the righteousness of a ruler earned him the sanction of Heaven in the struggle with his competitors. No matter how tenuous his own position or how mighty that of his neighbors, Heaven's champion cannot be overcome:[9]

宋人使樂嬰齊告急于晉, 晉侯欲救之. 伯宗曰 : 不可. 古人有言曰雖鞭之長, 不及馬腹. 天方授楚, 未可與爭, 雖晉之彊, 能違天乎? (*Zuo zhuan* Xuan 宣 15 = 594 B.C., 325)

The people of Song sent Yue Yingqi to tell Jin its troubles. Marquis [Jing 景] of Jin [r. 599–581 B.C.] wanted to save them. Bozong said, "You cannot. The ancients have a saying: Though a whip be long, it cannot reach the horse's belly. Heaven has just invested Chu, and you cannot fight with them. Though Jin be strong, can you resist Heaven?"

Rulers are invested by Heaven, and a transfer of power from one ruler to another is interpreted as the realization of Heaven's Will. King Wu 武 of Zhou (r. 11th cent. B.C.) is recorded to have justified his conquest of Shang along these lines:

觀政于商, 惟受罔有悛心, 乃夷居, 弗事上帝神祇, 遺厥先宗廟弗祀, 犠 牲粢盛既于凶盜. 乃曰: 吾有民, 有命, 罔懲其侮. 天佑下民, 作之君, 作 之師. 商罪貫盈, 天命誅之, 予弗順天, 厥罪惟鈞. (*Shujing* 5.1.1.6f., 9)[10]

I have observed the government of Shang; but Shou [= Zhou, the last ruler of Shang] does not have a repentant heart. He sits squatting [i.e. is indolent]; does not serve High Di [the high god] or the spirits of Heaven and Earth; and neglects the temple of his ancestors, without sacrificing to them. The sacrifice and [sacrificial] millet vessels have been robbed by the wicked.[11] And he says, "I have a mandate to possess the people." He does not correct his disgraces. Heaven provides for the people below, making for them rulers, making for them leaders. . . . The crimes of Shang are bounteous. Heaven mandates that I destroy them; if I were not to comply with Heaven, my crime would be as great.

Heaven installs rulers for the protection of the people, and demands in exchange beneficent government and reverent worship. A tyrant such as Zhou violates this contract and prompts Heaven to choose a more worthy representative. The evil king is surely doomed to perdition at the hands of Heaven's new vicegerent.

It was therefore understandable that rulers continuously inquired of their ministers concerning portents that might shed light on their standing with Heaven. Eclipses were a favorite topic: do they forecast drought or plenty, prosperity or ruin? Courtiers constructed an intricate cosmology in order to answer these questions, with considerations that included the time of year, relative positions of the celestial bodies, and interplay of *yin* and *yang*:

日有食 [= 蝕] 之. 梓慎曰: 將水. 昭子曰: 旱也. 日過分而陽猶不克, 克必 甚, 能無旱乎? 陽不克莫, 將積聚也. (*Zuo zhuan* Zhao 24 = 518 B.C., 701)

There was a solar eclipse. Zi Shen said, "There will be floods." Zhaozi said, "There will be drought. The sun has passed the equinox and *yang* still does

not predominate. When it predominates it will be extreme—can there be no drought? *Yang* does not display its dominance, so it will accumulate."

Cosmology qualified as an independent field of study, and cosmological explanations were formulated in a specialized vocabulary.[12]

There were those who rejected this opaque teratology, arguing instead that unusual happenings are not harbingers of fortune or calamity—for these are determined by people's actions:

十六年春,隕石于宋五,隕星,六鷁退飛過宋都,風也.周內史叔興聘于宋,宋襄公問焉:是何祥也?吉凶焉在?對曰:今茲魯多大喪,明年齊有亂,君將得諸侯而不終.退而告人曰:君失問.是陰陽之事,非吉凶所生也,吉凶由人.吾不敢逆君故也. (*Zuo zhuan* Xi 16 = 644 B.C., 170)

In the spring of the sixteenth year, there fell five stones in Song; there fell a star; six water fowl flew backwards over the capital of Song; there was wind. Shuxing, the Royal Secretary of Zhou, was a guest in Song; Duke Xiang of Song [r. 650–637 B.C.] asked about it: "What are these omens? What fortune or misfortune is in them?" He answered: "Now in Lu there will be many great deaths [i.e. deaths of great personages]; next year there will be chaos in Qi. My Lord will obtain [precedence among] the various lords, but it will not be permanent." He retired and said to someone: "The lord asked incorrectly. These are affairs of *yin* and *yang*; they are not what gives rise to fortune and misfortune. Fortune and misfortune come from men. I did not dare oppose the lord's reasoning."

Zichan 子產 of Zheng (d. 522 B.C.), or Gongsun Qiao 公孫僑, is especially famous for having challenged the idea that the pattern of portents can be known to humans:[13]

夏五月,火始昏見,丙子風.梓慎曰:是謂融風,火之始也.七日其火作乎!戊寅,風甚,壬午,大甚,宋衛陳鄭,皆火.梓慎登大庭氏之庫以望之,曰:宋衛陳鄭也,數日皆來告火.裨灶曰:不用吾言,鄭又將火.鄭人請用之,子產不可,子大叔曰:寶以保民也,若有火國幾亡,可以救亡,子何愛焉?子產曰:天道遠,人道邇,非所及也,何以知之?灶焉知天道,是亦多言矣,豈不或信!遂不與,亦不復火.鄭之未災也,里析告子產曰:將有大祥,民震動,國幾亡,吾身泯焉,弗良及也,國遷其可乎?子產曰:雖可,吾不足以定遷矣. (*Zuo zhuan* Zhao 18 = 524 B.C., 669)

In the summer, in the fifth month, the Fire [Star] started to appear at dusk; on *bingzi* day there was a wind. Zi Shen said, "This is called the north-east wind; it is the beginning of fire. In seven days O there will be fire!" On *wuyin*

day, the wind was extreme; on *renwu* day, it was greatly extreme. Song, Wei, Chen, and Zheng all had fires. Zi Shen ascended the magazine of Dating to observe it, and said, "Song, Wei, Chen, and Zheng will in a few days arrive [bearing] messages of fire." Bei Zao [who had earlier given intricate advice based on astrological calculations] said, "If you do not heed my words, Zheng too will catch fire." The people of Zheng requested that [the lord] heed him, but Zichan refused. Zidashu said, "Treasures are for the protection of the people; if there is a fire, the country will be largely destroyed. If you can save them from destruction, what do you begrudge them?" Zichan said, "The Way of Heaven is distant; the Way of Humanity is near. There is nothing that reaches the former; how can we know it? How does [Bei] Zao know the Way of Heaven? This is big talk—no wonder he is not always trustworthy." Accordingly he did not agree [to heed Bei Zao's advice], and the fires did not return. Before the calamity in Zheng, Li Xi announced to Zichan, "There will be a great omen; the people will move like an earthquake; the country will be largely destroyed. I myself will die in it, and not survive [to see the end of it]. Can the [capital of the] country be moved?" Zichan said, "Although it can be, I am inadequate to determine a removal [of the capital]."

Zichan's sober world view reminds us of Confucius's well-known admonition to respect the ghosts and spirits, but keep a distance from them 敬鬼神而遠之 (*Analects* 6.20).

Zichan and many thinkers after him ridiculed the belief of Bei Zao and others in a connection "extending between the above and the below" 達于上下, to use the phrase that we have seen in the *Documents*. Xunzi's assessment, as we shall see, was especially biting. But there are certain respects in which the movements of Heaven *do* correspond directly to events on earth. Ancient Chinese astronomers were aware that the courses of the sun and stars progress in harmony with the cycle of seasons on Earth.[14]

星有好風, 星有好雨, 日月之行, 則有冬有夏, 月之從星, 則以風雨. (*Shujing* 5.4.38)[15]

There are stars that are fond of wind; there are stars that are fond of rain. From the progression of the sun and moon there are winter and summer; from the moon's course among the stars there are wind and rain.

An entire section of the *Liji* 禮記 (*Book of Rites*), furthermore, is dedicated to charting the positions of the celestial bodies for each month.[16]

At issue, in other words, is not *whether* there is an affinity be-
tween affairs in Heaven and affairs on Earth, but the *extent* to which
such connections manifest themselves in meaningful ways.[17] Obser-
vation established that the positions of the sun and moon correlate
directly with the seasons; what else might one be able to read in
the sky? This question was critical to the agrarian society of pre-
Imperial China, in which agricultural life and the annual cycle of
religious festivals were perforce informed by the seasonal changes.[18]
It is thus not surprising that solar eclipses represent an enduring
source of cosmic worry for the ancient Chinese. Today we see
nothing abnormal in an eclipse, since we have learned that they
recur according to precise formulae; for an ancient society with-
out this information, but still aware that the movements of the
two luminaries were not trivial, the disturbance in the regular pro-
cession of the sun and moon embodied in an eclipse was under-
stood as a sign of great climatic irregularities on Earth.

The mythological belief that Heaven and Earth played the roles
of father and mother in the genesis of the universe contributed to
the notion that there may be a significant degree of intercourse
between the two realms. Consider the gloss in the *Yijing* 易經
(*Book of Changes*) on the divinatory sign *guimei* 歸妹 ("marrying a
younger sister"):[19]

歸妹,天地之義也,天地不交,而萬物不興.[20]

Guimei is the rightness of Heaven and Earth. If Heaven and Earth had no
intercourse, the myriad things would not prosper.

And the *Zhuangzi* declares most explicitly of all: "Heaven and Earth
are the father and mother of the myriad things" 天地者萬物之父
母也.[21]

It is therefore *not* the case that thinkers in the classical period
generally envisioned Heaven as an impersonal force with no active
involvement in human affairs;[22] there was, on the contrary, a body
of court officials such as Bei Zao, who, relying upon mythology
and astronomy, advocated the position that Heaven provided
glimpses of the future through portents such as eclipses and falling

stars. But if the idea of a causal link between the celestial and ter-
restrial had been challenged early on by figures such as Gongsun
Zichan, it was Xunzi who provided the most thorough and sys-
tematic criticism.[23]

星隊 [=墜] 木鳴,國人皆恐.曰:是何也?曰:無何也.是天地之變,陰陽
之化,物之罕至者也.怪之可也,而畏之非也.夫日月之有蝕,風雨之不
時,怪星之黨 [=儻] 見,是無世而不常有之. (*X* 11.17.209 = K 17.7)

When a star falls or a tree calls out, the people of the state are all terrified.
They say, "What is this?" I say: This is nothing. This is an [innocuous] change
of Heaven and Earth, the transformation of *yin* and *yang*, or the presence of
a material anomaly. To wonder at it is acceptable, but to fear it is not. Eclipses
of the sun and moon, untimely winds and rains, unforeseen appearances of
marvelous stars—no era has not often had these [things].

Anomalies have occurred all through history, Xunzi tells us, and
have had no impact upon the subsequent course of history.
Heaven's patterns are not affected by people's actions.

雩而雨,何也?曰:無何也.猶不雩而雨也.日月食〔=蝕〕而救之,天旱而
雩,卜筮然後決大事,非以為得求也,以文之也.故君子以為文,而百姓
以為神,以為文則吉,以為神則凶也. (*X* 11.17.211 = K 17.8)[24]

If the sacrifice for rain [is performed], and it rains, what of it? I say: It is
nothing. Even if there had been no sacrifice, it would have rained. When the
sun and moon are eclipsed, we save them [sc. by performing the proper rites];
when Heaven sends drought we [perform] the sacrifice for rain; we decide
great matters only after divining with scapula and milfoil. This is not in order
to obtain what we seek, but in order to embellish [such occasions]. Thus the
noble man takes [these ceremonies] to be embellishment, but the populace
takes them to be spiritual. To take them as embellishment is auspicious; to
take them as spiritual is inauspicious.

Augury and rain-dances must be understood as custom; they can-
not be intended as a means to alter the course of events to come.
For Heaven does not mold itself according to our specifications.

天不為人之惡寒也輟冬,地不為人之惡遼遠也輟廣.......天有常道
矣. (*X* 11.17.208 = K 17.5)

Heaven does not stop winter because people dislike cold; Earth does not stop its expansiveness because people dislike great distances. . . . Heaven has a constant Way.

Xunzi refers again to the constancy of Heaven to press his argument further: "The course of Heaven is constant; it is not preserved by Yao and is not destroyed by Jie" 天行有常，不為堯存，不為桀亡 (*X* 11.17.205). The properties of Heaven have been the same in times of both prosperity and catastrophe, and thus Heaven cannot be the cause of fortune on Earth.

治亂天邪？曰：日月星辰瑞 [＝環？] 麻，是禹桀之所同也，禹以治，桀以亂，治亂非天也．時邪？曰：繁啓蕃長於春夏，畜積收臧於秋冬，是又禹桀之所同也，禹以治，桀以亂，治亂非時也． (*X* 11.17.207f. = K 17.4)

Are order and chaos [in] Heaven? I say: The revolutions of the sun, moon, and stars, and the cyclical [or *rui* 瑞: "auspicious"?] calendar—these were the same under Yu and Jie. Since Yu [brought] order and Jie chaos, order and chaos are not [in] Heaven. And the seasons? I say: Multiflorously [vegetation] begins to bloom and grow in spring and summer; crops are harvested and stored in autumn and winter. This too was the same under Yu and Jie. Since Yu [brought] order and Jie chaos, order and chaos are not [in] the seasons.

We may remember here the contention of Royal Secretary Shuxing, who commented that the Duke of Song had asked the wrong question 失問 regarding the effect of portents upon human affairs. For auspiciousness and inauspiciousness arise from the actions of *people*. Xunzi builds upon Shuxing's philosophy and constructs a radically new omenology:

夫星之隊 [＝墜]，木之鳴，是天地之變，陰陽之化，物之罕至者也，怪之可也，而畏之非也．物之已至者，人祅則可畏也．楛耕傷稼，耘耨失薉，政險失民，田薉稼惡，糴貴民飢，道路有死人，夫是之謂人祅．政令不明，舉錯不時，本事不理，[25] 夫是之謂人祅．禮義不脩，內外無別，男女淫亂，父[26]子相疑，上下乖離，寇難並至，夫是之謂人祅．祅是生於亂，三者錯無安國． (*X* 11.17.209f. = K 17.7)

The falling of stars, the crying of trees—these are changes of Heaven and Earth, transformations of *yin* and *yang*, or presences of material anomalies. To wonder at them is acceptable, but to fear them is not. Among material

[anomalies] that have occurred, human portents are to be feared. Poor plowing that harms agriculture, hoeing and weeding out of season, governmental malice that causes the loss of people; when the hunt is untimely [or: "fields are (plowed) out of season"][27] and the harvest bad, the price of grain is high and the people starve, in the roads and streets there are dead people—these are called human portents. When governmental commands are unenlightened, corvée miscalculated or untimely, fundamental affairs disorderly—these are called human portents. When ritual and morality are not cultivated: when internal and external are not separated, male and female licentious and chaotic; when father and son are suspicious of each other, superior and inferior obstinate and estranged; when crime and hardship occur together—these are called human portents. Portents are born of chaos; when the three [types of portents; i.e. lack of separation between internal and external, male and female; friction between father and son, superior and inferior; and crime and hardship] obtain, there is no peace in the country.

A brief look at philology reveals what Xunzi has accomplished in the passage above. Phonologically *yao* 妖, the term used by the *Zuo zhuan* and other texts for "portent," is indistinguishable from *yao* 祅 as in *ren* 人 *yao*, Xunzi's "human portent." The two represent different graphs for the same word: in the classical language, 妖 is the unmarked, or general character for "portent," and 祅 the marked character bearing the sense of *"inauspicious* portent." Xunzi's cooptation of this character amounts to a flat denial of celestial involvement in human affairs. The inauspicious portents that Xunzi identifies—friction between father and son, etc.—are not supernatural prodigies sent down by Heaven, but are the result of ill-considered conduct on the part of humanity. Shooting stars and screaming trees are not portents, Xunzi argues, because they tell us nothing about the times in which they occur and have no effect on our existence on Earth. Freakish events occur indiscriminately under the rule of those as virtuous as the Sage Yu or those as iniquitous as the tyrant Jie. But ineffective agricultural techniques, or benighted edicts of governance augur only ill, for they bring about economic catastrophe and human misery. We make our own omens, and thus make our own *destiny*.

Xunzi's tone jibes with what we have seen in the previous chapter. A person can choose to become a sage or a villain; a ruler can choose feast or famine.

彊本而節用, 則天不能貧, 養備而動時, 則天不能病, 脩道而不貳, 則天
不能禍. 故水旱不能使之饑渴, 寒暑不能使之疾, 祅怪不能使之凶. (*X*
11.17.205 = K 17.1)

Whoever strengthens the base and spends in moderation, Heaven cannot
impoverish. Whoever completes the nourishment [sc. of the people] and
moves in accordance with the seasons, Heaven cannot cause to be ill. Who-
ever cultivates the Way and is not of two [minds], Heaven cannot ruin. Thus
floods and drought cannot bring about famine and thirst; cold and heat can-
not bring about disease; portents and wonders cannot bring about an inaus-
picious situation.

故明於天人之分, 則可謂至人矣. 不為而成, 不求而得, 夫是之謂天職.
如是者, 雖深其人不加慮焉, 雖大不加能焉, 雖精不加察焉, 夫是之謂
不與天爭職. 天有其時, 地有其財, 人有其治, 夫是之謂能參. (*X*
11.17.205f. = K 17.1–2a)

Therefore who is enlightened with respect to the division between Heaven
and humanity can be called a "supreme person." Not to act, but to complete;
not to seek, but to obtain—this is called the work of Heaven. This being the
case, however profound, such a person does not apply deliberation to it [i.e.
the work of Heaven]; however great, he or she does not apply abilities to it;
however refined, he or she does not apply inquiry to it. This is called not
competing with Heaven in its work. Heaven has its seasons; Earth has its
resources; people have their order. This is called the ability to form a triad.

People can form a triad with Heaven and Earth because they are
granted order over them. People can apprehend the pattern of
Heaven and the resources of Earth, and, by acting in harmony
with them, can use them to their advantage.

好惡喜怒哀樂臧焉, 夫是之謂天情. 耳目鼻口形能 [= 態] 各有接而不相
能也, 夫是之謂天官. 心居中虛以治五官, 夫是之謂天君. 財 [= 裁] 非其
類以養其類, 夫是之謂天養. 順其類者, 謂之福, 逆其類者, 謂之禍, 夫
是之謂天政. 暗其天君, 亂其天官, 棄其天養, 逆其天政, 背其天情, 以
喪天功, 夫是之謂大凶. 聖人清其天君, 正其天官, 備其天養, 順其天政,
養其天情, 以全天功. 如是則知其所為, 知其所不為矣. 則天地官而萬
物役矣. 其行曲治, 其養曲適, 其生不傷, 夫是之謂知天. (*X* 11.17.206f. =
K 17.3a)

Love, hate, delight, anger, sorrow, and joy are stored within. These are called
the Heavenly emotions. The ear, eye, nose, mouth, and body can each sense

[objects] but their abilities are not interchangeable. These are called the Heavenly faculties. The heart [=the mind] resides in the central cavity and orders the five faculties. This is called the Heavenly lord. It appropriates what is not of its kind to nourish its kind [i.e. takes food etc. as nourishment]. This is called the Heavenly nourishment. Being in accord with one's kind is called fortune, being contrary to one's kind is called calamity. Darkening the Heavenly lord, bringing chaos to the Heavenly faculties, abandoning the Heavenly nourishment, rebelling against the Heavenly order, turning one's back on the Heavenly emotions, and thereby destroying Heaven's accomplishments — this is called great misfortune. The Sage purifies his Heavenly lord, rectifies his Heavenly faculties, prepares his Heavenly nourishment, follows the Heavenly order, nourishes the Heavenly essence, and thereby makes Heaven's accomplishments whole. Thus he knows what he does and knows what he does not do. Heaven and Earth are his ministers and the myriad things his servants. His actions are minutely ordered, his nourishments minutely suited, and his life suffers no injury. This is called knowing Heaven.

Heaven has established its works, but thereafter, like an absentee god, plays no active role in terrestrial affairs.[28] Instead, Heaven has bestowed upon us the faculties by which we may apprehend the patterns of nature and act in such a way as to make these work for our benefit. The primary faculty is the mind, which monitors the senses and makes use of the world around us. At this point Xunzi may begin to sound to us like an eighteenth-century deist. Consider for example the position of the Englishman Matthew Tindal (ca. 1656–1733), who wrote what was considered in his day to be the "Deist Bible":

I freely declare, that the Use of *those faculties*, by which Men are distinguish'd from Brutes, is the only Means they have to discern whether there is a God; and whether he concerns himself with human Affairs, or has given them any Laws; and what those Laws are? And as Men have no other Faculties to judge with, so their using these after the best manner they can, must answer the End for which God gave them, and justify their Conduct. . . . And if God designed all Mankind shou'd know, what he wills them to know, believe, profess, and practise; and has given them no other Means for this, but the Use of Reason; Reason, human Reason, must then be that Means: For as God has made us rational Creatures, and Reason tells us, that 'tis his Will, that we act up to the Dignity of our Natures; so 'tis Reason must tell when we do so. What God requires us to know, believe, profess, and practise, must be in itself a reasonable Service; but whether what is offer'd to us as such, be

really so, 'tis Reason alone which must judge. As the Eye is the sole Judge of what is visible; the Ear of what is audible; so Reason, of what is reasonable.[29]

God granted us reason, Tindal tells us, in order for us to discover his will. He continues: What *is* the will of God?

> Men, if they sincerely endeavour to discover the Will of God, will perceive, that there's a *Law of Nature*, or *Reason*; which is so call'd, as being a Law which is common, or natural, to all rational Creatures; and that this Law, like its Author, is absolutely perfect, eternal, and unchangeable: and that the Design of the Gospel was not to add to, or to take from this Law; but to free Men from that Load of Superstition which had been mix'd with it.[30]

Having set the Law of Nature in motion, Tindal's God *retires*, and leaves us to carry out the rest in accordance with what Nature allows and demands:

> God does not act arbitrarily, or interpose unnecessarily; but leaves those Things, that can only be considered as Means (and as such are in their own Nature mutable) to human Discretion, to determine as it thinks most conducing to those Things, which are in their own Nature obligatory.[31]

Tindal is especially critical of the dissemination of fabulous tales ("What a number of Ideas must *Balaam's* Ass have, to be able to reason with his Master; when he saw, and knew an Angel?"),[32] and accuses the clerical establishment of educating the people in superstition, in order to preserve their own privileged position as authorities on the miraculous:[33]

> The Ecclesiasticks, tho' they cry up the precepts of Mens *loving their* own *Enemies*; yet they effectually evade this, and all other moral precepts, by telling them 'tis their Duty to *hate God's Enemies*; and those to be sure are God's Enemies, who refuse blindly to submit to their Dictates; especially in Matters relating to their Power and Profit.[34]

Thinkers closer to the mainstream were often persuaded by this brand of free-thinking. David Hume (1711–1776), for example, took up the deists' enthusiasm for debunking tales of miracles in order to discredit orthodox Church doctrine:

No testimony is sufficient to establish a miracle, unless the testimony be of such a kind, that its falsehood would be more miraculous, that the fact, which it endeavours to establish. . . When anyone tells me, that he saw a dead man restored to life, I immediately consider with myself, whether it be more probable, that this person should either deceive or be deceived, or that the fact, which he relates, should really have happened. I weigh one miracle against the other; and according to the superiority, which I discover, I pronounce my decision, and always reject the greater miracle. If the falsehood of his testimony would be more miraculous, than the event which he relates; then, and not till then, can he pretend to command my belief or opinion.[35]

Although Tindal's (and Hume's) agenda was completely alien to anything in Xunzi's thinking, we can still observe intriguing points of contact between the two world views. An impersonal, creative force brings forth a universe that obeys a congeries of natural laws. The force then plays no active role in the governance of that universe. We are granted various faculties, chief among them *reason*, by which means we can perceive the laws of nature and harness them for our profit. Prodigies, or supernatural occurrences, are either unimportant (as in Xunzi's view)—or frauds perpetuated by a body of divines bent on duping the populace (Tindal).[36]

But if we are to think of Xunzi as a sort of classical Chinese deist, we must recognize that there is another aspect to Xunzi's Heaven. The argument against the ancient notion of a capricious Heaven with a discernible Will represents an important facet of Xunzi's view of Heaven, but is not all that he has to say on the matter. Elsewhere Xunzi postulates a definite order to nature, and maintains that it is not merely *good*, or *profitable*, for us to conform to that order, but *essential to the noble journey*.[37] The sage may reject the *yin-yang* prestidigitation of the Court Astrologers, but this does not mean that he can afford to remove Heaven entirely from his purview. It is inaccurate, in other words, to read Xunzi's treatise on Heaven as a denial of the material relevance of Heaven.

The same is true, to be sure, of Tindal's work. Most deists insisted, like him, that their purpose was not the abrogation of religion, but the propagation of a purer form of it. In the case of Xunzi, however—and this is where he surpasses the deists—this

spiritual dimension is developed into one of the most sophisti-
cated aspects of his philosophy. If it is true, as Tindal declares, that
"there's a Law of Nature," then how are we to learn that law and
live in harmony with it? By means of our faculty of reason, is Tindal's
simple answer. Xunzi takes a more complex approach: he postu-
lates instead a set of Sage Kings, who knew the Way of Heaven,
and established a code of ritual for future generations to follow.[38]

水行者表深，表不明則陷．治民者表道，表不明則亂．禮者表也，非禮昏
世也，昏世大亂也．(*X* 11.17.212＝K 17.11).

Those who ford waters mark deep [spots]; if the markers are not clear, then
[those who come after will] drown. Those who govern people mark the Way;
if the markers are not clear, then there is chaos. Ritual is the marker; to abol-
ish ritual is to confuse the world. Confusing the world is great chaos.

Xunzi has much to say about these rituals—about what they
are, what they do, and how they work. The subject will occupy us
in the next chapter.

Chapter 3

Ritual and Music

It is the opinion of a great number of scholars that the most impor-
tant topic in the *Xunzi* is ritual.[1] But before we examine his writings
on the subject, it will be profitable to consider some recent Western
approaches. This review will afford the reader a particular view of
the range and insight of Xunzi's philosophy. For we shall see that
much of the modern literature on ritual rests on ideas not so dis-
tantly removed from what we find already in Xunzi.

Ritual constitutes a central issue in contemporary anthropology.
What are rituals? How do they work? And, above all, what do
they *do*? Some scholars have attempted to shed some light on these
questions by drawing on the notion of *performative utterance* — the
speech act.[2] It was J.L. Austin who first approached the phenom-
enon of performative utterance as a discrete subject and studied it
in depth.[3] Austin distinguished *constative* statements, or statements
which can be true or false, from *illocutionary* acts — "i.e. performance
of an act *in* saying something as opposed to performance of an act
of saying something."[4] An illocutionary act, in other words, is a
speech act: a statement that brings about an action through its
utterance, as in, "I now pronounce you husband and wife"; "I sen-
tence you to death"; "I bet you three dollars." In saying that he or
she pronounces a couple husband and wife, the speaker *marries*
them; likewise, in saying that he or she sentences a defendant to
death, the speaker sentences him or her; and in saying that he or
she will bet three dollars, the speaker engages in a bet.

There is a kind of sorcery in this, as is often observed; the speaker
utters his words — often of a formulaic flavor — and, as though it

were an incantation, something happens. And speech acts seem to occur in a ritual forum and in formulaic language. "I now pronounce you husband and wife" obtains its efficacy only during the rite of marriage. If the speaker were to deliver these words to a company of frogs, the utterance would have no performative force whatsoever. Even the phrase, "I bet you three dollars that . . ." requires a ritual context: the addressee must accept; the wager must be concluded in good faith; there must be a handshake or other sign; etc.

Whatever the connection between ritual and performative utterance, however, it is not possible to say that ritual *consists* exclusively of speech acts. Many rituals are silent gestures—kissing the bride, or shaking hands after a game of chess—which certainly convey some meaning, and are as such communicative acts, but do not rely on the medium of speech. But the greatest problem is that speech acts are not easy to define. John Locke (1632–1704) first made this observation:

> For when a Man says that *Gold is Malleable*, he means and would insinuate something more than this, that *what I call Gold is malleable*, (though truly it amounts to no more), but would have this understood, *viz.* that *Gold*; i.e. *what has the real Essence of Gold is malleable*, which amounts to thus much, that *Malleableness depends on, and is inseparable from the real Essence of Gold*.[5]

In other words, what may appear to be a purely constative statement still has illocutionary force, and hence some performative component. The functional meaning of the statement, "Gold is malleable," is "I think gold is malleable"; or "What I call gold is malleable"; or, most clearly, "I call such and such a malleable substance gold."[6] The distinction between "constative" and "performative" wears thin under scrutiny; the two ideas are only abstractions of dimensions contained in all utterances.[7] This is so because no statement can be removed from its speaker. When I declare that "some subject performs some predicate,"—"some S does p"—it can always mean only, "I declare that some S does p"; "I propose . . ." and so on. All acts of speech are thus in some sense speech acts.

So it is not false to say that ritual acts can be or often are speech acts; but in such a sense, it would be difficult to point to *any* kind

of utterance that is not a speech act. While ritual may be reminiscent of, or even consanguine to performative utterance, and while ritual and performative utterance seem to operate in similar ways, the processes of ritual cannot be understood without considering features beyond the performative.

A pioneering advance came with Marcel Mauss's (1872–1950) study on the gift. In many societies, Mauss tells us—he may as well have said *all* societies—there exists a custom of gift-giving: "exchanges and contracts take place in the form of presents; in theory these are voluntary, in reality they are given and reciprocated obligatorily."[8] These gifts may occur irregularly or in conjunction with special or ritual events, but in either case, whether or not the offering is perceived to be free or nonbinding, there exists an expectation and hence an obligation to answer in kind. Mauss cites the Samoan *oloa* and *tonga*, the masculine and feminine goods received and reciprocated by a husband and wife after the birth of a child. When all is said and done, despite the great masses of wealth presented before them, the couple is no richer than before.[9]

The situation brought about by such a custom is one in which the participants in the ceremony of gift-giving know precisely what to expect before the offering and eventual exchange of gifts has taken place. The new father and mother know that they will receive gifts; the givers of these gifts for their part know that the *oloa* and *tonga* will be answered; and no less are the husband and wife aware of the obligation to reciprocate with which they are charged upon receipt of the gifts. What is remarkable is that the conceptions of the participants do not affect the real outcome of the ceremony. The father and mother may believe that the gifts are rendered in sincere celebration of their good fortune—though they may or may not be; the givers may perceive themselves to be especially generous by virtue of their offering, though indeed there may be no one of like relation to the young couple who has exempted himself from the customary duty of presenting *oloa* and *tonga*; and similarly the husband and wife may consider it a voluntary and noble act to reciprocate with their own gifts, though they may incur lasting indignation were they in such manner not to behave as is expected of them. Regardless of what anyone believes,

everyone has expectations, and everyone's expectations are harmonious.

The social function of gift-giving, then, is to establish a code of behavioral expectations. I know how you will act; you know how I will act; and by knowing what you *will* do, I know also that you will not pour poison into my ear in the middle of the night. The ritual is actually an unarticulated agreement that allots to the members of society various tasks, which everyone else relies upon them to discharge. It is an agreement to which everyone assents because it is to everyone's advantage.

Recent work in game theory has yielded similar conclusions by means of a different approach:

> Two soldiers, Tom and Dan, are manning two nearby strongposts in an attempt to hold up an enemy advance. If both remain at their posts, they have a fairly good chance of holding off the enemy until relief arrives, and so of both surviving. If they both run away, the enemy will break through immediately, and the chance of either of them surviving is markedly less. But if one stays at his post while the other runs away, the one who runs will have an even better chance of survival than each will have if both remain, while the one who stays will have an even worse chance than each will have if they both run. Suppose that these facts are known to both men, and each calculates in a thoroughly rational way with a view simply to [his] own survival. Tom reasons: if Dan remains at his post, I shall have a better chance of surviving if I run than if I stay; but also if Dan runs away I shall have a better chance if I run than if I stay; so whatever Dan is going to do, I would be well advised to run. Since the situation is symmetrical, Dan's reasoning is exactly similar. So both will run. And yet they would each have had a better chance of survival, that is, of achieving the very end they are, by hypothesis, aiming at, if both had remained at their posts.[10]

A related scenario is the so-called Prisoner's Dilemma. Suppose two men are charged with a crime and are faced with the following array of choices. If both confess, both will be sentenced to seven years' incarceration. If one confesses and the other does not, the one who confesses will be granted immunity, while the one who does not will be convicted and imprisoned for ten years. But if *neither* confesses, they will each be convicted of a lesser charge and receive a one-year sentence. The men are kept in separate rooms,

so that neither knows how the other will decide. Both men will reason as follows. If the other confesses, I will be better off by confessing: for if I do not confess, my sentence will be ten years, but if I do, it will be seven. And if the other does not confess, again, I will be better off by confessing: if I do not confess, I will receive a one-year sentence, while if I do, I will be granted immunity. In fact, no matter what the other prisoner does, I will be better off confessing. So both men confess, and both go to jail for seven years, whereas had they both not confessed, they would have gone to jail for only one year. The paradigms of the two soldiers and the two prisoners illustrate a situation in which each actor may calculate his best course of action rationally, and yet both are caught up in a system in which the choices that appear to be the safest are precisely those which bring the least good to all involved.

However, if each actor knew that the other would not desert or betray him, the entire mechanism would change. Tom would be led to stay at his post, and so would Dan; and neither of the two prisoners would confess. Both cases would yield the optimum result. Tom might, naturally, have the impulse to doublecross his partner and run, leaving Dan to be overwhelmed by the enemy. But this tactic earns a reputation, and works only once: the next time he is in such a situation, he can be sure that the other soldier will not risk following in Dan's footsteps. *Over the long run*, in other words, it pays to trust Dan. If Tom cannot count on Dan to remain at his post, Tom will flee, and the two soldiers will be back where they started. The soldier's fidelity is rewarded over the long run by an improved chance of survival.

What is worth more, the short-term benefit of betraying one's partner, or the long-term benefit of loyalty? The Prisoner's Dilemma answers this question unmistakably. In a so-called "one-shot game"—a case in which the prisoners face their dilemma only once—the benefit of treachery (0 years vs. 7 years) is great. But suppose the prisoners are to face one hundred consecutive dilemmas? The traitor fares well in the first dilemma, getting off scot-free. But in the remaining ninety-nine dilemmas, no one will trust

him; everyone will confess, and he will be sentenced ninety-nine times to seven years in prison—or 693 years. Over one hundred dilemmas, then, the traitor can expect an aggregate sentence of 693 years (0+693). By contrast, the trustworthy prisoner is rewarded with his partners' trust; all the other prisoners will find it in their interest not to confess, and he will be sentenced one hundred times to one year in prison—or only 100 years.[11] The relative value of loyalty or treachery thus depends on the number of dilemmas that the prisoners face. When that number is small, the bounty of treachery may be high; but when the number is sufficiently large, it is far outweighed by the profit won through loyalty.[12]

The example makes clear in mathematical terms an idea that we sense as a social fact: man reaps greater benefit as a cooperating member of a society than he does as a solitary agent in a world of uncontrolled competition. We move now from models to reality: what of a case in which the actors face a new trial *at every instant*— a virtually infinite number of trials? At every moment the actors are presented with an alternative: try to engineer some personal gain at another's expense, or remain steadfast, and risk being exploited by others out to garner their own advantage. Consider a situation in which a number of actors, of equal strength and intelligence, are pitted against each other, in contention for the same objects, in an arena in which only a finite number of such objects exists. And suppose, further, that there is no law to regulate the actors' interactions. Such a condition is well known to us through the writing of Hobbes:

> Nature hath made men so equall, in the faculties of body, and mind; as that though there bee found one man sometimes manifestly stronger in body, or of quicker mind then another; yet when all is reckoned together, the difference between man, and man, is not so considerable, as that one man can thereupon claim himselfe any benefit, to which another may not pretend, as well as he. For as to the strength of body, the weakest has strength enough to kill the strongest, either by secret machination, or by confederacy with others, that are in the same danger with himselfe.
>
> And as to the faculty of the mind . . . I find yet a greater equality amongst men, than that of strength. . . . That which may perhaps make such equality incredible, is but a vain conceipt of ones owne wisdome, which almost all

men think they have in greater degree, than the Vulgar; that is, than all men but themselves, and a few others, whom by Fame, or for concurring with themselves, they approve. For such is the nature of men, that howsoever they may acknowledge many others to be more witty, or more eloquent, or more learned; Yet they will hardly believe there be many so wise as themselves: For they see their own wit at hand, and other mens at a distance. But this proveth rather that men are in that point equall, than unequall. For there is not ordinarily a greater signe of the equall distribution of any thing, than that every man is contented with his share.[13]

From this equality of ability, ariseth equality of hope in the attaining of Ends. And therefore if any two men desire the same thing, which neverthelesse they cannot both enjoy, they become enemies; and in the way to their End, (which is principally their owne conservation, and sometimes their delectation only,) endeavour to destroy, or subdue one another.[14] And from hence it comes to passe, that where an Invader hath no more to feare, than an other mans single power; if one plant, sow, build, or possesse a convenient Seat, others may probably be expected to come prepared with forces united, to dispossesse, and deprive him, not only of the fruit of his labour, but also of his life, or liberty. And the Invader again is in the like danger of another.[15]

I may choose to fight you, or not; but in such a state, no matter how I decide, I cannot avoid the certainty of being attacked myself. Thus I am forced to bear arms, whether to pillage the hoards of others or merely to protect my own; and as I wage war upon all, so too do all the other actors upon each other. This multi-party variant of the Prisoner's Dilemma reminds us of Tom and Dan, the two soldiers: though taken singly, the actors' choices may each appear advantageous, taken collectively, they bring about *Paretoinferiority*, or an outcome that is to the detriment of all.[16]

Whatsoever therefore is consequent to a time of Warre, where every man is Enemy to every man; the same is consequent to the time, wherein men live without other security, than what their own strength, and their own invention shall furnish them withall. In such condition, there is no place for Industry; because the fruit thereof is uncertain: and consequently no Culture of the Earth; no Navigation, nor use of the commodities that may be imported by Sea; no commodious Building; no Instruments of moving, and removing such things as require much force; no Knowledge of the face of the Earth; no account of Time; no Arts; no Letters; no Society; and which is worst of all, continuall feare, and danger of violent death; And the life of man, solitary, poore, nasty, brutish, and short.[17]

But we have found that the two soldiers and the two prisoners are able to free themselves from their predicament if they are allowed to come to an agreement. Similarly, in order to avoid[18] the Hobbesian War, the potential combatants must make a *covenant*, or the mutual renunciation of their rights, so that these no longer conflict.[19] And as "Covenants, without the Sword, are but Words,"[20] the participants require a Power that will tie men to their oaths.

> The only way to erect such a Common Power, as may be able to defend them from the invasion of Foraigners, and the injuries of one another, and thereby to secure them in such sort, as that by their owne industrie, and by the fruites of the Earth, they may nourish themselves and live contentedly; is, to conferre all their power and strength upon one Man, or upon one Assembly of men, that may reduce all their Wills, by plurality of Voices, unto one Will: which is as much to say, to appoint one man, or Assembly of men, to beare their Person; and every one to owne, and acknowledge himselfe to be Author of whatsoever he that so beareth their Person, shall Act, or cause to be Acted, in those things which concerne the Common Peace and Safetie; and therein to submit their Wills, every one to his Will, and their Judgements, to his Judgement. This is more than Consent, or Concord; it is a reall Unitie of them all, in one and the same Person, made by Covenant of every man with every man, in such manner, as if every man should say to every man, *I Authorise and give up my Right of Governing my selfe, to this Man, or to this Assembly of men, on this condition, that thou give up thy Right to him, and Authorise all his Actions in like manner.*[21]

To insure that covenants be binding, all the actors must agree to one prime covenant, which is the cession of the right of governance to a third party.[22] Hobbes is not reticent about the significance of the prime covenant:

> This done, the Multitude so united in one Person, is called a COMMON-WEALTH, in latine CIVITAS. This is the Generation of that great LEVIA-THAN, or rather (to speake more reverently) of that *Mortall God*, to which wee owe under the *Immortall God*, our peace and defence.[23]

Indeed the Commonwealth performs functions that are in other moral systems typically reserved for God.[24] Emile Durkheim (1858–1917), Mauss's father-in-law, remarks in this regard:

Kant postule Dieu, parce que sans cette hypothèse, la morale est inintelligible. Nous postulons une société spécifiquement distincte des individus, parce que, autrement, la morale est sans objet, le devoir sans point d'attache. . . . Je ne vois dans la divinité que la société transfigurée et pensée symboliquement.[25]

Kant postulates God, because without this hypothesis, morality is unintelligible. We postulate a society specifically distinct from individuals, because, otherwise, morality is without object, duty without anchorage. . . . I see in Divinity nothing other than society transfigured and conceived symbolically.

We may avoid the question of whether Durkheim aptly characterizes Kant's position;[26] the point here is that the moral dictates of society in social philosophy correspond to the moral dictates of God in theology. The Creator is replaced by the Contract, and the system of ethics resulting from the prisoners' contract shares in the same element of sanctity that believers associate with the divine commandments. Contracts are *holy*, because they are the foundation of the Commonwealth, and hence of peace, prosperity, and justice.[27] Contracts are the rituals of the contractarian religion.[28]

The idea of the contract brings us back to our original question: What is ritual, and how does it work? Ritual is the formulaic expression of the nexus of contracts to which members of a society all consent. Rituals work because they are *recognized* as such. The priest marries the young couple because he is invested with the authority to marry them; a highway loafer who has no such recognized power cannot marry anyone. Rituals, contracts, and conventions are all children of the same parentage: each owes its existence to the willingness of members of society to partake in them. Together, they appear everywhere and govern virtually all aspects of our social life.

Naturally, when we think of ritual, we usually have in mind not contracts as much as collective behavior occurring within a specially designated space. This is the sense of ritual, for example, with which Durkheim operates:

D'ailleurs, sans symboles, les sentiments sociaux ne pourraient avoir qu'une existence précaire. Très forts tant que les hommes sont assemblés et s'influencent réciproquement, ils ne subsistent, quand l'assemblée a pris fin, que sous la forme de souvenirs, qui, s'ils sont abandonés à eux-mêmes, vont

de plus en plus en pâlissant; car, comme le groupe, à ce moment, n'est plus présent et agissant, les tempéraments individuels reprennent facilement le dessus. Les passions violentes qui ont pu se déchaîner au sein d'une foule tombent et s'éteignent une fois qu'elle s'est dissoute, et les individus se demandent avec stupeur comment ils ont pu se laisser emporter à ce point hors de leur caractère. Mais si les mouvements par lesquels ces sentiments se sont exprimés viennent s'inscrire sur des choses qui durent, ils deviennent eux-mêmes durables. Ces choses les rapellent sans cesse aux esprits et les tiennent perpétuellement en éveil; c'est comme si la cause initiale qui les a suscités continuait à agir. Ainsi l'emblématisme, nécessaire pour permettre à la société de prendre conscience de soi, n'est pas moins indispensable pour assurer la continuité de cette conscience.

Il faut donc se garder de voir dans ces symboles de simples artifices, des sortes d'étiquettes qui viendraient se surajouter à des répresentations toutes faites pour les rendre plus maniables: ils en sont partie intégrante.[29]

Moreover, without symbols, social sentiments could have only a precarious existence. Though very strong as long as men are assembled and influence each other reciprocally, they do not persist after the assembly has ended, except under the form of recollections, which, if they are left to themselves, become feebler and feebler; for, since the group, at this moment, is no longer present and active, individual temperaments easily regain the upper hand. The violent passions which were able to break out in the midst of a crowd fall away and are extinguished once it is dissolved, and the individuals ask themselves in amazement how they could have let themselves be transported so far from their character. But if the movements through which these sentiments are expressed come to be inscribed on things that last, they become lasting themselves. These things bring them ceaselessly to mind and keep them perpetually awake; it is as though the initial cause which had aroused them continued to be in force. Thus emblemization, which is necessary to allow the society to become conscious of itself, is no less indispensable for the assurance of the continuity of this consciousness.

So in these symbols we must not see simple artifices, or kinds of labels which happen to attach themselves to representations already made, in order to make them more manageable: they are an integral part of them.

The rituals depicted in this passage are among the most visible kind: rituals of *assembly*. But in this convincing analysis of one class of rituals, the author remains silent with regard to all the others.[30] The greater part of rituals are daily and subtle, and may even pass unnoticed before both observer and participant: rules governing commerce; the manner in which we partake of food, water, or any

good whatsoever; oral communication, written communication, nonlinguistic communication; gathering of crops, distribution of labor, disposal of waste; construction, destruction, irrigation, agriculture; care for the young, care for the old; reproduction, marriage, death; and so on. Our ritual environment can affect even our emotional life. Embarrassment, for example, is a state that only a social being can ever experience: to be embarrassed we must envision expectations in our fellows and reckon that we have not lived up to them.[31] But all rituals exist because we acquiesce to them, explicitly or otherwise. At every instant in which we are in contact with our fellows, we are performing rituals.[32] A person without ritual is one who lives with no connection to society whatsoever.[33]

Loosening the semantic bounds of "ritual" in this manner has one benefit: it affords us a different perspective into the mechanisms of social interaction. The difference between contract and ritual is thin, and our use of one word rather than the other is governed by the contexts at hand. The affinity of contract and ritual lies in that both are institutions addressing the problem of social control. They adopt similar methods of regulating human behavior.[34] There are of course situations in which it would be wise to maintain the consuetudinary distinction between contract and ritual. I may sue in court, for example, for breach of contract, but not indiscriminately for the breach of ritual. Within the confines of civil philosophy, however, and particularly in the discussion which follows, rituals are treated as expressions of the primal covenants to which social actors must assent. For these agreements are so basic that they are perceived as something deeper, holier, than the contracts between parties which the Covenants make possible by bringing about civil society.

* * * * * *

We see that Xunzi means something very earnest by *li* 禮, or "ritual," when he affirms that it can mean the difference between life and death:

由禮則治通,不由禮則勃 [=悖] 亂提僈.食飲衣服居處動靜,由禮則和節,不由禮則觸陷生疾.容貌態度進退趨行,由禮則雅,不由禮則夷固

[＝居] 僻違庸眾而野. 故人無禮則不生, 事無禮則不成, 國家無禮則不
寧. (*X* 1.2.13f. = K 2.2)[35]

By following ritual, there is order and success; by not following ritual, there
is shiftlessness and chaos, sloth and neglect. When food and drink, clothing,
residence, movement and quietude follow ritual, there is harmony and
measure; when they do not follow ritual, they are offensive and lowly and
beget disease. When appearance, attitude, entrance and exit, and rapid walk-
ing follow ritual, there will be elegance; when they do not follow ritual, there
will be indolence, depravity and perversion, vulgarity and wildness. Thus
people without ritual cannot live; affairs without ritual cannot be completed;
the state and its families without ritual cannot be at peace.

And further:

體恭敬而心忠信, 術禮義而情愛人, 橫行天下, 雖困四夷人莫不貴. (*X*
1.2.16 = K 2.6)

If your body is respectful and reverent and your mind loyal and trustworthy;
if your methods [conform to] ritual and morality and your essence loves
others; then [even if] you roam randomly under Heaven and are impover-
ished by the Four Barbarians, no one will not see you as noble.

所失微而其為亂大者禮也. (*X* 19.27.327 = K 27.40)

What causes great chaos through minute neglect is ritual.

In Xunzi's extension of the discussion to military science, rituals
are again paramount: the more powerful army is not the one with
the better weaponry or tactics, but the one whose ruler has been
more assiduous at cultivating the rituals.

禮者治辨之極也, 強國之本也, 威行之道也, 功名之總也. 王公由之, 所
以得天下也, 不由所以隕社稷也. 故堅甲利兵不足以為勝, 高城深池不
足以為固, 嚴令繁刑不足以為威, 由其道則行, 不由其道則廢. (*X*
10.15.186f. = K 15.4)[36]

Ritual is the ridgepole of order and discrimination, the basis of strengthening
the state, the Way of awesome success, the sum of achievement and reputation.
When kings and dukes follow it, that is how they obtain all under Heaven;
when they do not follow it, that is how they ruin the altars of soil and grain.
Thus strong armor and keen arms are not enough to be victorious; high

walls and deep moats are not enough to be secure; strict commands and manifold punishments are not enough to inspire awe. Following the Way brings about success; not following it brings about downfall.

古之兵, 戈矛弓矢而已, 然而敵國不待試而詘. 城郭不辨 [=辦], 溝池不拊 [=扣], 固塞不樹, 機變不張, 然而國晏然不畏外而內 [=固]³⁷ 者, 無它故焉, 明道而分鈞 [=均] 之, 時使而誠愛之, 下之和上也, 如影嚮 [=響]. (*X* 10.15.188 = K 15.4)

The arms of the ancients were only lances, spears, bows, and arrows, but enemy states recoiled without a test. Walls and battlements were not managed, pits and moats not dug, strongholds and fortresses not planted, [war] machinery and changes [i.e. surprise tactics] not set up; however, that the state, in peace, did not fear foreigners, but was secure—there was no other reason for this, but that it was enlightened with respect to the Way and divided the people [i.e. their responsibilities] equitably, employed them in a timely fashion and sincerely loved the people; inferiors were in harmony with their superiors, like a shadow or an echo.

臣所聞古之道, 凡用兵攻戰之本, 在乎壹民. 弓矢不調, 則羿不能以中微, 六馬不和, 則造父不能以致遠, 士民不親附, 則湯武不能以必勝也. 故善附民者, 是乃善用兵者也. (*X* 10.15.176 = K 15.1a)³⁸

From what I have heard of the Way of the ancients, the basis of all use of arms to attack in war is the unification of the people. If the bow and arrow are not aligned, then Yi [a legendary bowman][39] cannot hit the bull's-eye. If the six horses are not in harmony, then Zaofu [a legendary charioteer][40] cannot make [the chariot] go far. If the knights and [common] people are not close like family, then Tang and Wu cannot be sure of victory. Thus to be good at making the people close is to be good at using arms.

The ruler's use of ritual is more important than the might of his army; for a massive military force, however well armed, cannot achieve victory without conforming to the proper rituals, whereas an appropriately ordered state will inspire such awe in its enemies that they will not even dare to fight.[41]

Xunzi never tires of affirming the efficacy of rituals, and we shall see in a moment how he justifies the exalted position he accords them. For now, let us inquire into Xunzi's explanation of their origin. We examined earlier, in a different connection, the proem with which Xunzi begins his essay on ritual:

禮起於何也?曰:人生而有欲,欲而不得,則不能無求,求而無度量分界,
則不能不爭,爭則亂,亂則窮.先王惡其亂也,故制禮義以分之,以養人
之欲,給人之求,使欲必不窮乎物,物必不屈於欲,兩者相持而長,是禮
之所起也. (*X* 13.19.231 = K 19.1a)

Whence did rituals arise? I say: People are born with desires; if they desire
and do not obtain [the object of their desires], then they cannot but seek it.
If, in seeking, people have no measures or limits, then there cannot but be
contention. Contention makes chaos, and chaos privation. The Former Kings
hated such chaos, and established ritual and morality in order to divide them
[i.e. people], in order to nourish people's desires and grant what people seek.
They brought it about that desires need not be deprived of objects, that objects
need not be depleted by desires; the two support each other and grow: this is
where rituals arise from.

And two similar passages, which we also cite for the second time:

夫貴為天子,富有天下,是人情之所同欲也.然則從人之欲,則埶 [= 藝]
不能容,物不能贍,故先王案為之制禮義以分之. (*X* 2.4.44 = K 4.12)

To be honored as the Son of Heaven [i.e. the ruler on earth], and to possess
richly all under Heaven—this is the common desire of human essence. But if
people follow their desires, then boundaries cannot contain [them] and objects
cannot satisfy them. Thus the Former Kings restrained them and established
for them ritual and morality in order to divide them.

今以夫先王之道,仁義之統,以相群居,以相持養,以相藩飾,以相安固
邪? (*X* 2.4.41 = K 4.10)

Now the Way of the Former Kings, the principle of humanity and righteous-
ness, are they not that by which societies live together, by which we support
and nourish each other, by which we screen and adorn each other, by which
we are peaceful and secure with each other?

Xunzi has specific rituals in mind—as of salutation, of mourning,
of eating—but the precise nature of the rituals is of only secondary
importance to his argument. He will explain elsewhere why the
rituals take their proper form; at this stage, the point is that what-
ever these rituals may be, they exist as a legacy of the Former Kings,
and the observance of the precepts of this inheritance is critical to
the survival of the state.

Xunzi's account sounds familiar. *Li* is merely a name for the nexus of regulations that allow humankind to enjoy nature's bounty harmoniously.[42] With ritual in place, "desires need not be deprived of objects [and] objects need not be depleted by desires," as he puts it. It is true that there is at least one basic difference from what we have seen in Hobbes: in Xunzi it is the Former Kings who establish ritual and morality, while in *Leviathan* the corresponding stage is completed by the people who cede their claims to all things unto the sovereign. But the thinking appears to be by and large the same. "Contention makes chaos, and chaos privation" 爭則亂, 亂則窮—here in six characters lies the classical Chinese equivalent of the Hobbesian War. Replace "rituals" with "contracts" (or "laws"), and Xunzi emerges as a shining contractarian.[43] People have desires, and were they each to go about satisfying them in *anomia*, the consequence would be *unrequited* desire. But chaos is resolved through ritual: with the establishment of a few ground rules, the roving egoists[44] can fulfill their desires happily, and be sure that they will not be impeded by others in their midst. All people have their place, like the hairs in the famous figure of the fur collar (*X* 1.1.9; *K* 1.11). As Xunzi says elsewhere:

國危則無樂君, 國安則無憂民. 亂則國危, 治則國安. 今君人者, 急逐樂而緩治國, 豈不過矣哉! 譬之是由好聲色而恬無耳目也, 豈不哀哉! 夫人之情, 目欲綦色, 耳欲綦聲, 口欲綦味, 鼻欲綦臭, 心欲綦佚, 此五綦者, 人情之所必不免也. 養五綦者有具, 無其具則五綦者不可得而致也. 萬乘之國可謂廣大富厚矣, 加有治辨彊固之道焉, 若是則恬愉無患難矣, 然後養五綦之具具也. 故百樂者生於治國者也, 憂患者生於亂國者也. 急逐樂而緩治國者非知樂者也. (*X* 7.11.137 = *K* 11.4)

When the state is imperiled, there is no pleasure for the lord; when the state is at peace, there is no worry for the people. When there is chaos, the state is imperiled; when there is order, the state is at peace. Lords today hasten to pursue pleasure and delay ordering the state; O how is this not a transgression! They are like one who loves sounds and colors though his face has no ears or eyes; O how is this not lamentable! Human essence is such that people's eyes desire superlative colors; their ears desire superlative sounds; their mouths desire superlative tastes; their noses desires superlative smells; their minds desire superlative leisure. These five superlatives are what human essence cannot avoid. For the five superlatives to be nourished, there are conditions. Without these conditions, the five superlatives cannot be obtained and brought

about. A state with myriad chariots can be called expansive and wealthy; [suppose] it has in addition a Way of order and differentiation, strength and security—if it is like this, then there will be concord and contentedness, and no vexation or hardship, and then it would meet the conditions for the five superlatives. Thus the many pleasures arise in an ordered state; worry and vexation arise in a chaotic state. Hastening to pursue and delaying ordering the state is not to know pleasure.

禮者政之輓也，為政不以禮政不行矣. (*X* 19.27.325 = K 27.23)

Rituals are the reins of government. If you cause the government not to be in accordance with ritual, the government will not succeed.

The noble man who knows ritual, therefore, is attracted to a well-ordered state as turtles are to deep ponds (*X* 9.14.172; K 14.2).[45]

There are, however, two further aspects in which Xunzi diverges from Hobbes.[46] In the Hobbesian model, it is the enticement of economic benefit, and above all the urge to self-preservation, that provides the most decisive impetus to the formation of the Commonwealth.

For every man is desirous of what is good for him, and shuns what is evil, but chiefly the chiefest of natural evils, which is death; and this he doth by a certain impulsion of nature, no less than that whereby a stone moves downward. It is therefore neither absurd nor reprehensible, neither against the dictates of true reason, for a man to use all his endeavours to preserve and defend his body and the members thereof from death and sorrows.[47]

But Xunzi postulates a moral order that encompasses material benefit even as it transcends it:[48]

先義而後利則榮，先利而後義則辱. 榮者常通，辱者常窮，通者常制人，窮者常制於人. 是榮辱之大分也. (*X* 2.4.36 = K 4.6)

Setting morality before profit entails honor; setting profit before morality entails shame. The honorable are eternally successful; the shameful are eternally indigent. The successful administer people, the indigent are administered by people. This is the great difference between honor and shame.

Whereas Hobbes is satisfied to allow man to do "what is good for him," Xunzi is careful to distinguish between morality and profit.

The one, indeed, tends to bring about the other, and Xunzi loves to point out that it is profitable to be moral. But he does not justify morality solely by appealing to its profit. He is not, in that respect, a utilitarian.[49]

The second difference is far more important. The actors in Hobbes's world are free, by and large, to formulate their own contracts, and in particular the sovereign is completely untrammeled with regard to the laws that he may enact. Hobbes is known, after all, as a forerunner of the legal positivists. But to Xunzi, *li* do not come so easy, as he makes clear in his criticism of a more liberal opponent.

慎子蔽於法而不知賢. (*X* 15.21.262 = K 21.4)

Master Shen was blinded by laws and did not know [the value of] worthy people.

Master Shen is Shen Dao 到.[50] Elsewhere Xunzi elaborates:

尚法而無法,下脩而好作.上則取聽於上,下則取從於俗,終日言成文典,反紃察之,則偶然無所歸宿.不可以經國定分.......是慎到田駢也. (*X* 3.6.58f. = K 6.5)

[Some] place laws at the top but have no laws; they place self-cultivation at the bottom and like to be creative. Above, they obtain audience from the lofty; below, they obtain followers from the common folk. All day their speech is perfected, patterned, and documented, but if examined closely back and forth, then [it appears to be] unrestrained and have no place to which it returns. They cannot regulate the state or establish [social] distinctions. . . . These are Shen Dao and Tian Pian.

The bone that Xunzi has to pick with Shen Dao involves the provenance of law. Shen Dao believes that sovereigns create laws in order to rule their states and avoid anarchy. But this arrangement is unacceptable to Xunzi, because it permits the possibility of bad laws.[51] Xunzi's response echoes an argument that harkens back to Confucius:

子曰:道之以政,齊之以刑,民免而無恥.道之以德,齊之以禮,有恥且格. (2.3.1–2)

The Master said: If you lead them with government and make them uniform
with punishments, the people will avoid [the punishments] but have no shame.
If you lead them with virtue and make them uniform with ritual, then they
will have shame and be correct.

According to Confucius, people governed by laws and punish-
ments do not receive any moral instruction. They must be shown
the proper rituals: then they will know how to behave both as
moral and as social beings.[52] From Xunzi's point of view, Shen
Dao's laws have no authority because they are implemented by
willful rulers or ministers, and do not necessarily accord with the
rituals. They are what he has called above *wu suo gui su* 無所歸宿,
"without place to which to return."

For there are rituals that are right, and pretender rituals that
are wrong. The proper rituals were established by the Sage Kings,
and are proper because they conform to *human nature*. Xunzi is
speaking here not of *xing*, but of the characteristic in us that makes
us unique:

人之所以為人者,何已也?曰:以其有辨也.飢而欲食,寒而欲煖,勞而欲
息,好利而惡害,是人之所生而有也.是無待而然者也,是禹桀之所同
也.然則人之所以為人者,非特以二足而無毛也,以其有辨也.今夫狌
狌形笑[=肖],亦二足而[無]毛也.然而君子啜其羹,食其胾.故人之所
以為人者,非特以其二足而無毛也,以其有辨也.夫禽獸有父子而無父
子之親,有牝牡而無男女之別.故人道莫不有辨. (*X* 3.5.50= K 5.4)

What is it that makes humans human? I say: their making of distinctions.
Desiring food when hungry, desiring warmth when cold, desiring rest when
toiling, liking profit and hating injury—these are all possessed by people from
birth. They are not things such that they must wait for them to be so. This is
the similarity between Yu and Jie. This being the case, what makes humans
human is not specifically that they have two feet and no pelt [or plumage—
i.e. that they are featherless bipeds]. It is their making of distinctions. Now
the *shengsheng*-ape resembles [humans], and also has two feet and no pelt.
But the noble man sips his soup and eats his cutlet [i.e. eats his food cooked].[53]
Thus what makes humans human is not specifically that they have two feet
and no pelt. It is their making of distinctions. The birds and beasts have
parents and children but no affection between parents and children. They
have males and females but no separation between man and woman. Thus
the way of humans is nothing other than to make distinctions.

Xunzi's argument here is that human beings, by virtue of their nature, make certain distinctions that all other animals do not. Humans are unique in that they not only *can* make distinctions, but *do*, and live by them. Male is distinguished from female, old from young, and so on. Xunzi continues:

辨莫大於分, 分莫大於禮, 禮莫大於聖王. (*X* 3.5.50 = K 5.4)

There are no greater distinctions than social distinctions. There are no greater social distinctions than the rituals. There are no greater rituals than [those of] the Sage Kings.

And similarly:

君子既得其養, 又好其別, 曷謂別?曰:貴賤有等, 長幼有差, 貧富輕重皆有稱者也. (*X* 13.19.231 = K 19.1c)[54]

The noble man having attained his nourishment, he will also be fond of separation. What is separation? I say: Noble and base have their ranks; old and young have their disparate [status]; poor and rich, light and heavy, all have what is fitting to them.

Put succinctly, ritual is the ridgepole of the Way of Humanity 禮者人道之極也 (*X* 13.19.237; K 19.2d).

Xunzi cannot accept Shen Dao's flippant approach to laws because of his own commitment to the idea that human beings have a certain *essence*, a peculiar characteristic in which no other species shares and which they obtain from nature. This characteristic is their penchant for discrimination. We distinguish male from female, old from young, and so on; and it is *altogether natural that we do so*. That is the Way. The rituals of the Sage Kings identify the natural order, and augment it, by confirming the distinctions that people are bound to make by nature. This is why there is only one set of legitimate rituals. There is only one Way.[55] The Sage Kings apprehended it, and their rituals embody it. There is no other Way, and no other constellation of rituals that conforms to the Way. It is through the Way, moreover, that Heaven plays a role in our lives. Though without bias or caprice, and with no involvement

whatsoever in the daily progression of human history, Heaven has nevertheless decreed the Way, and this Way functions as the fundamental mold of human existence.

This is Xunzi's conception of Heaven's Mandate 天命. We have seen Xunzi reject emphatically the notion that Heaven is a willful and unpredictable power, whose vagaries can be deduced from events transpiring on Earth. Nevertheless, Xunzi reserves a critical place for Heaven in people's lives.[56] Heaven is not a personage, like a ruler, whose moods and predilections a minister must learn to recognize. Heaven is a constant force with a constant *ethic* by which people must learn to live. All beings have thier particular virtues, their part in the plan. Heaven's Mandate is that human beings be social creatures.

It would therefore be misleading to characterize Xunzi as a conventionalist.[57] While it is true that Xunzi recognizes the value of convention in the process of harmonizing society, he does not tolerate the Legalist idea that these cultural conventions can be arbitrarily chosen and yet retain their efficacy. Therein lies his most significant departure from any kind of contractarianism. Had we chosen to compare Xunzi not to Hobbes, but to Rawls, or to Rousseau, or to any other contractarian, we would have had to come to the same conclusion: any social theory without an analogous cosmological dimension is ultimately incompatible with Xunzi's system. For the rituals have a *double* function: they facilitate peaceful society by establishing conventions of interaction; and they ensure at the same time that these conventions are appropriate to the human situation—and to the Way.

Xunzi has taken a dogmatic turn, and now lies vulnerable to what has been considered a major objection for several centuries. Our answer in chapter 1 to Huang Baijia's question—if one's *xing* is evil, then what is one's impetus to become good?—was that it is prudent to be good: when everyone follows the rituals, everyone is better off. People perceive their alternatives and make a choice. But if the rituals of the Sage Kings, as we read here, are merely the codification of tendencies innate in humans anyway, then is it not so that the root of the human urge to goodness lies within? And if

that is the case, to what extent is it illuminating to say that human *xing* is evil? Xunzi seems to be caught saying two different things about human nature. And though it is true that human *xing* is *not* the same thing as "that which makes humans human" 人之所以為人者, Xunzi hardly elaborates on the distinction. *Xing* is what is so from birth 生之所以然者—but the tendency to make distinctions is presumably inborn as well. The dilemma is best viewed as one arising from shifts in focus: *xing* emphasizes the appetitive and concupiscent aspect of human nature. Yet the gift of discrimination is no less a part of this nature; and it is this gift that represents his potential for salvation. A person is ultimately a *union* of *xing* and artifice 偽 (*wei*).[58]

Xunzi is aware of the ramifications of his theory. Social distinction leads to specialization and hierarchy. For Xunzi, this is all to the good: the result is autarky.[59]

水火有氣而無生,草木有生而無知,禽獸有知而無義,人有氣有生有知,
亦且有義,故最為天下貴也.力不若牛,走不若馬,而牛馬為用,何也?
曰:人能群,彼不能群.人何以能群?曰:分.分何以能行?曰:義.故義
以分則和. (*X* 5.9.104 = K 9.16a)

Water and fire have breath but no life; grass and trees have life but no knowledge; birds and beasts have knowledge but no morality. Human beings have breath and life and knowledge, and also morality; thus humans are the most noble under Heaven. They do not work like an ox, or run like a horse, but oxen and horses are used [by them]—why is this? I say: People can form societies; they [i.e. animals] cannot form societies. How can people form societies? I say: Through division [of labor]. How can division proceed? I say: Morality. Thus division with morality brings about harmony.

分均則不偏 [=遍],執齊則不壹,眾齊則不使.有天有地,而上下有差,
明王始立,而處國有制.夫兩貴之不能相事,兩賤之不能相使,是天數
也.執位齊而欲惡同,物不能澹則必爭,爭則必亂,亂則窮矣.先王惡其
亂也,故制禮義以分之,使有貧富貴賤之等,足以相兼臨者,是養天下
之本也. (*X* 5.9.96 = K 9.3)

When divisions are equal there is no abundance; when status is the same there is no unity; when the populace is the same there is no employment [i.e. one class would not serve the other]. There is Heaven and there is Earth, and above and below have disparities. When an enlightened ruler begins to stand

[i.e. arises], those dwelling in the state have rules. That two nobles cannot serve each other, two commoners cannot employ each other—this is Heaven's reckoning. When status and position is the same and likes and dislikes similar, objects cannot placate [i.e. there is not enough to go around] and there must be contention. Contention brings about chaos, and chaos brings about privation. The Former Kings hated this chaos; thus they established ritual and morality to divide them, and made it so that there are the ranks of poor and rich, noble and base. Whatever suffices to make everyone near to each other [i.e. cooperative] is the basis of nourishing all under Heaven.

職業無分,如是則人有樹事之患,而有爭功之禍矣.男女之合,夫婦之分,婚姻娉內 [=納] 送逆無禮,如是則人有失合之憂,而有爭色之禍矣. (*X* 6.10.114 = K 10.1)

If there were no division of occupation and enterprise—if it were like this—then people would have the vexation of sowing their own affairs and the catastrophe of contending for achievement. If union between man and woman, division between husband and wife, marriage, betrothal, sending and receiving [of the bride] were without ritual—if it were like this—then people would have the worry of losing union [i.e. losing the apparatus of union between man and woman] and the catastrophe of contention for sex.

不知壹天下建國家之權稱,上功用大儉約而優差等,曾不足以容辨異縣君臣. (*X* 3.6.58 = K 6.4)

[Some] do not know the steelyard and weight of unifying all under Heaven and establishing the state and its families; they take achievement and utility to be highest, frugality and economy to be greatest; but they neglect status and rank.

The last passage is revealing: hierarchy is not only reconcilable with economic efficiency, it is *essential* to it. The advantage that human beings have over the animals is their faculty of division; through specialization and socialization, they produce more than the oxen or horses, though in physical prowess these beasts vastly exceed them. Humans rule by economic suzerainty.[60]

兼足天下之道在明分.掩地表畝,刺艸殖穀,多糞肥田,是農夫眾庶之事也.守時力民,進事長功,和齊百姓,使人不偷,是將率之事也. (*X* 6.10.118f. = K 10.7)[61]

The Way of sufficiency under Heaven is in understanding division. Covering the earth [i.e. plowing?] and marking acres, cutting away weeds and sowing grain, [applying] much manure to make the field fecund — these are the affairs of the farmers and general populace. Guarding the seasons in the people's labors [i.e. making sure tasks are done at the right time], entering into undertakings that will increase production, harmonizing and equalizing the common folk, causing people not to slin — these are the affairs of the leaders and commanders.

The rituals are the key not only to well-ordered statehood and a prosperous economy, but also to personal development. The rituals help people balance the two aspects of their nature, *xing* and artifice:

兩情者,人生固有端焉.若夫斷之繼之,博之淺之,益之損之,類之盡之,
盛之美之,使本末終始,莫不順比,足以為萬世則,則是禮也.非順孰
[=熟]脩為之君子莫之能知也.故曰:性者,本始材朴也,偽者,文理隆
盛也.無性則偽之無所加,無偽則性不能自美.性偽合,然後聖人之名
一. (*X* 13.19.243 = K 19.5b–6)

A person has the incipience of two emotions [i.e. happiness and sorrow] from birth. If they are stopped and continued, broadened and made shallow, increased and diminished, categorized and exhausted, made to flourish and be beautiful, and caused to be — in trunk and branch, from end to beginning — in all respects appropriate and suitable, so that they can be a standard for myriad generations, this standard is ritual. Other than the noble man who cultivates [himself] and acts appropriately and with maturity, no one can know [this]. Thus I say: the *xing* is the basis and origin, the material and simple [state of humanity]. Artifice is refinement and pattern, the exalted and flourishing [state]. Without *xing*, artifice has nothing to add itself onto; without artifice, *xing* cannot make itself beautiful. When *xing* and artifice are united, then one is at one with the name of Sage.

Everyone has emotions: they are part of the *xing*. But the rituals take our most basic feelings and reconstitute them into "standards for myriad generations." Thus mourning rituals embody certain emotions, sartorial rituals others, birth rituals yet a third set. By channeling our unmediated sensations into the foundations of civilization, the rituals show our how to unite the *xing* and *wei*.

This psychology is best illustrated by Xunzi's "Discourse on Music" 樂論.[62] Music, in Xunzi's parlance, denotes those rituals

which the Sage Kings devised in order to regulate our natural and inescapable outpouring of emotion.

夫樂者，樂也，人情之所必不免也. 故人不能無樂. 樂則必發於聲音，形
於動靜，而人之道聲音動靜性術之變盡是矣. 故人不能不樂，樂則不能
無形，形而不為道，則不能無亂. 先王惡其亂也，故制雅頌之聲以道之，
使其聲足以樂而不流. (*X* 14.20.252 = K 20.1)

Music is joy—that which human essence cannot avoid. Thus people cannot be without music. Joy must be expressed in sounds and tones; it must be formed in motion and quietude. And the Way of human beings—sounds, tones, motion, quietude, and the vagaries of the art of the *xing*—are completely [expressed in music]. Thus people cannot be without joy; joy cannot be without form. But if the form is not with the Way, then there cannot but be chaos. The Former Kings hated this chaos; therefore they instituted the Odes and Hymns in order to make them [conform to] the Way. They made their sounds sufficient [to give form] for joy but not [lead to] dissipation.

Xunzi has introduced a new concept: *wen* 文. The term originally meant something like "line" or "pattern" (as in *wen* 紋, "wrinkle"), but in philosophical literature comes to mean a patterned, in particular a literary, response either to urges emanating from human will or to stimuli affecting human nature from outside.

"Poetry speaks for the will" 詩言志, as the venerable Shun supposedly declared (*Shujing* 2.1.5.24);[63] it was a belief shared by many. Confucius himself is said to have quoted from an ancient book: "Words are sufficient [to express] the will; *wen* is sufficient to [give power] to words. If one does not speak, who will know one's will? If one speaks without *wen*, [the words] will not go far" 言足以志，文足以言，不言誰知其志？言之無文行而不遠 (*Zuo zhuan* Xiang 襄 25 = 548 B.C., 512).[64] *Wen* represents the refinement of one's words that augments their suasive force.

Xunzi's account of the roots of the aesthetic impulse builds on these older sources, but creates out of them the first systematic explanation as to how the various components—will, *wen*, emotion, and so on—are coordinated. Xunzi's framework was then adopted wholesale by many later texts.[65] The "Great Preface" 大序 to the *Odes*, for example, attributed to Wei Hong 衛宏 (fl. A.D. 1st cent.), reads:

詩者,志之所之也.在心為志,發言為詩.情動於中,而形於言,言之不
足,故嗟歎之,嗟歎之不足,故永歌之,永歌之不足,不知手之舞之,足之
蹈之也.......故正得失,動天地,感鬼神,莫近於詩.先王以是經夫婦,
成孝敬,厚人倫,美教化,移風俗.[66]

Poetry is where the will goes. What is in the mind is the will; when it is
expressed in words, it is poetry. The emotions move from inside, and are
given form with words. When words are not enough, we sigh and exclaim
them; when sighs and exclamations are not enough, we sing and chant them;
when songs and chants are not enough, unconsciously, our hands dance them
and our feet stamp them. . . . Thus to rectify successes and failures, to move
Heaven and Earth, to move the ghosts and spirits, there is nothing closer [to
hand] than poetry. The Former Kings used it to regulate husband and wife,
achieve filiality and reverence, thicken relations between people, beautify teach-
ing and transformation, and change customs.

This famous passage bears Xunzi's unmistakable *imprimatur*.[67]
Emotions are natural and irrepressible; they burst forth in words,
poems, songs, and dances. This phenomenon in humans is neither
reprehensible nor indeed alterable: "People cannot be without
music," as Xunzi concluded. There is a danger, however, that this
effusion of passion may overstep its proper bounds by violating
the principles of the Way, and what began as a natural human ten-
dency may metamorphose into a source of chaos. But the Sage
Kings took steps to address just that problem: they established
rituals of artistic expression, ensuring that poems and song con-
form to the Way. For when the people of a state sing and hear
proper music, they are influenced by its power to bring themselves
in line with the Way as well.

夫聲樂之入人也深,其化人也速.故先王謹為之文.樂中平則民和而不
流,樂蕭莊則民齊而不亂.民和齊則兵勁城固.......樂姚冶以險則民
流僈鄙賤矣,流僈則亂,鄙賤則爭,亂爭則兵弱城犯.......故先王貴禮
樂而賤邪音. (*X* 14.20.253 = K 20.2)[68]

Sounds and music enter the people deeply and transform them rapidly. Thus
the Former Kings were assiduous at making [music] *wen*. When music is
centered and balanced, the people are harmonious and not [consumed by]
dissipation. When music is sober and dignified, the people are uniform and
not chaotic. When people are harmonious and unified, the army is stiff and

the cities secure. . . . When music is ornate and seduces [people] to malice, then the people are dissipated, indolent, crude, and base. Dissipation and indolence lead to chaos, crudity and baseness to contention. When there is chaos and contention, the army is soft and the cities are pillaged. . . . Thus the Sage Kings took ritual and music to be noble, and seductive tones to be base.

Xunzi's understanding of the importance of ritual in music informs the entire discussion of music in the *Liji*.

> 凡音之起由人心生也，人心之動，物使之然也. 感於物而動，故形於聲，聲相應，故生變，變成文，[69] 謂之音.......非性也. 感於物而后動，是故先王慎所以感之者，故禮以道其志，樂以和其聲，政以一其行，刑以防其姦，禮樂刑政，其極一也，所以同民心而出治道也.[70]

All tones that arise are born in the human mind. Movement in the human mind is caused by [external] objects. [The mind] is stirred by objects into movement; thus it takes form in sounds. Sounds respond to each other and give birth to changes [i.e. in sound]. When changes are made into *wen*, [the sounds] are called tones. . . . This is not [in] the *xing*. [The mind] is stirred by objects *and then* moves. Thus the Former Kings were cautious about what they stirred [the people] with. They used ritual to make their wills [conform] to the Way, music to harmonize their sounds, government to unify their actions, and punishments to prevent licentiousness. Rituals, music, punishments, and government are ultimately one: a means to make the people's minds similar and bring about the ordered Way.

The schema here is hardly different from what we have seen in the other texts. External objects and events cause man to react by uttering sounds, which can be made articulate by being transformed into *wen*. But the Former Kings were cautious about the kind of music and *wen* that people might compose, lest lewd airs impel the state into debauchery. So they established rituals of music that would "make their wills conform to the Way."

The details of this process are far less clear. There is a vague presumption of a certain amount of determinism involved in the growth of the human psyche. Music is efficacious because it spurs the wills of those who listen to it. Those who hear lewd ballads cannot help reacting to them by contributing sounds and tones and *wen* of their own, all of which will mirror the content of the ballads that stimulated them in the first place. In other words, licen-

tiousness pullulates, like a parasite, in the womb of the human mind. The Former Kings hoped to inculcate the correct mores by the same method of injecting stimuli into people and watching them resound and multiply in the recesses of their turbulent essence.[71]

Thus Xunzi attributes three faces to ritual: moral, political, and economic.[72] The rituals allow people to transcend their base natures and become civil. They offer rulers the means to organize their states. And by establishing division and specialization, they open the possibility of economic development. The rituals embody everything that distinguishes humans from the rest of the animal kingdom. The human being is *homo distinguens* or *homo civilis*. And in keeping with the rest of Xunzi's philosophy, it is always up to us to make our move. Those who follow the rituals are able to live in harmony not only with their fellows, but also with the cosmos enveloping all. Those who do not are wicked and pitiable. The choice is ours.

Chapter 4

Language and the Way

There was a certain group of philosophers in Xunzi's time known as the Dialecticians 辯者 (sometimes rendered "Sophists"), who delighted in constructing ludicrous paradoxes, such as, "A white horse is not a horse"; "Eggs have hair"; and the like. Having thus startled their audience, the Dialecticians would subsequently "prove" them to be true. The persuasions of these Dialecticians represented a continuing source of annoyance for Xunzi, and he criticized them repeatedly for their philosophical uselessness:

不法先王,不是禮義,而好治怪説,玩琦辭,甚察而不惠 [=急?],辯而無用,多事而寡功,不可以為治綱紀,然而其持之有故,其言之成理,足以欺惑愚眾,是惠施鄧析也. (*X* 3.6.59＝K 6.6)[1]

[They] do not model themselves after the Former Kings, and do not affirm ritual or righteousness, but like to govern [i.e. learn] strange persuasions and play with peculiar speeches. They investigate deeply but for no benefit (or 不急 "[into matters of] no urgency"); they dispute but without use, [concerning] many topics but with few results. [Their speeches] cannot be made into principles of government, yet what they support has basis, what they speak is completed with logic. This is enough to confuse the ignorant masses. Such are Hui Shi and Deng Xi [two famous Dialectician].

惠子蔽於辭而不知實. (*X* 15.21.262＝K 21.4)

Master Hui was blinded by propositions and did not know reality [or "objects"].

Master Hui is Hui Shi 惠施 (fl. 4th cent. B.C.), one of the most famous Dialecticians, known for his Ten Paradoxes.

Xunzi may have been unequivocal in his assertion that the Dialecticians were wasting their time, or not contributing to significant philosophical inquiry, but he did not extend these views to an underestimation of their influence. On the contrary, in his criticism of Hui Shi and Deng Xi, he places them in the company of Mencius, Mo Di 墨翟 (fl. 5th cent. B.C.), Shen Dao, and seven other critical pre-Imperial philosophers. The Dialecticians may only be playing games, but for some reason Xunzi takes these games very seriously, and accords them much attention.

What was Xunzi worried about? More than forty of the Dialecticians' riddles have survived:

A. *The Ten Paradoxes of Hui Shi*[2]

1. 至大無外,謂之大一;至小無內,謂之小一.

The greatest has nothing outside it; call it "Great Unity." The smallest has nothing inside it; call it "Small Unity."

2. 無厚,不可積也,其大千里.

Something without thickness cannot be accumulated, yet its size is 1,000 *li*.

3. 天與地卑,山與澤平.

Heaven is as low as Earth; mountains are as flat as swamps.

4. 日方中方睨,物方生方死.

The sun is in the center and at an angle at the same time [i.e. it is noon and afternoon at the same time]; objects live and die at the same time.

5. 大同而與小同異,此之謂小同異;萬物畢同畢異,此之謂大同異.

Being largely similar to but different from the slightly similar is called "small similarity and difference"; when the myriad things are similar to the end and different to the end, we call this "great similarity and difference."

6. 南方無窮而有窮.

The South has no limit but has a limit.

7. 今日適越而昔來.

Today I went to Yue but got there yesterday.

8. 連環可解也.

Linked rings can be loosed.

9. 我知天下之中央,燕之北越之南是也.

I know the center of the world: it is north of Yan [the northernmost state] and south of Yue [the southernmost state].

10. 氾愛萬物,天地一體也.

Let there be flowing love for the myriad things; Heaven and Earth are one body.

B. *The Paradox Made Famous by Gongsun Long* 公孫龍 [3]

11. 白馬非馬也.

A white horse is not a horse.

C. *Twenty-one Paradoxes of Other Dialecticians* [4]

12. 卵有毛.

Eggs have hair.

13. 雞三足.

Chicken: three legs.

14. 郢有天下.

Ying [a city] contains all under Heaven.

15. 犬可以為羊.

Dogs may be called sheep.

16. 馬有卵.

Horses have eggs.

17. 丁子有尾.

Frogs have tails.

18. 火不熱.

Fire is not hot.

19. 山出口.

Mountains speak. Or: Mountains are spoken. Mountains emerge from mouths.

20. 輪不蹍地.

Wheels do not touch the ground.

21. 目不見.

Eyes do not see.

22. 指不至,至不絕.

Pointing does not reach; the reaching never stops.

23. 龜長於蛇.

Tortoises are longer than snakes.

24. 短不方,規不可以為圓.

T-squares are not square; compasses cannot make circles.

25. 鑿不圍枘.

Sockets do not surround pegs.

26. 飛鳥之景未嘗動也.

The shadow of a flying bird has never moved.

27. 鏃矢之疾而有不行不止之時.

There are times when a speedy barbed arrow is neither moving nor stopping.

28. 狗非犬.

A *gou* [a name for a dog] is not a *quan* [another name for a dog].

29. 黃馬驪牛三.

An ochre horse and a dark ox make three.

30. 白狗黑.

White dogs are black.

31. 孤駒未嘗有母.

An orphaned colt never had a mother.

32. 一尺之捶,日取其半,萬世不竭.

If you have a foot-long stick, and remove half of it each day, in ten thousand generations it will not be used up.

D. *Some Later Mohist Paradoxes*[5]

33. 苟是石也白,敗是石也盡與白同.是石也唯大,不與大同.

If this stone is white, when you smash it, all of it is the same as the "white." But this stone alone is big; [the pieces] are not the same as the "big."

34. 獲之親人也,獲事其親非事人也.

The parents of Huo [a stock example for a woman] are people, but Huo's serving her parents is not serving people.

35. 其弟美人也,愛其弟非愛美人也.

Her [Huo's] younger brother is a handsome man, but loving her younger brother is not loving handsome men.

36. 車木也，乘車非乘木也．

A carriage is wood, but riding a carriage is not riding wood.

37. 船木也，入船非入木也．

A boat is wood, but entering a boat is not entering wood.

38. 盜人人也，多盜非多人也，無盜非無人也．

Robbers are people, but having many robbers is not having many people, and having no robbers is not having no people.

39. 讀書非書也，好讀書好書也．

Reading books is not books, but being fond of reading books is being fond of books.

40. 鬥雞非雞也，好鬥雞好雞也．

Cockfights are not cocks, but liking cockfights is liking cocks.

41. 且入井非入井也，止且入井止入井也．

Being about to fall into a well is not falling into a well, but stopping [someone] from being about to fall into a well is stopping [someone] from falling into a well.

42. 桃之實桃也，棘之實非棘也．

The fruit of the peach is the peach, but the fruit of the bramble is not the bramble.

43. 問人之病問人也，惡人之病非惡人也．

Asking about a man's illness is asking about the man, but disliking the man's illness is not disliking the man.

44. 祭人之鬼非祭人也，祭兄之鬼乃祭兄也．

Sacrificing to a man's ghost is not sacrificing to a man, but sacrificing to one's older brother's ghost is sacrificing to one's older brother.

45. 之馬之目眇,則謂之馬眇,之馬之目大而不謂之馬大.

If this horse's eyes are blind, we call this horse blind, but if this horse's eyes are big, we do not call this horse big.

46. 之牛之毛黃,則謂之牛黃,之牛之毛眾而不謂之牛眾.

If this bull's hairs are yellow, we call this bull yellow, but if this bull's hairs are many, we do not call this bull many.

E. *Two Otherwise Unknown Paradoxes Quoted by Xunzi (X 2.3.23f.)*[6]

47. 齊秦襲.

Qi [the state farthest to the east] and Qin [the state farthest to the west] are adjacent.

48. 姁有須.

Old women have whiskers.

We can reconstruct solutions for most of these paradoxes. Let us begin with those of Hui Shi. (1) and (5) are not paradoxes, but definitions, and (10) is merely the ultimate consequence of the other nine. Solutions to the remaining seven items are as follows:[7]

2. The "something" in question is a plane. It is true that an object with no thickness, when added to another object, does not increase that object's thickness (this is similar to an argument of Zeno the Eleatic [fl. 460 B.C.]).[8] But in two dimensions, it may cover one thousand *li*.

3. This presumes infinite space. Heaven is as far from the highest point in space as Earth; Earth is as far from the lowest point in space as Heaven. The same is true of mountains and swamps.

4. The high sun is already in the process of declining; the living organism is already in the process of dying. Strictly speaking, there is no parallelism. The paradox of the sun works because the temporal point in which the sun is at high noon is infinitesimally small. The paradox of life and death works no matter how long the organism lives—as long as it dies eventually.

6. "South" is infinite, but does not contain *everything*: it does not, for example, include "north."[9]

7. Two solutions: (a) if I leave for Yue today, I will get there sometime in the future, but from the point of view that I will have on the day after I arrive, I will have gotten there yesterday; (b) if I cross into Yue precisely on the border between today and tomorrow, I will have left today but arrived yesterday.

8. The size of an intersection point between two rings is zero. Thus there is nothing blocking them from being loosed.

9. Every point in (infinite) space is as far away from the end as any other; thus the center may be anywhere. Compare to (3).

It has long been observed that the ten paradoxes of Hui Shi hinge on the unimaginable nature of infinite space.[10] Since space is infinitely large, there are no absolute spatial relations between objects; hence mountains are no closer to the highest point in space than swamps. Since points are infinitesimally small, they do not, in one sense exist; hence the sun is never at any given point, and rings are never interlocked.

Some later paradoxes are variations on Hui Shi:

14. Ying is at the center of the universe (since the center can be anywhere), and therefore contains a portion of everything. Compare to (3), (9), (47).

20. The intersection point has no size. Compare to (4), (8).

26. For anything to move, it must go from point to point. But at any given instant, the shadow must be at one point, since it cannot be at two different points at the same time. Therefore it cannot move.[11]

27. Variant of (26).

47. Qi is no closer to the eastern end of the universe than Qin. Compare to (3), (9), (14).[12]

There are two important observations to be made about Hui Shi. First, despite Xunzi's position, he himself does not consider his paradoxes to be merely entertaining diversions, as is clear from his summation paradox (10): "Let there be flowing love for the myriad things; Heaven and Earth are one body." Hui Shi is convinced that the previous nine planks in his argument imply a significant didactic conclusion: he believes that they will persuade the

audience to a form of Mohism—that man will love man univer-
sally.[13] Second, Hui Shi's paradoxes may include what we recog-
nize now as faulty logic—as in the assertion that a flying arrow
cannot move. But in one respect, at least, they are one niveau higher
than the other paradoxes. For they do not make use of the
Dialectician's favorite trick, the one technique held in common by
all of the known solutions to other paradoxes. This is to use a key
term or terms either in a sense different from that expected by
one's audience, or in one sense in one part of the paradox, and in a
different sense in another.[14]

This technique may manifest itself in different forms. Gongsun
Long's paradox (11), for example, involves the difference between
use and *mention*. Horse is not the same as "horse": horse is a quadru-
ped mammal frequently used for riding; "horse" is the five-letter
word we use to name that mammal. The distinction can be critical,
especially in discussions involving numbers. Two is the smallest
prime integer; "two" (or "2") is just a symbol for that integer.[15]
The crux of Gongsun Long's argument is that "white horse" does
not have the same functional significance as "horse," because some-
one calling for a "white horse" will accept only a white horse, whereas
someone calling for a "horse" will be satisfied by a horse that is
yellow or any other color. Gongsun Long does not mean that a
white horse is not a horse, but that the *designation* "white horse" is
not the same as the designation "horse." Thus the statement, "A
white horse is not a horse," could have been written, "'White horse'
is not 'horse'"—had there been quotation marks in ancient China.[16]

With few exceptions, the twenty-one paradoxes of the other
Dialecticians, as far as we can understand them, are just variations
on this technique:

12. The character *luan* 卵 can mean "egg" or "in an egg"; the
character *you* 有 can mean "has" or "there exists"; *mao* 毛 can mean
"hair," "pelt," or "feathers." "In an egg there exists hair"—the feathers
of the unborn chick inside. This interpretation is made possible by
reading all three characters in permissible, but unidiomatic senses.

13. A chicken has two (legs). Speaking of the chicken is one
(act). The sum is three. This is pure word-play. The key question is
"Three what?" The audience assumes that "three" refers to the

chicken's legs; but "Chicken: three legs" means more or less "A chicken plus two legs equals three." Compare to (29).

15. A dog may be called a sheep because the name is arbitrary. By "sheep," the audience assumes that the Dialectician means sheep; but he does not—he means a different possible name for a dog.

16. A variation on the above. Fetuses may be called "eggs" and eggs "fetuses," because names are arbitrary. Compare to (28).

18. More accurately, "Fire is not heat": they are two different things. But the audience's first interpretation of the statement would be, "Fire is not hot."

19. One explanation invokes the echo: mountains respond to calls, as though they had a mouth. Another explanation reminds us of (15), (16), and (28): human mouths give mountains their name.[17]

21. Eyes do not see: people see, with the help of eyes. The Dialectician uses the term "see" in the sense of "to perceive"; but under normal circumstances, anyone would say that eyes can see.

23. Tortoises are longer than snakes in one important respect: tortoises are longer-lived. Again, the Dialectician uses his terms cleverly: "long" here with respect to age rather than body.

28. The names are arbitrary. *Gou* 狗 can also mean "puppy" or "small dog." Compare to (15), (16), (19).

29. Two explanations: (a) the horse is one thing, the ox another, and the act of speaking a third thing; and (b) the horse is one thing, the ox another, and their colors a third. The pivotal question here is familiar: "Three what?" The Dialectician, contrary to the expectations of the audience, does not mean three animals or objects. Compare to (13).

30. A white dog is black (in one respect) if it has black eyes. According to conventional language, of course, a dog is said to be "black" only if its hair is black.[18]

Whereas most of the above paradoxes are word games rather than paradoxes of logic, the Later Mohist paradoxes (33–46) are *veridical paradoxes*, or paradoxes of logic that yield a true, but surprising result.[19] They are examples of what Rudolf Carnap (1891–1970) called the "paradox of the name relation."[20] On a certain occasion, King George IV asked whether Sir Walter Scott was the author of *Waverley*, an anonymous novel. Sir Walter Scott was

indeed the author of *Waverley*, but "Sir Walter Scott" and "the author of *Waverley*" are not perfectly interchangeable in sentences. Thus the Later Mohist might have pronounced, "Sir Walter Scott is the author of *Waverley*, but asking about Sir Walter Scott is not asking about the author of *Waverley*"—since it may *not* be said that King George IV asked to know whether Sir Walter Scott was Sir Walter Scott. For King George knew Sir Walter Scott well.[21] Many solutions to the paradox of the name relation have been proposed. One of the most influential is that of Gottlob Frege (1848–1925), who pointed out that a distinction must be made between *sense* and *reference*.[22] "Sir Walter Scott" and "the author of *Waverley*" *refer* to the same man, but do not have the same *sense*. They are different modes of expression of the same object. One of Frege's examples involved Phosphorus and Hesperus, the brightest object in the morning sky and the brightest object in the evening sky. Both happen to be Venus. "Phosphorus" and "Hesperus" have the same reference, but not the same sense. One may say, "The evening-star was so named because it is the brightest object in the evening sky," but not, "The morning-star was so named because it is the brightest object in the evening sky."[23]

The logic of the Later Mohist paradoxes represents a fertile variant of the Dialectician's trick of using key terms in obscure senses. The Later Mohist equates two terms of identical reference but not identical sense, and then exults as he demonstrates that the two terms may not be used interchangeably. The paradoxes hinge on the (unstated) copula in "X is Y" (X Y 也). X *is* Y from the point of view of reference, but X *is not* Y from the point of view of sense; or X is the same as Y in one respect, but not in another.[24]

Did anyone in ancient China understand how the paradoxes worked?[25] The Later Mohists were on the right track when they observed:

服執,貌巧轉,則求其故.
難成言,務成之執,則求執之法.

[Canon:] When [people] devote themselves to a claim [in this case a claim contrary to common sense, such as, "Chickens have three legs," etc.], if the description turns subtly, then investigate their reasons.
[Explanation:] If [people] object to an established saying [i.e. conventional

observation, e.g. "Chickens have *two* legs"], and make it their duty to establish this claim, then investigate the method of their claim.[26]

And similarly:

音利察次端.

When the sound flows [i.e. when the argument sounds suspicious?], examine the order [of the argument] and initial meanings [of the terms].[27]

In other words, when someone makes an argument attempting to prove a ludicrous proposition, look at the initial meanings of his terms. He is likely to have deceived you in the course of his argument.

Xunzi also knew exactly how the Sophistic technique worked:

子宋子曰:見侮不辱.應之曰:凡議必將立隆正,然後可也.無隆正,則是非不分而辨訟不決.故所聞曰:天下之大隆,是非之封界,分職名象之所起,王制是也.故凡言議期命,是非以聖王為師.而聖王之分,榮辱是也.是有兩端矣.有義榮者.有埶榮者.有義辱者.有埶辱者. (*X* 12.18.228 = K 18.9)

Master Song [Song Keng 牼, fl. late 4th cent. B.C.] says: To be insulted is no disgrace. I counter him, saying: Every argument must first establish an exalted rectification; only then is it acceptable. If there is no exalted rectification, right and wrong are not distinguished and the dispute is undecided. Thus I have heard: "The Great exalted [rectification] under Heaven, that which gives rise to the boundary between right and wrong, distinctions of offices, names, and images, is the kingly regulation." Thus all arguments about time, fate, right, and wrong, take the Sage Kings as their model. And the allotment of the Sage Kings is glory and disgrace. These have two meanings. There is moral glory; there is social glory. There is moral disgrace; there is social disgrace.

Xunzi here objects to Song Keng's famous aphorism, "To be insulted is no disgrace." Song Keng held that if no one were to feel disgraced by being insulted, there would never be strife and warfare.[28] Songzi was not known as a Dialectician, but Xunzi points out that the justification of his tenet follows the same technique as that of the Dialecticians. What is meant by the term *longzheng* 隆正, "exalted rectification," is an order in argumentation, a frame of

reference. Before entering into a debate, Xunzi tells his students, one must define one's terms. Songzi confuses the different senses of the term *ru* 辱, "disgrace," leading him to a statement as absurd as those of the Dialecticians.[29]

The idea imbedded in the concept of the exalted rectification, that *names must fit reality*, is a prolific pre-Imperial theme that long antedates Xunzi. We read in the *Analects*:

子路曰:衛君待子而為政,子將奚先?子曰:必也正名乎!子路曰:有是
哉!子之迂也,奚其正?子曰:野哉由也!君子於其所不知,蓋闕如也.名
不正,則言不順,言不順,則事不成,事不成,則禮樂不興,禮樂不興,則
刑罰不中,刑罰不中,則民無所措手足.故君子名之必,可言也,言之必,
可行也.君子於其言無所苟而已矣. (13.3.1–7)

Zilu [=Zhong You 仲由, 542–480 B.C., a disciple] said: The Lord of Wei awaits you in order to administer the government. What will you place first? The Master said: What is necessary is to rectify names. Zilu said: This! You are wide of the mark—why such rectification? The Master said: You are wild, [Zhong] You. With respect to what he does not know, the noble man is reserved. If names are not rectified, speech is not appropriate. If speech is not appropriate, then affairs are not completed. If affairs are not completed, then ritual and music do not flourish. If ritual and music do not flourish, then punishments and penalties do not hit the mark. If punishments and penalties do not hit the mark, then the people have nothing with which to occupy their hands and feet. Thus the noble man's names must be usable in speech, and his speech must be practicable. The noble man has no error with respect to his speech.[30]

Confucius expressed the idea succinctly in a different passage:

子曰:觚不觚.觚哉!觚哉! (6.23)

The Master said: [What is called] *gu*-goblet is not a [real] *gu*-goblet. *Gu*-goblet! *Gu*-goblet!

The *gu*-goblet was originally a ritual implement, by Confucius's time long out of use; Confucius here objects to the continued usage of the term to designate a vessel of a shape different from that of the original. Only a genuine *gu*-goblet should go by that name.[31]

So Xunzi cannot accept the logic of the Dialecticians because, like Confucius, he believes that names are not trivial. One must

formulate one's arguments in accordance with the "exalted rectification." Xunzi elaborates on this concept in his theory of naming. We observe objects, and choose names for what we perceive.[32]

何緣而以同異？曰：緣天官．凡同類同情者，其天官之意物也同．故比方之疑［＝擬］似而通，是所以共其約名以相期也．形體色理以目異，聲音清濁調竽奇聲以耳異，甘名鹹淡辛酸奇味以口異，香臭芬鬱腥臊洒［＝漏］酸[33] 奇臭以鼻異，疾養［＝癢］滄熱滑鈹[34] 輕重以形體異．(*X* 16.22.276f. = K 22.2c–d)

What does one rely upon to [determine] same and different? I say: one relies upon the senses. The senses of all members of the same species with the same essence—their senses perceive things in the same way. Thus we associate things that appear similar upon comparison; in this way we grant their designated names with which they define each other [i.e. we define one in terms of the other]. Shape, body, color, pattern, are distinguished by the eye. Sound, tone, treble, bass, mode, harmony—odd sounds are distinguished by the ear. Sweet, bitter, salty, bland, pungent, sour—odd tastes are distinguished by the mouth. Fragrant, smelly, sweet-smelling, odorous, rank, fetid, putrid, acrid—odd smells are distinguished by the nose. Pain, itching, cold, heat, smooth, sharp, light, and heavy are differentiated by the body.

Once the object is perceived, it can receive any name at all. Xunzi comes to the Saussurian conclusion that names are not intrinsically appropriate or inappropriate.[35]

知異實者之異名也，故使異實者莫不異名也．......名無固宜．約之以命．約定俗成，謂之宜．異於約則謂之不宜．(*X* 16.22.278f. = K 22.2f–g)

We know that different objects must have different names; therefore we cause different objects all to have different names. . . . Names have no inherent appropriateness. We designate them [by some word] in order to name [them]. If the designation is fixed and the custom completed, then it is called appropriate. If [the name people use] is different from the designation, then it is called inappropriate.

Thus, while the names themselves are arbitrary, there can be no discussion over *what gets named*. We name what we perceive. Xunzi does not seem to envision any kind of ontological confusion: what one person sees is what another will see. Naming is an easy undertaking. We perceive a thing, and we name it.

This method of naming presupposes the idea, known to contemporary theories of perception, that seeing is *seeing as*. When we observe a cluster of matter, we impose an order onto our vision *in the act* of seeing. When we look around, we do not see an amorphous jumble of matter; rather, we see walls, tables, books, people. When we see the face of an acquaintance, we do not see a fleshy mass, or even a constellation of features—eyes, nose, mouth, cheeks; we see a *face*, someone we recognize, someone we know. But as Ludwig Wittgenstein (1889–1951) has shown, perceiving the face and perceiving the face to be the face of an acquaintance, are, elementally, distinct actions.

> I met someone whom I have not seen for years; I see him clearly, but fail to know him. Suddenly I know him, I see the old face in the altered one. I believe I should do a different portrait of him now if I could paint.
>
> Now, when I know my acquaintance in a crowd, perhaps after looking in his direction for quite a while,—is this a special sort of seeing? Is it a case of both seeing and thinking? or an amalgam of the two, as I should almost like to say?[36]

Perceiving a face in a crowd, and then recognizing that the face is that of someone we know, correspond to the stages of perception and *apperception*, respectively. Xunzi assumes implicitly that every act of perception incorporates an act of apperception.[37] When we see a certain object, naturally we perceive it; but before we can begin to choose a name for that object, we must also *apperceive* the object as an object. In a sense, it is *not* the case that the nose distinguishes fragrant from rancid. The nose *smells* fragrant and rancid; but the distinction made between fragrant and rancid as *entities* is made in the same apperceptive node as the distinction between, say, sweet and bitter. Today we would call this node the *sensus communis*, or the brain. Xunzi cannot mean that each sense organ perceives and apperceives in isolation from the others, but that the five senses, collectively, apperceive reality.

One way or the other, the consequence is inescapable: within Xunzi's system, once names are chosen, they demand strict compliance. For names represent *reality*, and their abuse results in a faulty characterization of the world.

名也者,所以期累[=異]實也,辭也者,兼異實之名以論一意也,辨[=辯]
説也者,不異實名以喻動靜之道也,期命也者,辨説之用也,辨説也者,
心之象[=像]道也,心也者,道之工宰也,道也者,治之經理也.......
以正道而辨姦,猶引繩以持曲直.是故邪説不能亂,百家無所竄. (*X*
16.22.281 = K 22.3f)

Names are that by which different objects are designated. Propositions con-
nect the names of different objects in order to sort ideas into one.[38] Disputa-
tions and explications do not differentiate [between] reality and name in order
to illustrate the Way of movement and quietude [this statement is inherently
ambiguous in the Chinese original as well]. Designating and naming are the
application of disputations and explications. Disputations and explications
are the mind's image of the Way. The mind is the craftsman and manager of
the Way. The Way is the plan and pattern of order. . . . Using the correct Way
to distinguish lewd [doctrines] is like leading [i.e. stretching] rope to deter-
mine the crooked and straight. For this reason, heterodox explications can-
not [cause] chaos, and the Hundred Schools have no place to hide.

In the term *dao* 道, or Way, Xunzi postulates a single and universal
ontology. The Way is the way of the universe, the "plan and pattern"
of reality, and theories are "heterodox" if they do not conform to
it.[39] The exalted rectification—or rectification of names—is a tool
that the philosopher can use to distinguish lewd antinomies from
truths compatible with the Way. Xunzi execrates the paradoxes of
the Dialecticians because they obscure and even mock the Way.
Xunzi illustrates the frivolity of the paradoxes by means of the con-
cept of the *noble man*. Where the petty men deny the Way, the
noble man embraces it:

若夫充虛之相施易也,堅白同異之分隔也,是聰耳之所不能聽也,明目
之所不能見也,不知無害為君子,知之無損為小人. (*X* 4.8.79 = K 8.4)

As for those theorems that make the full into the empty, and *vice versa*, or the
separation of hard and white and identity and difference—these are what the
keen ear cannot hear, what the clear eye cannot see. Not knowing them is no
damage to becoming a noble man; knowing them is no hindrance to becoming
a petty person.

The ramifications of this strategy of Xunzi's are wide-ranging.
He claims legitimacy, for one thing, virtually by *fiat*. Even if I have
not convinced you, he tells us, I am still right, because *I know the*

Way. I am right because that is the way things are. Who does not agree with Xunzi is not only wrong, but deluded, for he has perceived reality improperly. Moreover, while the actual names of objects may be a trivial matter, the objects themselves are not open to interpretation. Objects are as Xunzi perceives them. If we are free to name objects as we see fit, we are not free to perceive the universe according to any order other than the Way.

Xunzi's uncompromising objectivism represents a genuine choice, because other alternatives existed.[40] Zhuang Zhou, for example, is famous for having advanced a theory that comes close to the ontological relativity of our times.[41]

故有儒墨之是非,以是其所非,而非其所是.欲是其所非,而非其所是,
則莫若以明.物無非彼,物無非是.自彼則不見,自知則知之,故曰:彼出
於是,是亦因彼,彼是方生之說也.雖然,方生方死,方死方生,方可方不
可,方不可方可,因是因非,因非因是.是以聖人不由,而照之於天,亦因
是也.是亦彼也,彼亦是也.彼亦一是非,此亦一是非.果且有彼是乎
哉?[42]

Thus there are the "right and wrong" of the Confucians and Mohists, by which they think right what [the others] think wrong, and they think wrong what [the others] think right. If you wish to think right what [others] think wrong, and think wrong what [others] think right, then there is no better means than clarity. There are no objects which are not "that"; there are no objects which are not "this." From [the point of view of] "that," one cannot see [that this is true]; from [i.e. through] knowledge one can know it. Thus I say: "that" comes out of "this," and "this" also depends on "that"—which is to say that "that" and "this" give birth to each other. Although this is so, if they are born together, they die together; if they die together, they are born together; if they are acceptable together, they are unacceptable together; if they are unacceptable together, they are acceptable together; what depends on right depends on wrong; what depends on wrong depends on right. Taking this [i.e. for this reason] the Sage does not follow ["this" and "that"], but illuminates them [both] in Heaven. [He] also depends on "this." "This" is also "that"; "that" is also "this." There there is one right and wrong; here there is one right and wrong. So is there a "that" and a "this"?

Zhuangzi argues that two different people will have two different ideas of what is right and wrong, two different ideas of what is "this" and what is "that"—or two different ontologies. Everyone sees a different "this" and sees "this" differently. Seeing a different

"this" entails maintaining a different ontology; and those who share the same ontology may still see "this" differently, that is to say, have different perceptions of the same ontology. The hairsplitting of the Confucians and Mohists is misguided by its *narrowness*: it presupposes only one way of looking at the world.[43] Zhuangzi therefore never needs to consider the question of names. There is no call for an analysis of how objects are to be named when it is not even clear what the objects are. But if Xunzi knew of this opinion, it did not influence him in the slightest. "This" and "that" are not problems for him. We perceive this, and this is "this." We perceive that, and that is "that." Knowing the Way is as easy as opening one's eyes[44] — and the heart of Xunzi's message is that we must do precisely that: strive to make ourselves *dao*.

Seeing the notion of the Way as central to Xunzi's philosophy, however, represents an important departure from previous interpretations. For centuries, the traditional attitude has been that Xunzi's main arguments revolved around the *xing*. In his *Disputation on Xunzi* 荀子辯, Xu Ji 徐積 (1028–1103), for example, opens with the quote, "Human *xing* is evil" 人之性惡, adding archly, "Xunzi is wrong" 荀子非也. The rest of the treatise is devoted to an injudicious demonstration of this single claim, with the consistent application of Neo-Confucian meanings to *xing* and other terms.[45] But what is remarkable about Xu Ji's work is not its blunt judgments and pervasive anachronisms—for these are the rule rather than the exception in later Chinese discussions of earlier thinkers; the one feature of the *Disputation on Xunzi* worthy of note is its complete failure to consider any of Xunzi's writings other than the criticism of Mencius. Topics such as Heaven, ritual, and naming are brought in only in the most perfunctory manner, and at that only where they are thought to shed light on Xunzi's grand thesis—that human nature is evil. Xu Ji's essay, admired by successive generations as exemplary, is illustrative of the intellectual climate of the time. After the Mencian revival, the consensus regarding Xunzi was that, in contrast to Mencius, he held *xing* to be evil; and that he was wrong.[46]

We saw in chapter 1, however, that a superficial reading of the refutation of Mencius leads to few concrete results. Both Xunzi

and Mencius affirm the perfectibility of human beings; and both Xunzi and Mencius agree that sagehood is attainable only by those who cultivate themselves diligently. So we took an alternate route: perhaps the issue here is not the *xing*, but the mind 心. Just as the rulers of states may choose from a number of policies to govern their states—and just as it is the rulers' policies, and not the states' natural resources, that determine whether the states will prosper or fall—so may the human mind choose to behave in any way it wants, and so too is it the path that one chooses to follow, rather than one's native endowments, that determine whether one will become a sage or a villain. But what is the path that leads to sagehood? How does one apprehend it?

The rituals of the Sage Kings, of course, are the path; they represent the code of behavior most conducive to the attainment of sagehood because they encapsulate the essence of humanity into a practicable program. This essence is the tendency to make distinctions. For making distinctions is the Human Way. Xunzi brooks no argument in this regard. It is simply axiomatic that making distinctions is the Human Way. It is so because the Way is as it is, the principle of the universe, the "plan and pattern." Our duty is not to rebel against this order, or to argue with it, but to perceive it and understand it, and live in harmony with it.

There are those who comprehend one or another aspect of the Way, but few who are sensible to the Way in its totality. Xunzi casts this idea in decisive terms: those who know one side of the Way are the other schools; those who know the Way completely are the Confucians.

萬物為道一偏，一物為萬物一偏．愚者為一物一偏，而自以為知道，無知也．慎子有見於後，無見於先，老子有見於屈，無見於信，墨子有見於齊，無見於畸，宋子有見於少，無見於多．有後而無先，則群眾無門，有屈而無信，則貴賤不分，有齊而無畸，則政令不施，有少而無多，則群眾不化． (*X* 11.17.213 = K 17.12)

The myriad things are one aspect of the Way; one thing is one aspect of the myriad things. The stupid who [fixate] on one aspect of one thing, and think that they know the Way—they have no knowledge. Shenzi had insight into posterity, but lacked insight into predecessors. Laozi had insight into the bent but lacked insight into the stretched. Mozi had insight into the ordinary

but lacked insight into the extraordinary. Songzi had insight into the few, but lacked insight into the many. If there is posterity but no predecessors, then the masses will have no gateway. If there is bending but no stretching, then noble and base are not differentiated. If there is the ordinary but no extraordinary, then governmental commands are not carried out. If there are few but not many, then the masses are not transformed.

The wording here is often cryptic; it is not always obvious where the other thinkers went awry. But the message is clear: Shenzi, Laozi, Mozi, and Songzi all grasped one idea, but did not know how to fit what they knew into the vast Way. In another passage Xunzi elaborates on this thought:

墨子蔽於用而不知文,宋子蔽於欲而不知得,慎子蔽於法而不知賢,申子蔽於埶而不知知,惠子蔽於辭而不知實,莊子蔽天而不知人.故由用謂之道盡利矣,由俗[=欲]謂之道盡嗛[=慊]矣,由法謂之道盡數矣,由埶謂之道盡便矣,由辭謂之道盡論矣,由天謂之道盡因矣.此數具者,皆道之一隅也,夫道者,體常而盡變,一隅不足以舉之.曲知之人,觀於道之一隅,而未之能識也.故以為足而飾之,內以自亂,外以惑人,上以蔽下,下以蔽上,此蔽塞之禍也.孔子仁知且不蔽,故學亂術足以為先王者也,一家得周道,舉而用之,不蔽於成積也. (*X* 15.21.261f.= K 21.4)

Mozi was blinded by utility and did not know refinement. Songzi was blinded by desire and did not know attainment. Shenzi was blinded by laws and did not know [the value of] worthy people. Shenzi [=Shen Buhai 不害, d. 337 B.C.] was blinded by [administrative] skill and did not know knowledge. Huizi was blinded by propositions and did not know objects [or reality]. Zhuangzi was blinded by Heaven and did not know humanity. Thus, by following utility and calling it [the Way], the Way will be entirely [a matter of] profit. By following desire and calling it the Way, the Way will be entirely pleasure. By following laws and calling it the Way, the Way will be entirely calculation. By following skill and calling it the Way, the Way will be entirely convenience. By following propositions and calling it the Way, the Way will be entirely theories. By following Heaven and calling it the Way, the Way will be entirely reliance [on the forces of nature]. All of these several [ideas] are one corner of the Way. The Way is constant in body and exhaustively changing [i.e in motion]. One corner is not enough to extrapolate it [i.e. one cannot know the whole Way from one corner]. People with parochial knowledge look upon one corner of the Way, and are never able to recognize it [as such]. Thus they think it sufficient and adorn it. Inside, they bring chaos upon themselves with it; outside, they use it to delude others. Superiors becloud inferiors with it; inferiors becloud superiors with it. This is the catastrophe of stop-

page [i.e. stupidity]. Confucius was humane, knowledgeable, and not blinded. Thus he studied the various arts to the point that he was the equal of the Former Kings. One school obtained the universal Way. They deduced from it and applied it, and were not blinded by their accomplishments.

The only real Daoists, in a manner of speaking, are the Confucians, since they constitute the only school which does not overemphasize one aspect of the Way to the exclusion of the others. The Confucians alone comprehend the Way in all its manifestations; and hence to be Confucian is to know the Way.

What is the Way? There is no simple answer. Xunzi provides surprisingly few details.

道者, 古今之正權也, 離道而內自擇, 則不知禍福之所託 [=托]. 易者, 以一易一, 人曰得亦無喪也, 以一易兩, 人曰無喪而有得也, 以兩易一, 人曰無得而有喪也. 計者取所多, 謀者從所可, 以兩易一, 人莫之為, 明其數也. 從道而出, 猶以一易兩也, 奚喪? 離道而內自擇, 是猶以兩易一也, 奚得? (*X* 16.22.286 = K 22.6c)

In antiquity and the present, the Way is the correct balance. Leaving the Way and choosing personally [i.e. reckoning on a private scale] is not to know how catastrophe and fortune are measured. When a trader trades one for one, people say there is no gain and no loss. If he trades two for one, people there is no loss but gain. If he trades two for one, people say there is no gain but loss. Those who plan take [the alternative] that is greater; those who plot follow what is possible. Trading one for two—no one would do that, because [everyone] understands counting. To proceed by following the Way is like trading one for two. How could there be loss? Leaving the Way and choosing personally is like trading two for one. How could there be gain?

先王之道, 仁之隆也, 比中而行之. 曷謂中? 曰: 禮義是也. 道者, 非天之道, 非地之道, 人之所以道也, 君子之所道也. (*X* 4.8.77 = K 8.3)

The Way of the Former Kings is to exalt humanity, and follow the center and practice it. What is the center? It is ritual and morality. The Way is not the Way of Heaven or the Way of Earth; it is that by which people are led, what the noble man embodies.

The Way is not merely the intermingling of *yin* and *yang*, but the eternal and unchanging Way that governs all the processes of the cosmos. Xunzi avoids lengthy characterizations of the Way

because it is ultimately ineffable. We may come to understand the workings of the Way by performing the rituals, but the task of self-cultivation does not end there; for the rituals are but one manifestation of the multivalent Way. To practice the rituals and ignore all else would be to act as blindly as Mozi and the Hundred Schools, who knew one thing and could not integrate the rest. To become a sage, one must make oneself *dao*.

君子處仁以義, 然後仁也, 行義以禮, 然後義也, 制禮反本成末, 然後禮也. 三者皆通, 然後道也. (*X* 19.27.325 = K 27.21)

When the noble man has dwelt in humanity by means of righteousness, he is humane. When he has practiced righteousness by means of [conforming to] ritual, he is righteous. When he has formulated ritual by returning to the root [i.e. humanity and righteousness] and perfecting the branch [i.e. ritual], he [has attained] ritual. When he has mastered these three, he is Dao.

Another way of putting this, to use a term that we encountered earlier, is to say that the aim of the noble man is to be *cheng* 誠, to conform with the Way. To be *dao* is to know the baseness of one's unfiltered desires and to overcome them through self-restraint and fortitude; to choose the rituals and engage ceaselessly in the constant task of self-cultivation. To be *dao* is not to be seduced by simplistic characterizations of the world—that *yin* and *yang* determine events; that universal love will lead to universal salvation; that present gratification outweighs future concerns.

For the vastness of the Way cannot be tamed by comforting maxims. "To be insulted is no disgrace," exclaimed Song Keng, and with this pronouncement professed to have solved all the problems of human interaction. Bear insult stoically, and there will never be cause for strife. There is simply more to it than that, we hear Xunzi reply; not only is the argument fallacious on formal grounds, as we have seen—but it addresses only one corner of the noble edifice. Aspirants to sagehood cannot content themselves with having mastered the arts of diplomacy, or even patience in the face of ridicule. Xunzi enjoins us rather to inquire into the ontic presence that lies behind everything we see in the world—and then to bring ourselves into harmony with that force. It is not an undertaking to

be assumed lightly. Xunzi impresses it upon us repeatedly that taking this path amounts to the dedication of one's entire life to the project. But there is hope: the Sages were successful, and left behind a map to help us ford the river. These are the rituals, and the noble man cultivates them religiously.

Still, he must keep everything in its proper place. Though the rituals are invaluable as a map to the realm of the Way, they are, in the end, but a chart of the waters, a compass, or pole-star. Xunzi's noble man must recognize the function of ritual rather than be enslaved by it. However great a boon expertise in the rituals represents, it is still not humanity's final destination.[47] Heaven has an enduring Way 常道, a set of laws and forces that establish what one must do to be successful, and our project is to apprehend that Way and apply it to the advantage of humanity.

If this world view appears contrived, or fatalist, or curiously Sinitic, let us remember that an idea very similar to the Way was immensely popular in the period of our Enlightenment under the name, "natural law."[48] Xunzi's refutation of Shen Dao's legal positivism, after all, is analogous to that upheld even today by those who affirm some form of natural law: legislators ought not enact regulations merely as they like them. Some types of behavior are good, and some types bad; what is *unnatural* is bad.

Xunzi's fundamental message, then, is marked by a naturalistic piety. The Way is the one force that transcends the human will, and the noble man must learn to accept it and live in accordance with it, rather than deny it or rebel against it. We are granted two priceless gifts that enable us to fulfill our calling. These are the ancient rituals, and, more formidable still, our unfettered minds. By choosing the right path, and by accumulating through artifice the merit we were not born with, we can fuse our being with the all-encompassing Way.

Notes

Preface

1. For recent discussions of *junzi*, see e.g. Simon Leys, tr., *The Analects of Confucius* (New York and London: Norton, 1997), xxvif.; and Julia Ching, *Mysticism and kingship in China: The heart of Chinese wisdom*, Cambridge studies in religious traditions (Cambridge, 1997), 90–92.

2. The *Xinbian* 新編 *Zhuzi jicheng* edition of *Xunzi jijie*, edited by Shen Xiaohuan 沈嘯寰 and Wang Xingxian 王星賢, 2 volumes (Beijing: Zhonghua, 1988), was unavailable to me while I was writing this book.

3. This is not to suggest, however, that Pinyin (or Wade-Giles, for that matter) is more precise. A major flaw of Wade-Giles is that it does not distinguish between initial retroflex and palatal affricates. Thus the characters 春 and 群 are Romanized in Wade-Giles as *ch'un* and *ch'ün*, respectively, although the initial consonants are *not* identical. The former initial is retroflex, the latter palatal. But Pinyin has its corresponding drawbacks. Unvoiced, unaspirated initials are Romanized in Pinyin by their voiced counterparts. The character 大, for example, is Romanized in Pinyin as *da*, although the initial consonant is not voiced. Except for sonorants, in fact, Mandarin Chinese has no voiced consonants.

Introduction

1. The best modern biography is John Knoblock, *Xunzi: A Translation and Study of the Complete Works* (Stanford: Stanford University Press, 1988), I, 3–35; see also Hu Yuanyi 胡元儀 (1848–1907), *Xun Qing biezhuan* 郇卿別傳, reprinted in *X*, kaozheng 考證 B.25–38; You Guo'en 游國恩, "Xun Qing kao" 荀卿考, in *Gushi bian* 古史辨, ed. Luo Genze 羅根澤 *et al.* (Beiping: Jinshan shushe, 1926–37), IV, 94–104; Qian Mu 錢穆, "Xun Qing kao" 荀卿攷, *Gushi bian*, IV, 115–23; and Luo Genze, "Xun Qing youli kao" 荀卿遊歷考, *Gushi bian*, IV, 123–36. Whereas for most other collections of reprints I shall note the original bibliographical data (as given), in the case of the *Gushi bian*, since these articles are often substantially revised, and furthermore often appeared in journals that are now difficult to obtain, all such information is omitted here. The major classical biography is *Shiji* 史記 (Beijing: Zhonghua, 1959), 74.2348–50; see also the preface to *Xunzi* by Liu Xiang 劉向 (79–8 B.C.). Xun Kuang has sometimes—

though rarely in recent centuries—been referred to as Sun 孫 Kuang. The alternation is trivial until Xunzi ("Master Xun") is called Sunzi ("Master Sun"), by which name he may be confused with Sunzi or his supposed descendant Sun Bin 臏, the famous military strategists. It is curious, however, that the characters *xun* and *sun* should have been interchanged; they do not appear ever to have rhymed (despite the Romanizations, they do not rhyme today). In Old Chinese, *xun* was something like **zwyin*, while *sun* was **sun*; Old Chinese reconstructions in this study will generally follow William H. Baxter, *A Handbook of Old Chinese Phonology*, Trends in Linguistics Studies and Monographs 64 (Berlin and New York: Mouton de Gruyter, 1992), with some minor variations. Knoblock, I, 234ff., considers the question of Xunzi's family name in detail, and concludes that 孫 was substituted for the original 荀 in accordance with the custom of avoiding characters in imperial taboo-names. Cf. Yang Liang's commentary to *X* 4.8.75; and Yan Shigu's 顏師古 (581–645) commentary to *Hanshu* 漢書 (Beijing: Zhonghua, 1962), 23.1087—curiously referring to Xunzi as a native of Chu 楚. Recently Long Yuchun 龍宇純, "Xun Qing hou'an" 荀卿後捎, *Zhongyang Yanjiu Yuan Lishi Yuyan Yanjiusuo jikan* 中央研究院歷史語言研究所集刊 43 (1971), reprinted in Long's *Xunzi lunji* 荀子論集 (Taipei: Taiwan xuesheng, 1987), 1f., has discussed the same matter.

2. I borrow the term "live philosophical interest" from A.C. Grayling, *Berkeley: The Central Arguments* (La Salle, Ill.: Open Court, 1986), vii.

3. The oldest documentation, however, appears to be the notice at the very end of Lu Ji's 陸機 (A.D. 261–303) *Maoshi caomu niaoshou chongyu shu* 毛詩草木鳥獸蟲魚疏, in *Yingyin Wenyuan'ge Siku quanshu* 景印文淵閣四庫全書, LXX, B.18a.

4. On the indebtedness of the *Han Shi waizhuan* to Xunzi, as well as a translation of primary texts elucidating Xunzi's role in the transmission of the *Odes*, see e.g. James Robert Hightower, "The *Han Shih wai chuan* 韓詩外傳 and the *San chia Shih* 三家詩," *Harvard Journal of Asiatic Studies* 11.3/4 (1948), 241–310.

5. The seminal essay on Xunzi's part in transmitting the classical texts is Wang Zhong 汪中 (1745–1794), "Xun Qingzi tonglun" 荀卿子通論, *Shuxue buyi* 述學補遺, B.5b–14a, in *Jiangdu Wangshi congshu* 江都汪氏叢書 (Shanghai: Zhongguo shudian, 1925), reprinted in *X*, kaozheng B.14–25; see also Bernhard Karlgren, "The Early History of the Chou Li and Tso Chuan Texts," *Bulletin of the Museum of Far Eastern Antiquities* 3 (1931), 18ff.; and Feng Youlan 馮友蘭, "*Daxue* wei Xunxue shuo" 大學為荀學說, *Gushi bian*, IV, 175–83. Guo Moruo 郭沫若, "*Zhouguan* zhiyi" 周官質疑, in *Jinwen congkao* 金文叢考 (Beijing: Renmin, 1954), 49a–81b, argues that the *Zhouli* 周禮 too was probably compiled by a student of Xunzi. Li Fengding 李鳳鼎, "Xunzi chuanjing bian" 荀子傳經辨, *Gushi bian*, IV, 136–40, objects to Wang Zhong's arguments vehemently and at times unreasonably; his argument is that Xunzi cannot be credited with having participated in the transmission of texts that merely quote him. In any case, Xunzi's influence on the intellectual reception of the *Odes* seems to have

been substantial; see e.g. Steven Van Zoeren, *Poetry and Personality: Reading, Exegesis, and Hermeneutic in Traditional China* (Stanford: Stanford University Press, 1991), 74ff.; and Haun Saussy, *The Problem of a Chinese Aesthetic*, Meridian: Crossing Aesthetics (Stanford: Stanford University Press, 1993), 101f.

6. See e.g. Luo Genze, *Zhuzi kaosuo* 諸子考索 (Beijing: Renmin, 1958), 384: Xunzi is more "modern" than Mencius; Chen Daqi 陳大齊, *Xunzi xueshuo* 荀子學説, Xiandai guomin jiben zhishi congshu, 2nd series (Taipei: Zhonghua wenhua chuban shi weiyuanhui, 1954), 13: Xunzi's method is similar to that of modern science; Li Deyong 李德永, *Xunzi* 荀子 (Shanghai: Renmin, 1959), 16: Xunzi is scientific; Xu Junru 許鈞儒, *Xunzi zhexue* 荀子哲學, Changyan congshu (Taipei, 1971), 22: Xunzi is scientific; Hu Yuheng 胡玉衡 and Li Yu'an 李育安, *Xun Kuang sixiang yanjiu* 荀況思想研究 (Henan: Zhongzhou, 1983), 1: Xunzi is a materialist; Xiang Rengdan 向仍旦, *Xunzi tonglun* 荀子通論 (Fuzhou: Fujian jiaoyu, 1987), 71: Xunzi is rich in "affinity to the people" 人民性, a standard Communist compliment. Xia Zhentao 夏甄陶, *Lun Xunzi de zhexue sixiang* 論荀子的哲學思想 (Shanghai: Renmin, 1979), 73ff., explains Xunzi's view of human nature from the point of view of class conflict. In *Xun Kuang* 荀況 (Xi'an: Renmin, 1975), Kong Fan 孔繁 does not adequately justify his Marxist presuppositions. Against these arguments see e.g. Kanaya Osamu 金谷治, "Junshi no tenjin no bun ni tsuite" 荀子の天人の分について, *Shūkan tōyōgaku* 集刊東洋學 24 (1970), 5f., who makes the crucial observation that Xunzi's approach to Nature is *not* empiricist or scientific in a Western sense: for as soon as a moral lesson is to be gained, further observation of Nature ceases.

7. See e.g. *The Structure of Scientific Revolutions*, 2nd edition (Chicago: University of Chicago Press, 1970).

8. Cf. Wing-tsit Chan, "Syntheses in Chinese Metaphysics," in *The Chinese Mind: Essentials of Chinese Philosophy and Culture*, ed. Charles A. Moore, with the assistance of Aldyth V. Morris (Honolulu: University of Hawaii Press, East-West Center Press, 1967), 146.

9. With its unassuming nature and astonishing breadth, the *Xunzi zazhi* 荀子雜志, in *Dushu zazhi* 讀書雜志 (Jiangsu: Guji, 1985), compiled by Wang Niansun 王念孫 (1744–1832) with the aid of his son Wang Yinzhi 引之 (1766–1834), is indispensible and a personal favorite. This and virtually all other Chinese commentaries through the nineteenth century are included in Wang Xianqian's 王先謙 (1842–1918) *Xunzi jijie* 荀子集解 of 1891, reprinted in Zhongguo sixiang mingzhu (Taipei: Shijie, 1992). Japanese commentaries through the early nineteenth century are incorporated in Kubo Ai's 久保愛 (1759–1832) *Junshi zōchū* 荀子增注 of 1820. Some important twentieth-century Chinese commentaries are Liang Qixiong 梁啓雄, *Xunzi jianshi* 荀子柬釋 (Shanghai: Shangwu, 1936); Ruan Tingzhuo 阮廷焯, *Xunzi jiaozheng* 荀子斠證, Yuexiu shanfang congshu (Taipei, 1959); Zhang Heng 張亨, *Xunzi jiacuo zipu* 荀子假錯字譜, Wenshi congkan (Taipei: Guoli Taiwan Daxue Wenxue Yuan, 1963); Xiong Gongzhe 熊公哲, *Xunzi jinzhu jinyi* 荀子今註今譯 (Taipei: Shangwu, 1975);

Rao Bin 饒彬, *Xunzi yiyi jishi* 荀子疑義輯釋 (Taipei: Lantai, 1977); and three selective studies by Long Yuchun: "*Xunzi jijie* buzheng" 荀子集解補正, *Dalu zazhi* 大陸雜志 11 (1955), reprinted in Long's *Xunzi lunji* 125–72; "Du *Xun Qingzi* zhaji" 讀荀卿子札記, *Xianggang Zhongwen Daxue Chongji Shuyuan huaguo* 香港中文大學崇基書院華國 6 (1971), reprinted in *Xunzi lunji*, 173–222; and "Du *Xun Qingzi* sanji" 讀荀卿子三記, *Xunzi lunji* 223–325. Eighty-three Chinese and Japanese commentaries are reprinted in Yan Lingfeng 嚴靈峰, *Xunzi jicheng* 荀子集成 (Taipei: Chengwen, 1977). An overview of the commentarial history of the text appears in Knoblock, I, 105–20.

10. We know of only fourteen miniscule classical references to passages in the *Xunzi* that do not appear in the present text. A number of these, furthermore, may not be genuine; and most may not indicate quotations from the *Xunzi*, but oral traditions directly from the Master. See Knoblock, III, 288–92, who consolidates previous work on these fragments: Ruan Tingzhuo, "*Xunzi* tongkao" 荀子通考, *Dalu zazhi* 大陸雜志 34 (1967), 241–48; and Zhu Xuan 朱玄, "*Meng Xun* shu shi kao ji Meng Xun liezhuan shuzheng" 孟荀書十考及孟荀列傳疏證, *Guowen yanjiusuo jikan* 國文研究所集刊 10 (1966), 69–216.

11. Henri Maspero first pointed out this tradition: see e.g. "Le Roman de Sou Ts'in," *Etudes Asiatiques* 2 (1925), 127–41; revised as "Le Roman historique dans la littérature chinoise de l'antiquité," in *Mélanges posthumes sur les religions et l'histoire de la Chine*, Publications du Musée Guimet, Bibliotheque de Diffusion 57–60 (Paris: Civilisations du Sud, 1950), III, 53–62.

12. John H. Knoblock, "The Chronology of Xunzi's Works," *Early China* 8 (1982/3), 28–52, proposes the dates of ca. 310 B.C.–ca. 210 B.C. Knoblock's dates differ significantly from those in e.g. Qian Mu, *Xian-Qin zhuzi xinian* 先秦諸子繫年, 2nd edition, Canghai congshu (Hong Kong: Hong Kong University Press, 1956; rpt., Taipei: Dongda, 1990), sect. 103; Luo Genze, "Xun Qing youli kao"; and Long Yuchun, "Xun Qing hou'an," 17ff.; while agreeing in large part with those in You Guo'en, 103f.

13. Most biographies indicate that Xunzi's journey to Qi occurred in his fiftieth year, rather than in his fifteenth. But for the reading 十五 (rather than 五十), I follow Ying Shao's 應劭 (d. before A.D. 204) *Fengsu tongyi* 風俗通義: see Wang Liqi 王利器, *Fengsu tongyi jiaozhu* 校注 (Beijing: Zhonghua, 1981; rpt., Taipei: Mingwen, 1982), 7.322. See also Knoblock, "Chronology," 33f. Note that the age of fifteen *sui* 歲 means fourteen—or even thirteen—rather than fifteen years by Western reckoning, because a baby was said to have attained one *sui* at birth, and two *sui* at the advent of the next New Year, whether or not his first birthday had passed. A number of scholars, such as e.g. Luo Genze, "Xun Qing youli kao," 133, accept the idea that Xunzi went to Qi at the age of 50 *sui*.

14. Despite e.g. Zhao Jihui 趙吉惠, "Lun Xunxue shi Jixia Huang-Lao zhi xue" 論荀學是稷下黃老之學, *Daojia wenhua yanjiu* 道家文化研究 4 (1994), 103–17.

15. See e.g. Liang Qichao 梁啓超, "Xun Qing ji *Xunzi*" 荀卿及荀子, *Gushi*

bian, IV, 104–14; Hu Shi 胡適, *Zhongguo zhexueshi dagang* 中國哲學史大綱 (Shanghai: Shangwu, 1931), I, 306; Zhang Xitang 張西堂, "*Xunzi* zhenwei kao" 荀子真偽考, *Shixue jikan* 史學集刊 3 (1936), 165–236; Yang Yunru 楊筠 如, "Guanyu *Xunzi* benshu de kaozheng" 關於荀子本書的考證, in Yang's *Xunzi yanjiu* 荀子研究, Renren wenku 42/43 (Shanghai: Shangwu, 1931; rpt., Taipei: Shangwu, 1966), 15–27, reprinted in *Gushi bian*, VI, 120–46. Knoblock, I, 121ff., disagrees with all of the above sources, concluding that the traditional text is "in general" made up of authentic works by Xun Qing. But Knoblock's summary of Yang's study, in particular, is insufficient: he neglects to consider Yang's provocative, if tenuous, suggestion that much of the *Xunzi* was forged by Meng Qing 孟卿 and his son Meng Xi 孟喜 (both fl. first century B.C.), or by their associates; see also Yang, *Xunzi yanjiu*, 209f. Meng Xi is otherwise known as a transmitter of the *Yijing* 易經: see *Hanshu* 88.3597; and Fung Yu-lan, *A History of Chinese Philosophy*, tr. Derk Bodde, 2nd edition (Princeton: Princeton University Press, 1952), II, 109ff. Knoblock's opinion is similar to that of Long Yuchun, whom he does not cite: "*Xunzi* zhenwei wenti" 荀子真偽問題, *Zhongshan xueshu wenhua jikan* 中山學術文化集刊 30 (1983), reprinted in Long's *Xunzi lunji*, 25–53. Robert Eno, *The Confucian Creation of Heaven*: *Philosophy and the Defense of Ritual Mastery*, SUNY Series in Chinese Philosophy and Culture (Albany, 1990), 137, suggests that "the text as a whole should be viewed as the statement of a scholastic sect over the period of, say, 100 years, and analyzed in terms of the enduring interests of that sect, rather than in terms of any supposed political ambitions of its leader."

16. On Lao Dan, see A.C. Graham, "The Origins of the Legend of Lao Tan," in *Studies in Chinese Philosophy and Philosophical Literature*, SUNY Series in Chinese Philosophy and Culture (Albany, 1990), 111–24. On this point in general, with specific references to both the *Laozi* and *Heguanzi*, see Graham's *Disputers of the Tao*: *Philosophical Argument in Ancient China* (La Salle, Ill.: Open Court, 1989), 216.

17. *Han Shi waizhuan* (*Sibu congkan* 四部叢刊), 4.13b–15a; Liu Xiang 劉 向, *Zhanguo ce* 戰國策 (Shanghai: Guji, 1978; rpt., Taipei: Liren, 1990), 17.567. That Han Fei repeats part of the epistle, but without attributing it to Xun Kuang, may be reason enough to consider the whole anecdote spurious; Chen Qiyou 陳 奇猷, *Han Feizi jishi* 韓非子集釋, Zhongguo sixiang mingzhu (Beijing: Zhong-hua, 1958; rpt., Taipei: Shijie, 1991), 4.14.251f. The commentary of Gu Guangqi 顧廣圻 (1776–1835), 264, observes that the section is repeated in *Zhanguo ce* and *Han Shi waizhuan*, but does not draw any conclusions. On the other hand, the *fu* with which the *Zhanguo ce* and *Han Shi waizhuan* versions conclude appears in the received *Xunzi* (X 18.26.319f.) and hence may be genuine. Yangism refers to the philosophy ascribed to Yang Zhu 楊朱 (5th cent. B.C.) and his school— and may well have little to do with Yang Zhu's actual teachings. The core tenet of Yangism is the sanctity of the body. The entire Empire may not be worth possessing if its administration were to damage one's physical integrity.

18. *Shiji* 87.2547.

19. *Law's Empire* (Cambridge, Mass.: Harvard University Press, Belknap Press, 1986).

Chapter 1

1. I.A. Richards, *Mencius on the Mind: Experiments in Multiple Definition* (London: Routledge and Kegan Paul, 1932), 19, suggests that the sound is the "unpleasant sound of the child thudding down into the well, not the mere rumour or report of what has happened."

2. For the translation of *qing* 情 as "essence," see A.C. Graham, "The Background of the Mencian Theory of Human Nature," *Tsing Hua Journal of Chinese Studies* 6, no. 2 (1967), reprinted in Graham's *Studies in Chinese Philosophy and Philosophical Literature*, SUNY Series in Chinese Philosophy and Culture (Albany, 1990), 59ff. By the third century the meaning of the character had begun to change. Xunzi uses it in both senses, i.e. "essence" and "emotion"; Chad Hansen, "Qing (Emotions) 情 in Pre-Buddhist Chinese Thought," in *Emotions in Asian Thought: A Dialogue in Comparative Philosophy*, ed. Joel Marks and Roger T. Ames (Albany: State University of New York Press, 1995), 181–211, suggests that the *Xunzi* is in fact the source text for the derived sense of "emotion." See also Kwong-loi Shun, "Mencius and *Jen-hsing*," *Philosophy East and West* 47, no. 1 (1997), 6ff. Rendering *qing* uniformly as "emotion," however, can result in a misunderstanding of Xunzi. Chen Dengyuan 陳登元, *Xunzi zhexue* 荀子哲學, Guoxue xiao congshu (Shanghai: Shangwu, 1930), 156ff., for example, argues that Xunzi means *qing e* ("emotions are evil"), and not literally *xing e* ("human nature is evil"). This interpretation is neither tenable nor original: Jiang Kuizhong 姜奎忠, *Xunzi xing shan zheng* 荀子性善證 (N.p.: Xiangqiao shu, 1926), had earlier attempted to bring Xunzi into harmony with obsolescent orthodoxy, claiming that *xing e* really means *xing shan* ("human nature is good"), and that *qing* may be good or evil. My edition of Jiang's work bears a calendrical date that may refer to any year removed from 1926 by a multiple of sixty. Since Jiang quotes Chen Li 陳澧 (preface dated 1871), 1866 is not possible. The outline of Xunzi's philosophy in Edward T. Ch'ien, *Chiao Hung and the Restructuring of Neo-Confucianism in the Late Ming*, Neo-Confucian Studies (New York: Columbia University Press, 1986), 144ff., also reads *qing* as "emotion."

Finally, it is noteworthy that 情 in Old Chinese is the voiced counterpart of *qing* 清, "pure," a word with two cognates in Tibetan: *śiŋ*, "clear," and *śiŋs*, "pure." The initial voicing in 情 indicates an archaic prefix, probably with derivative force, yielding for 清 —"pure"— 情 —"that which is pure," "essence," etc. This interpretation makes apparent the connection with *jing* 精, "refined essence, quintessence," or "semen." The characters *sheng* 生, *xing* 性, *qing* 青, 清, and 情 might all be related; for the connection between 生 and 青, see Paul Rakita Goldin, "Some Old Chinese Words," *Journal of the American Oriental Society* 114, no. 4 (1994): 628–31.

3. *Lu Jiuyuan ji* 陸九淵集 (Beijing: Zhonghua, 1980), 35.470.

4. Mencius could hardly reply here that the American student had "lost his true mind" 失其良心 —for if every example contrary to his theory can be explained away as the result of a fault in the subject, the theory loses all power to convince.

5. See the account in the *Lunheng* 論衡 (*Discourses Weighed*) of Wang Chong 王充 (A.D. 27–ca. 100): Liu Pansui 劉盼遂, *Lunheng jijie* 集解, Zhongguo sixiang mingzhu (Beijing: Guji, 1957; rpt., Taipei: Shijie, 1990), 3.13.62.

6. Cf. Tang Junyi 唐君毅, *Zhongguo zhexue yuanlun* 中國哲學原論: *Daolun pian* 道論篇, 2nd edition (Hong Kong: Xinya, 1974), 263ff.; and Robert E. Allinson, "A Hermeneutic Reconstruction of the Child in the Well Example," *Journal of Chinese Philosophy* 19, no. 3 (1992): 298ff. The example of the well contradicts the claim of Herrlee G. Creel, *Chinese Thought from Confucius to Mao Tse-tung* (Chicago: University of Chicago Press, 1953), 87, that Mencius preached enlightened self-interest; cf. Bryan W. Van Norden, "Mengzi and Xunzi: Two Views of Human Agency," *International Philosophical Quarterly* 32, no. 2 (1992): 161–84.

7. Various commentators have proposed numerous unnecessary corrections to the text; e.g. 文 for 分; 縱 for 從. My practice will be in general to avoid altering the text, making exceptions only for obvious errors or lost radicals.

8. The translation of *yi* 義 as "morality" for Xunzi requires some justification. Mencius uses it exclusively as an aretaic term; hence for that thinker I retain the conventional rendering of "righteousness." But it has been observed that Xunzi associates the term repeatedly with *li* 禮, by which he doubtless means "ritual" or "convention," and also with *fen* 分, or "[social] division." See e.g. A.S. Cua, "Hsun-tzu and the Unity of Virtues," *Journal of Chinese Philosophy* 14, no. 4 (1987): 386ff.; and Hoyt Cleveland Tillman, *Ch'en Liang on Public Interest and the Law*, Monographs of the Society for Asian and Comparative Philosophy 12 (Honolulu: University of Hawaii Press, 1994), 23ff. *Yi* is a social phenomenon which comes about through the practice of the proper conventions. Thus "morality," with its root sense of "conventionality" (Latin *mos* and *moralis*), recommends itself.

9. Homer H. Dubs, *Hsüntze: The Moulder of Ancient Confucianism*, Probsthain's Oriental Series 15 (London, 1927), 83, compares Jie colorfully to Nero. Dubs's work should be read in conjunction with J.J.L. Duyvendak, "Notes on Dubs' Translation of *Hsün Tzu*," *T'oung Pao* 29 (1932): 1–42. See also Duyvendak's "Hsün-tzu on the Rectification of Names," *T'oung Pao* 23 (1924): 221–54.

10. On this point see e.g. David Shepherd Nivison, "Mencius and Motivation," in *Studies in Classical Chinese Thought*, ed. Henry Rosemont, Jr., and Benjamin Schwartz, *Journal of the American Academy of Religion* 47, no. 3, Thematic Issue S (1979): 417–32.

11. This observation goes back to Dai Zhen 戴震 (1724–1777), in his discussion of Xunzi in *Mengzi ziyi shuzheng* 孟子字義疏證 (Beijing: Zhonghua, 1961), B.31f., translated in Ann-Ping Chin and Mansfield Freeman, *Tai Chen on*

Mencius: *Explorations in Words and Meaning* (New Haven: Yale University Press, 1990), 124f. Dai Zhen believed that ritual and morality 禮義 emerged from the *xing* and were transmitted by the Sage Kings; that according to Xunzi, the Sage Kings *invented* ritual and morality; and that therein lay Xunzi's error.

12. Thus Graham, *Disputers*, 250.

13. Cf. Chen Li 陳澧, *Dongshu dushu ji* 東塾讀書記 (Shanghai: Shangwu, 1930), 3.2. D.C. Lau, "Theories of Human Nature in *Mencius* and *Shyuntzyy*," *Bulletin of the School of Oriental and African Studies* 15, no. 3 (1953): 541–65, expands on Chen's observations. A.S. Cua argues that the theories of Mencius and Xunzi complement rather than contradict each other. See e.g. "The conceptual aspect of Hsün Tzu's philosophy of human nature," *Philosophy East and West* 27, no. 4 (1977): 373–90; and "The quasi-empirical aspect of Hsun-Tzu's philosophy of human nature," *Philosophy East and West* 28, no. 1 (1978): 3–20.

14. E.g. Xu Fuguan 徐復觀, *Zhongguo renxing lun shi* 中國人性論史 (T'ai-chung: Sili Donghai daxue, 1963); Zhang Dainian 張岱年, *Zhongguo zhexue dagang* 中國哲學大綱 (Beijing: Zhongguo Shehui Kexue Yuan, 1982), 250ff.

15. Despite Donald J. Munro, *The Concept of Man in Early China* (Stanford: Stanford University Press, 1969), 214n46. Fu Sinian 傅斯年, *Xing ming guxun bianzheng* 性命古訓辨證 (Shanghai: Shangwu, 1947), A.40b, justly observes that 性 was not distinguished graphically from 生 until relatively late. But we cannot confuse graphs with words; two different words have commonly been represented in Chinese by the same graph. The fact that the two words came to be distinguished by the addition of the 心 radical in the case of 性 indeed indicates that there had been two distinct words all along. The Old Chinese form of 生 is clearly *sreng, while 性 appears to have a medial glide (*-y-). It has been suggested that the archaic medial *-r- served some morphological purpose in proto-Chinese or even Old Chinese: see e.g. Laurent Sagart, "L'infixe -r- en chinois archaïque," *Bulletin* 88, no. 1 (1993): 261–93, and Tsu-lin Mei, "Notes on the Morphology of Ideas in Ancient China," in *The Power of Culture: Studies in Chinese Cultural History*, ed. Willard T. Peterson *et al.* (Hong Kong: The Chinese University Press, 1994), 44.

16. Cf. Graham, "Background," 8ff.; Tang Junyi, *Zhongguo zhexue yuanlun*: *Yuanxing pian* 原性篇, (Hong Kong: Xinya, 1968), 3ff.

17. Guo Qingfan 郭慶藩, *Zhuangzi jishi* 莊子集釋, ed. Wang Xiaoyu 王孝魚, Xinbian Zhuzi jicheng, Series 1 (Beijing: Zhonghua, 1982), 4B.9.334.

18. Liu Wendian 劉文典, *Huainan Honglie jijie* 淮南鴻烈集解, ed. Feng Yi 馮逸 and Qiao Hua 喬華, Xinbian Zhuzi jicheng, Series 1 (Beijing: Zhonghua, 1989), 13.436. This is of course the Yangist credo. Graham, "Background," 9ff., offers many more examples; I have chosen two illustrative ones.

19. It was accepted, incidentally, by other members of the ancient Chinese philosophical community that the *xing* of an object may be altered or damaged by external interference with it; see e.g. Xu Weiyu 許維遹, *Lüshi chunqiu jishi* 呂氏春秋集釋, Zengding Zhongguo xueshu mingzhu, Series 1; Zengbu Zhongguo

sixiang mingzhu 19 (Beijing: Guoli Qinghua Daxue, 1935; rpt., Taipei: Shijie, 1988), 1.6b: 夫水之性清，土者拍之，故不得清 (Water's nature is clear. Mud dirties it; thus it does not obtain clarity). The passage continues (7a), moreover, to suggest that it is human nature to live long 壽.

20. This observation is likewise from Dai Zhen, B.25.

21. Cf. e.g. P.J. Ivanhoe, "Thinking and Learning in Early Confucianism," *Journal of Chinese Philosophy* 17, no. 4 (1990): 480ff.

22. The difference between *ren xing* and *ren zhi suoyi wei ren zhe* is implicit in Li Shuyou, "On Characteristics of Human Beings in Ancient Chinese Philosophy," *Journal of Chinese Philosophy* 15, no. 3 (1988): 233ff. Again I must disagree with Munro, who, in the face of the above, concludes that "the portrait of the human *xing* in the *Xunzi*, in spite of definite individual features, is consistent with that in the *Mencius*" (80).

23. Cf. P.J. Ivanhoe, "Human Nature and Moral Understanding in Xunzi," *International Philosophical Quarterly* 34, no. 2 (1994): 167–76, rejecting explicitly the straightforward interpretation of Homer H. Dubs, "Mencius and Sun-dz on Human Nature," *Philosophy East and West* 6 (1956): 213–22: Mencius thought human nature was good, Xunzi that it was evil. Ivanhoe objects as well to the compatibilist view of Cua. Dubs is preceded in any case by others, e.g. Fung, I, 288; and Yu Jiaju 余家菊, *Xunzi jiaoyu xue* 荀子教育學 (Shanghai: Zhonghua, 1935), 23. But the notion persists: see e.g. Chen Zhengxiong 陳正雄, *Xunzi zhengzhi sixiang yanjiu* 荀子政治思想研究 (Yungho: Wenjin, 1980), 78f.

24. Roger T. Ames, "The Mencian Conception of *Renxing*: Does it Mean 'Human Nature?'" in *Chinese Texts and Philosophical Contexts*, Critics and Their Critics 1, ed. Henry Rosemont, Jr. (La Salle, Ill.: Open Court, 1991), 143–75, is informed by the notions of "correlativity" and "transcendence" articulated in David L. Hall and Roger T. Ames, *Thinking Through Confucius*, SUNY Series in Systematic Philosophy (Albany, 1987), 12ff. In the present article, Ames criticizes scholars who attribute a "transcendent" dimension to *xing* — in other words, scholars who identify in human nature an immutable element imparted by Heaven, such as Tu Wei-ming, "On the Mencian Perception of Moral Self-Development," in Tu's *Humanity and Self-Cultivation*: *Essays in Confucian Thought* (Berkeley: Asian Humanities Press, 1979), 63. Ames maintains instead that *xing* must contain a notion of correlativity, although for Xunzi *xing* is a transcendent concept in this sense. See also David L. Hall and Roger T. Ames, *Anticipating China*: *Thinking Through the Narratives of Chinese and Western Culture* (Albany: State University of New York Press, 1995), 24, and 188ff. Irene Bloom, "Mencian Arguments on Human Nature (*Jen-hsing*)," *Philosophy East and West* 44, no. 1 (1994): 20, argues against Ames: "*renxing does* mean 'human nature'" — but, as we have seen, this is not quite accurate either. See also Bloom's "Human Nature and Biological Nature in Mencius," *Philosophy East and West* 47, no. 1 (1997): 21–32.

25. Kanaya Osamu 金谷治, "*Junshi* no bunkengaku teki kenkyū" 荀子の文獻學的研究, *Gakushiin kiyō* 學士院紀要 9, no. 1 (1951): 9–33, points out that

e hardly ever appears in the other chapters of the book, and may be a *façon de parler*. Kanaya's idea goes back to Guo Moruo, "Xunzi de pipan" 荀子的批判, in *Shi pipan shu* 十批判書, Moruo wenji, series 1, no. 2 (Shanghai: Qunyi, 1946), 195; and even Hu Shi, I, 317.

26. Cf. Philip J. Ivanhoe, *Confucian Moral Self Cultivation*, The Rockwell Lecture Series 3 (New York: Peter Lang, 1993), 40n.11.

27. For a discussion of Xunzi's conception of the state influenced by Popperian philosophy, see Henry Rosemont, Jr., "State and Society in the *Hsün Tzu*: A Philosophical Commentary," *Monumenta Serica* 29 (1970–71): 38–78.

28. Knoblock, II, 341n.2, remarks that minerals were said to be *mei* 美 if they corresponded auspiciously to the seasons. See, in addition to Knoblock's sources, Dai Wang 戴望, *Guanzi jiaozheng* 管子校正, in *Guanzi Shangjun shu* 商君書, Zhongguo sixiang mingzhu (Taipei: Shijie, 1990), 8.20.125; and *Guoyu* 國語 (Shanghai: Guji, 1978; rpt., Taipei: Liren, 1981), 6.240.

29. For the tale of the smith's wife Moye, who cast her hair and fingernails into the furnace, creating a sword named after her, see *Wu Yue chunqiu* 吳越春秋, Wanyou wenku (Shanghai: Shangwu, 1937), 2.42ff. The most recent discussion of the tale is Donald B. Wagner, *Iron and Steel in Ancient China*, Handbuch der Orientalistik; vierte Abteilung: China, neunter Band (Leiden: E.J. Brill, 1993), 113ff. Lionello Lanciotti, "Sword Casting and Related Legends in China, Part I," *East and West* 6, no. 2 (1955): 106–14, suggested that origin of this legend "is not purely Chinese," and that the characters for Moye and her husband Ganjiang 干將 are transliterations of foreign names. Similarly, Wagner believes that the languages of the Wu and Yue states may have been Austronesian; cf. Wagner's "The Language of the Ancient Chinese State of Wu," *East Asian Institute Occasional Papers* 6 (1990): 161–76. See also Anne Birrell, *Chinese Mythology: An Introduction* (Baltimore and London: Johns Hopkins University Press, 1993), 221ff.

30. The example of the indigo is common in early Chinese philosophy: cf. *Han Shi waizhuan*, 5.14a; and James Robert Hightower, *Han Shih wai chuan: Han Ying's Illustrations of the Didactic Application of the* Classic of Songs, Harvard-Yenching Institute Monograph Series 11 (Cambridge, Mass., 1952), 183n.2. Knoblock, I, 126, lists parallels to Xunzi's "Exhortation to Learning," from which this quotation is taken.

31. The triple self-examination 三省 is explained in *Analects* 1.4: 曾子曰：吾日三省吾身，為人謀，而不忠乎，與朋友交，而不信乎，傳不習乎—Zengzi said: I daily examine myself trebly: whether I have not been faithful in dealings with others; whether I have not been trustworthy in contacts with friends; whether I have not practiced what I transmit.

32. Cf. *Mencius* 1.1.5.2.

33. Huang Zongxi 黃宗羲, *et al.*, *Song-Yuan xue an* 宋元學案, Guoxue jiben congshu (Shanghai: Shangwu, 1936), 1.35.

34. Cf. Tang Junyi, *Yuanxing pian*, 53.

35. The "Discourse on Ritual," from which this quotation is taken, was incorporated with few changes in *Shiji* 23. For a parallel to this passage, see 23.1161.

36. *The Methods of Ethics*, 7th edition (Chicago: University of Chicago Press, 1962), 381.

37. Cf. Mencius 7.1.1.

38. See e.g. Luke J. Sim, S.J., with James T. Bretzke, S.J., "The Notion of 'Sincerity' (*Ch'eng*) in the Confucian Classics," *Journal of Chinese Philosophy* 21, no. 2 (1994): 179–212, for a survey of some of the implications of *cheng*. The stock-translation "sincerity" is not so much inaccurate as misleading to those unfamiliar with the context; on the basis of this rendering, Stephen R.L. Clark, *Aristotle's Man: Speculations upon Aristotelian Anthropology* (New York: Oxford University Press, 1975), I.16 and V.3.9, for example, draws between *cheng* and certain ideas in Aristotle (384/3–322/1 B.C.) parallels that are entirely anachoristic.

39. For a similar interpretation, see Tu Wei-ming, *Centrality and Commonality: An Essay on Confucian Religiousness*, SUNY Series in Chinese Philosophy and Culture, revised edition (Albany, 1989), 70ff.

40. Cf. Mou Zongsan 牟宗三, *Xunxue dalue* 荀學大略 (1953), reprinted in Mou's *Mingjia yu Xunzi* 名家與荀子, Xinya Yanjiusuo congkan (Taipei: Xuesheng, 1979), 213ff.; and Wei Zhengtong 韋政通, *Xunzi yu gudai zhexue* 荀子與古代哲學, Renren wenku 68/69 (Taipei: Shangwu, 1966), 42–79, esp. 61ff. Xunzi may be borrowing an older proverb here, since we read in *Lushi chunqiu jishi* 1.6a: "What first gives birth to it is Heaven; what nourishes and completes it is man" 始生之者, 天也, 養成之者, 人也; cf. also the saying attributed to Fan Li 范蠡, a contemporary of Confucius, in *Guoyu* 21.646: "Heaven relies on man; the Sage relies on Heaven. Man gives birth to it himself; Heaven and Earth make it apparent [i.e. respond to it with good or bad omens]; the Sage relies on it and completes it" 天因人, 聖人因天, 人自生之, 天地形之, 聖人因而成之. There are, of course, serious philosophical differences between Xunzi and Fan Li as he is presented in the *Guoyu*.

41. An enticing parallel to Xunzi's threefold functions of the mind is the trinity laid out by St. Augustine: *memoria, intelligentia,* and *voluntas*: *De Trinitate*, which makes up the 15th and 16th volumes of *Oeuvres de Saint Augustin*, Bibliothèque Augustinienne (Paris: Desclee de Brouwer, 1941–), X.xi.17 *et passim*. *Memoria* refers to the capacity to know without thinking consciously (*nosse*), *intelligentia* to the capacity to think actively (*cogitare*): ". . . neque enim multarum doctrinarum peritum, ignorare grammaticum dicimus, cum eam non cogitat, quia de medicinae arte tunc cogitat" ("For we do not say of one learned in many disciplines, that he does not know grammar while he is not thinking of it, because he is thinking of the art of medicine)—X.v.7. *Voluntas* is the faculty that conjoins *memoria* and *intelligentia*. Augustine's terms do not match those of Xunzi one for one. Xunzi subsumes both active and dormant knowledge under unity, while Xunzi's property of unlimited storage has no precise analogue in Augustine, though it represents a facet of *memoria*.

42. Cf. Willard Van Orman Quine, "Identity, Ostension, and Hypostasis," in *From a Logical Point of View: 9 Logico-Philosophical Essays*, 2nd edition (Cambridge, Mass., and London: Harvard University Press, 1980), 65.

43. E.g. Du Guoxiang 杜國庠, "Xunzi cong Song Yin Huang-Lao xuepai jieshoule shenme?" 荀子從宋尹黃老學派接受了甚麼? in *Du Guoxiang wenji* 文集 (Beijing: Renmin, 1962), 134–57; Janet A.H. Kuller, "The 'Fu' of the *Hsün Tzu* as an Anti-Taoist Polemic," *Monumenta Serica* 31 (1974–75): 205–18; Janet A.H. Kuller, "Anti-Taoist Elements in Hsün Tzu's Thought and their Social Relevance," *Asian Thought and Society* 3, no. 7 (1978): 53–67; Lee H. Yearley, "Hsün Tzu on the Mind: His Attempted Synthesis of Confucianism and Taoism," *Journal of Asian Studies* 39, no. 3 (1980): 465–80; Heiner Roetz, *Mensch und Natur im alten China: Zum Subjekt-Objekt-Gegensatz in der klassischen chinesischen Philosophie, zugleich eine Kritik des Klischees vom chinesischen Universalismus*, Europäische Hochschulschriften, Reihe 20 (Philosophie), Bd. 136 (Frankfurt: Peter Lang, 1984), 363ff.; and David S. Nivison, "Hsun Tzu and Chuang Tzu," in Rosemont, *Chinese Texts*, 129–42. The idea goes back at least to A. Forke, *Geschichte der chinesischen Philosophie* (Hamburg: Friederichsen, 1927), 216. Du's attributions of parts of the *Guanzi* to Song Keng and Yin Wen 尹文 rest on Guo Moruo, *Qingtong shidai* 青銅時代 (Beijing: Kexue, 1957), 245ff.; cf. Graham, *Studies*, 317; cf. Li Cunshan 李存山, "Neiye deng si pian de xuezuo shijian he zuozhe" 內業等四篇的學作時間和作者, *Guanzi xuekan* 管子學刊 1987.1, 31–37. But see also Takeuchi Yoshio 武內義雄, *Kanshi no Shinjutsu to Naigyō* 管子の心術と內業, *Shinagaku* 支那學, supplement 10 (1958); and, most recently, Zhang Dainian, "*Guanzi* de 'Xinshu' deng pian fei Song Yin zhuzuo kao" 管子的心術等篇非宋尹著作考, *Daojia wenhua yanjiu* 2 (1992): 320–26.

44. *Zhuangzi jishi* 3B.7.307. The *Zhuangzi* does not appear to have reached its final form until around 130 B.C.: see Harold Roth, "Who Compiled the *Chuang Tzu*?" in Rosemont, *Chinese Texts*, 122. Nevertheless the inner chapters are by all accounts centuries older than the later parts of the text.

45. *Zhuangzi jishi* 1B.2.56.

46. *Leviathan*, ed. C.B. Macpherson (New York: Penguin, 1968), VII.31. This edition retains the spelling and punctuation of the original, and is therefore superior to that in *The English Works of Thomas Hobbes*, ed. Sir William Molesworth (London: John Bohn, 1839–45). I shall cite passages from *Leviathan* according to the pagination of the first edition, 1651.

47. Cf. R.E. Ewin, *Virtues and Rights: The Moral Philosophy of Thomas Hobbes* (Boulder: Westview, 1991), 42ff.; and Richard Tuck, *Hobbes*, Past Masters (Oxford: Oxford University Press, 1989), 57.

48. On the difference between the understanding of *chengxin* 成心 in *Zhuangzi* and Confucianism, see e.g. Lisa Raphals, "Skeptical Strategies in the *Zhuangzi* and *Theaetetus*," *Philosophy East and West* 44, no. 3 (1994), reprinted in *Essays on Skepticism, Relativism, and Ethics in the* Zhuangzi, ed. Paul Kjellberg and Philip J. Ivanhoe, SUNY Series in Chinese Philosophy and Culture (Albany, 1996),

31f. The point goes back to Wang Fuzhi 王夫之 (1619–1692); see his *Zhuangzi jie* 解 (Beijing: Zhonghua, 1961), 16.

49. *Zhuangzi jishi* 1B.2.112.

50. *Zhuangzi jishi* 3A.6.275. The attribution, though doubtful, is to Confucius.

51. *Zhuangzi jishi* 1B.2.104.

52. The intellectual roots of modern phenomenalism go back to the immaterialism of George Berkeley (1685–1753); see especially *The Principles of Human Knowledge* and *Three Dialogues between Hylas and Philonous*, in A.A. Luce and T.E. Jessop, eds., *The Works of George Berkeley, Bishop of Cloyne*, 9 vols. (London and Edinburgh: Nelson, 1948–57). A.C. Grayling, *The Refutation of Scepticism* (La Salle, Ill.: Open Court, 1985), 27f., constructs (and rejects) an argument much like Zhuangzi's. Grayling's thesis is that human beings *must* assent to certain truths about the universe, because they *must* eat and breathe. See also David Hume, *A Treatise of Human Nature*, ed. L.A. Selby-Bigge, revised by P.H. Nidditch, 2nd edition (Oxford: Clarendon, 1978), I.iv.i.185ff.

53. Cf. *Da Dai Liji* (*Sibu congkan*), 7.7af.

54. Cf. e.g. *Mu tianzi zhuan* 穆天子傳 (*Sibu beiyao* 四部備要) 1.4a.; Zhang Zhan 張湛, *Liezi zhu* 列子注, in *Zhuangzi jijie* 莊子集解 *Liezi zhu*, Zhongguo sixiang mingzhu (Taipei: Shijie, 1992), 3.32. The *Liezi* is now widely considered to be a forgery of the first millennium A.D. See e.g. A.C. Graham, "The Date and Composition of *Liehtzyy*," *Asia Major* 11, no. 2 (1965), reprinted in Graham's *Studies*, 216–82. For the dating of parts of the *Mu tianzi zhuan* (but not this passage) to a period several centuries after the Warring States period, see Rémi Mathieu, *Le Mu tian-zi zhuan*, Mémoires de l'Institut des Hautes Etudes Chinoises 9 (Paris, 1978). For another late account of the myth, see the text adduced by Birrell, 236f.

55. Also the home of the dead: see *Zuozhuan* 佐傳 (Legge) Yin 隱 1 = 721 B.C., 2.

56. Cf. Guo Moruo, *Shi pipan shu*, 190; Y.P. Mei, "Hsun Tzu's Theory of Education," *Qinghua xuebao* 清華學報 2, no. 2 (1961): 361–79.

57. I hesitate to use the word "Daoist" in this connection as this aoristic term can cover anything from epistemology and cosmography to meditation and yoga; cf. Nathan Sivin, "On the Word 'Taoist' as a Source of Perplexity: With Special Reference to the Relations of Science and Religion in China," *History of Religions* 17 (1978): 303–30. The connections between Religious Daoist traditions of later centuries and the supposed "Daoism" of Laozi are attested by the many Religious Daoist sects that venerated Laozi as a sage or deity; cf. e.g. Holmes Welch, *Taoism: The Parting of the Way*, revised edition (Boston: Beacon, 1965), esp. 88ff. But for the period before the rise of Religious Daoism, the term is best avoided. See also Harold D. Roth, "Psychology and Self-Cultivation in Early Taoistic Thought," *Harvard Journal of Asiatic Studies* 51, no. 2 (1991): 604ff.

A more precise name for what I have in mind may be Huang-Lao, over which, however, there prevails among scholars only disagreement. R.P. Peerenboom, *Law*

and Morality in Ancient China: The Silk Manuscripts of Huang-Lao, SUNY Series in Chinese Philosophy and Culture (Albany, 1993), is now the most thorough inquiry, elucidating in particular a naturalistic approach to law in the Huang-Lao texts. Peerenboom associates Huang-Lao exclusively with what he has called "foundational naturalism," and refuses categorically to accept as Huang-Lao anything that does not correspond to this concept. However, at times this characterization appears too rigid—as when Peerenboom excludes from Huang-Lao the idea that "the right way to govern depends on the particular circumstances"; for immediately thereafter, he affirms that according to Huang-Lao, "one must wage war when the time is right" (351n.14).

The figure of Shen Dao 慎到 (fl. 310 B.C.) illustrates the tangled complexus of Huang-Lao. The *Shiji* (74.2347) mentions unmistakably that he studied Huang-Lao, and more than one contemporary scholar has appraised his philosophy as commensurate with that line of thinking (but not Peerenboom, 229ff.); see e.g. D.C. Lau, *Lao Tzu Tao Te Ching* (New York: Penguin, 1963), 48ff.; Jiang Ronghai 江榮海, "Shen Dao ying shi Huang-Lao sixiangjia" 慎到應是黃老思想家, *Beijing Daxue xuebao* 北京大學學報 1 (1989), 110–16. Nevertheless Shen Dao's extant *oeuvre* indicates that he was a legal *positivist* with little to say on nature and cosmic forces. See P.M. Thompson, *The Shen-tzu Fragments*, London Oriental Series 29 (Oxford: Oxford University Press, 1979), 242: 法雖不善, 猶愈於無法—roughly, "Though a law be not good, it is still preferable to no law"; 278: 治國, 無其法則亂—"In governing a country, without laws there will be chaos"; etc. The first quotation in particular is irreconcilable with a naturalism maintaining that only laws in accordance with a certain pre-ordained order may have normative value. In other words, the house of Huang-Lao appears to have contained under its roof both legal positivists and legal naturalists. For a definition of legal positivism, see e.g. H.L.A. Hart, *The Concept of Law*, Clarendon Law Series (Oxford, 1961), 253f.

For more on early Chinese naturalism, see e.g. Léon Vandermeersch, *La formation du Légisme: Recherche sur la constitution d'une philosophie politique caractéristique de la Chine ancienne*, Publications de l'Ecole Française d'Extrême-Orient 56 (Paris, 1965), 204; and Karen Turner, "War, Punishment, and the Law of Nature in Early Chinese Concepts of the State," *Harvard Journal of Asiatic Studies* 53, no. 2 (1993): 285–324.

58. The examples cited in the following pages are representative only. See also e.g. *Lüshi chunqiu jishi* 5.4bff.

59. Ma Xulun 馬敘倫, *Laozi jiaogu* 老子校詁 (Beijing: Guji, 1956), 1.46f. Many editions have 抱 for 裒; Bi Yuan's 畢沅 (1730–1797) commentary *ad loc.* suggests that the latter is a better reading. A similar passage is attributed to the *Laozi* by *Zhuangzi jishi* 8A.23.785; cf. also *Guanzi jiaozheng* 13.37.222; 16.49.271.

60. With Wing-tsit Chan, *The Way of Lao Tzu*, The Library of Liberal Arts (Indianapolis and New York: Bobbs-Merrill, 1963), 116f. The first character is

not excrescent or misplaced (*contra* many commentators), as the phrase *zai ying po* 載營魄 appears in the *Chuci* 楚辭 (*Elegies of Chu*): Hong Xingzu 洪興祖, *Chuci zhangju buzhu* 楚辭章句補注, ed. Chen Zhi 陳直, in *Chuci zhu bazhong* 楚辭注八種, Zhongguo wenxue mingzhu (Taipei: Shijie, 1989), 5.99, where the commentary of Wang Yi 王逸 (fl. A.D. 120) indicates that *ying po* represents *hun po* 魂魄, or the spiritual and corporeal souls. I follow Chan, and indirectly Wang, but with some misgivings: 載營魄 can easily mean "carrying and regulating the *po*." It is of course futile to address the question, as a number of commentators do, of which text borrowed the phrase from the other, especially since *neither* text can be assigned a firm date, and since either text may have drawn from a third source. For the complexities of the provenance of the *Chuci*, see e.g. David Hawkes, *The Songs of the South: An Ancient Chinese Anthology of Poems by Qu Yuan and other Poets*, 2nd edition (New York: Penguin, 1985), 28ff. Some traditions emend *zai* 載 to *dai* 戴, although in this case too the meaning is far from transparent. Victor H. Mair, *Tao Te Ching: The Classic Book of Integrity and the Way* (New York: Bantam, 1990), suggests that *dai* functions as an initial aspectual auxiliary (thus: "while").

61. *Laozi jiaogu* 2.81. Most other editions again have 抱 for 裒.

62. *Laozi jiaogu* 3.119f.

63. There is considerable commentarial disagreement over whether 貞 should read 正 or even 政—which would yield, " . . . to become the governors [of all] under Heaven."

64. *Laozi jiaogu* 3.128. Once again, 抱 is a frequent variant for 裒, as is 背 for 負.

65. For an overview of *yin* and *yang* in classical Chinese thought, see e.g. Nathan Sivin, *Traditional Medicine in Contemporary China*, Science, Medicine, & Technology in East Asia 2 (Ann Arbor: Center for Chinese Studies, University of Michigan, 1987), 55ff.

66. Kristofer Schipper, *The Taoist Body*, tr. Karen C. Duval (Berkeley: University of California Press, 1993), 130ff., traces the development of the idea of "keeping the One" in the *Laozi* into Religious Daoist sexual techniques aimed at preserving the body's seminal essence.

67. For preliminary studies of this rich but poorly understood text, see Carine Defoort, *The Pheasant Cap Master (He guan zi): A Rhetorical Reading*, SUNY Series in Chinese Philosophy and Culture (Albany, 1997); A.C. Graham, "A Neglected Pre-Han Philosophical Text: *Ho-kuan-tzu*," *Bulletin of the School of Oriental and African Studies* 52, no. 3 (1989): 497–532; Graham's "The Way and the One in *Ho-kuan-tzu*," in *Epistemological Issues in Classical Chinese Philosophy*, SUNY Series in Chinese Philosophy and Culture, ed. Hans Lenk and Gregor Paul (Albany, 1993), 31–43; revised as "A Chinese Approach to Philosophy of Value: *Ho-kuan-tzu*," in Graham's *Unreason within Reason* (La Salle, Ill.: Open Court, 1992), 121–35; and R.P. Peerenboom, "*Heguanzi* and Huang-Lao Thought," *Early China* 16 (1991): 169–86, who considers the text to be compatible with Huang-Lao. The date of the *Heguanzi* is not certain; but even if the text

is in fact later than Xunzi, its use of the One represents an older idea. See also Ōgata Toru 大形徹, "*Kakkanshi*—fukyū no kokka o gensō shita inja no hon" 鶡冠子—不朽の國家を幻想した隱者の本, *Tōhō shūkyō* 東方宗教 59 (1982): 43–65. Peerenboom, *Law and Morality*, 273–83, credits Lu Dian 陸佃 (1042–1102) with the first categorization of the *Heguanzi* as Huang-Lao, although Han Yu 韓愈 (768–824) had done so centuries earlier—see "*Du Heguanzi*" 讀鶡冠子, in *Han Changli wenji jiaozhu* 韓昌黎文集校注, ed. Ma Qichang 馬其昶 (Shanghai: Guji, 1986), 37f., also reprinted in Lu Dian, *Heguanzi jie* 解, in *Heguanzi deng niansan zhong* 等廿三種, Zengding Zhongguo xueshu mingzhu, Series 1; Zengbu Zhongguo sixiang mingzhu 12 (Taipei: Shijie, 1979), pref. 2a.

68. *Heguanzi* A.5.15af.

69. *Heguanzi* A.5.18af.

70. Cf. Defoort, 125ff.

71. *Heguanzi* A.5.19af.

72. Following throughout the commentary of Lu Dian. The original is terse, puzzling, and garbled. 空 may be an error for 同; 天 for 夫; 社 for 杜; etc.

73. *Heguanzi* A.5.18bf.

74. The most judicious discussion is W. Allyn Rickett, *Kuan-Tzu* (Hong Kong: Hong Kong University Press, 1965), 155f.

75. *Guanzi jiaozheng* 16.49.270; cf. also 13.37.223.

76. *Guanzi jiaozheng* 16.49.269.

77. Following, for lack of better, the anacoluthia in the commentary of Yin Zhizhang 尹知章 (d. 718); 利以安寧, rather than 利安以寧, would be closer to the meaning that Yin proposes.

78. *Guanzi jiaozheng* 16.49.269.

79. *Guanzi jiaozheng* 16.49.271; cf. also 13.37.223.

80. Despite e.g. Hu Jiacong 胡家聰, "Lun Rujia Xun Kuang sixiang yu Daojia zhexue de guanxi" 論儒家荀況思想與道家哲學的關係, *Daojia wenhua yanjiu* 6 (1995): 180ff., who points out some of the phraseological similarities between the texts discussed here, but does not consider philosophical implications. See also Li Deyong 李德永, "Daojia lilun siwei dui Xunzi zhexue tixi de yingxiang" 道家理論思維對荀子哲學體系的影響, *Daojia wenhua yanjiu* 1 (1992), esp. 259f.

81. This term has baffled commentators for centuries. I propose no elaborate theories here, taking the term simply as a euphemism for "deliberation." Edward J. Machle, "The Mind and the 'Shen-ming' in Xunzi," *Journal of Chinese Philosophy* 19, no. 4 (1992): 381, suggests that the passage reflects shamanic influence.

82. Such a scheme admits a degree of reflexivity: can the mind observe itself observing itself? The *Neiye* recognizes this curious consequence and suggests that the mind must have another mind within it: *Guanzi jiaozheng* 16.49.270. Xunzi does not discuss the potential problems of infinite regress (a mind within a mind within a mind etc.), postulating unquestioningly a mind supreme and unfettered, observing without bias affairs both within the self and all around it.

83. Despite Tang Junyi, *Yuanxing pian*, 57f., who crowns a learned and insightful discussion of Xunzi's philosophy of mind with the groundless criticism that it lacks a notion of introspection 反省. Tang ends his section with an apopemptic on the advance made by the metaphysics of Cheng Yi 程頤 (1033–1107) and Zhu Xi 朱熹 (1130–1200), which married Mencius's theory of original goodness to Xunzi's rationalistic concept of mind. He is right to point out Xunzi's influence on Cheng-Zhu philosophy, which must presuppose a concept of mind similar to that of Xunzi for its doctrine of *gewu* 格物 (external observation). An introduction to the concept of *gewu* in the work of Cheng Yi can be found in A.C. Graham, *Two Chinese Philosophers: The Metaphysics of the Brothers Ch'eng* (1958, rpt., La Salle, Ill.: Open Court, 1992), 74ff.

84. Cf. Richards, 67.

85. What the *historical* Gaozi may have had to say on the subject is open to speculation; for the view of Gaozi presented by authors partisan to Mencius is but a caricature.

86. It is perhaps this passage in particular that prompted Arthur Waley to call Mencius "nugatory": *Three Ways of Thought in Ancient China* (London: George Allen & Unwin, 1939), 194. Waley is now often criticized, whereas D.C. Lau, "On Mencius' Use of the Method of Analogy in Argument," *Asia Major* 10 (1963): 173–94, is hailed as one of Mencius's most forceful defenders. But, as even Lau remarks candidly, the use of analogy in argumentation is justifiable only as long as the analogy is apt—and as soon as the analogy breaks down, its continued use only obfuscates the issue. This, I think, was Waley's original point. For a judicious, if somewhat dated, examination of argument by analogy in general, see Margaret Macdonald, "The Philosopher's Use of Analogy," *Proceedings of the Aristotelian Society* 1937, no. 8, reprinted in (the first series of) *Logic and Language*, ed. Antony Flew, First and Second Series (Garden City, N.Y.: Doubleday, Anchor Books, 1965), 85–106.

87. Following D.C. Lau, *Mencius* (New York: Penguin, 1970), 264n.14.

88. To be sure, the Mencian conception of mind also includes a notion of will-power:

夫志氣之帥也，氣體之充也．夫志至焉，氣次焉，故曰：持其志，無暴其氣．(2.1.2.9)

The will is the leader of the *qi*. The *qi* is what fills the body. The will is chief; the *qi* is secondary. Thus I say: Support the will, and do not violate the *qi*.

The way to attain an unperturbed mind 不動心, in other words, is to cause one's will to lead the *qi*. This idea is at first sight similar to Xunzi's notion of vanquishing the *xing* through the mind. But will and *qi* in Mencius are not analogous to mind and *xing* in Xunzi—for Mencius emphasizes the necessity of *nourishing* the *qi*:

曰：我善養吾浩然之氣．敢問何謂浩然之氣？曰：難言也．其為氣也，至大至剛，以直養而無害，則塞于天地之間．其為氣也，配義與道．(2.1.2.11–14)

[Mencius] said: I am good at nourishing my flowing *qi*. [Gongsun Chou 公 孫丑 said:] May I ask what is called flowing *qi*? [Mencius] said: It is hard to say. This is what *qi* is—it is the greatest and the most unyielding; nourish it with rectitude and do not harm it, and it will lodge between Heaven and Earth. This is what *qi* is—it is the consort of righteousness and the Way.

The *qi* represents an essential aspect of man's being that must be cultivated and channeled. Mencius requires that we lead the *qi* and nourish it at the same time, for it represents our most basic source of sustenance. Xunzi, on the other hand, is not concerned with nourishing or cultivating the *xing*. For as we have seen, there is no dynamic or indispensible quality to *xing* in his view. Xunzi's *xing* must be flatly overcome: it is simply an impediment to sagehood.

89. Cf. Yang Yunru, *Xunzi yanjiu*, 44; Benjamin I. Schwartz, *The World of Thought in Ancient China* (Cambridge, Mass., and London: Harvard University Press, Belknap Press, 1985), 292.

90. Cf. Van Norden, 182f.

91. Cf. Cheng Zhaoxiong 程兆熊, *Xunzi jiangyi* 荀子講義 (Hong Kong: Ehu, 1963), 76: *xing* is "significant *xing*, not necessary *xing*" 重要性, 非必然性. Ch'i-yün Ch'en, *Hsün Yüeh and the Mind of Late Han China: A Translation of the Shen-chien with Introduction and Annotations*, Princeton Library of Asian Translations (Princeton, 1980), 10n.16, rightly observes that in Han times, a number of prominent thinkers agreed that *xing* may be good or bad, as long as "it can be transformed by human effort." Cf. Yang Xiong 揚雄 (53 B.C.–A.D. 18), *Fayan* 法言 (*Sibu beiyao*), 3.1a–b.

92. Cf. David S. Nivison, *The Ways of Confucianism: Investigations in Chinese Philosophy*, ed. Bryan W. Van Norden (Chicago and La Salle, Ill.: Open Court, 1996), 211ff.

93. Cf. Yu Jiaju, 23; Cai Yuanpei 蔡元培, *Zhongguo lunlixue shi* 中國倫理學史, Zhongguo wenhua shi congshu, Series 2 (Shanghai: Shangwu, 1937), 26; Guo Moruo, *Shi pipan shu*, 192.

Chapter 2

1. This passage, from the "Gaoyao mo" 皋陶謨, is attributed to Gaoyao, a minister of the Sage-Emperor Shun 舜; although it occurs in both the "Old Text" 古文 and "New Text" 今文 recensions of the *Shujing*, recent scholarship suggests that this text dates from the second half of the Zhou dynasty.

2. Two important studies of these passages are Kung-chuan Hsiao, *A History of Chinese Political Thought*, tr. F.W. Mote, Princeton Library of Asian Translations (Princeton, 1979), I, 206ff.; and Alfred Forke, *The World-Conception of the Chinese: Their Astronomical, Cosmological and Physico-Philosophical Speculation*, Probsthain's Oriental Series 14 (London, 1925), esp. 68ff. and 127ff.

3. The story also appears, with slightly different wording, in *Guoyu* 1.29f.

4. Not "Duke"; the reference is to the Marquis of Jin.

5. *Odes* 2.4.9.2.

6. *Shi* 師 refers to a high official in the bureaucracy; Charles O. Hucker, *A Dictionary of Official Titles in Imperial China* (Stanford: Stanford University Press, 1985), 5202, suggests "Second Class Administrative Official." The translation "Music Master" is customary in the case of this figure, a wise musician in the court of Jin. See e.g. *Han Feizi jishi* 3.10.170ff. for a famous story in which Music Master Kuang's advice is ignored, with disastrous consequences.

7. See e.g. Herrlee G. Creel, *The Origins of Statecraft in China* (Chicago and London: University of Chicago Press, 1970), 81–100, for the origins of the concept of Heaven's Mandate.

8. To these examples compare also the claim in *Guanzi jiaozheng* 1.2.5: "Whose achievements are harmonious with Heaven—Heaven assists him" 其功 順天者, 天助之. For more on the case of Confucius, see e.g. U. Hattori, "Confucius' Conviction of his Heavenly Mission," *Harvard Journal of Asiatic Studies* 1, no. 1 (1936): 96–108.

9. In a similar spirit, the Roman Emperor Marcus Aurelius (A.D. 121–178), when presented in 175 with the head of Avidius Cassius, a frustrated rebel, is reported by Vulcatius Gallicanus to have lamented that an occasion for clemency had been snatched from him. Marcus was reprimanded for his compassion: "Quid si ille vicisset?" ("What if [Cassius] had succeeded?"); whereupon he answered, "Non sic deos coluimus, nec vivimus, ut ille nos vinceret" ("I do not cultivate the Gods in such a way, or live in such a way, that he could have vanquished me"), adding a catalogue of examples from history to support his contention that the virtuous are not deposed. Text in C.R. Haines, ed., *The Communings with Himself of Marcus Aurelius Antoninus, Emperor of Rome, Together with his Speeches and Sayings*, revised edition, Loeb Classical Library (Cambridge, Mass., and London: Harvard University Press, 1930), 370ff.

10. Unfortunately, this passage, from the "Taishi" 泰誓, is spurious. A parallel passage (with significant differences) appears in Legge's appendix to this chapter (299), in which he reproduces Jiang Sheng's 江聲 (1721–1799) reconstruction of the original based on classical quotations.

11. One textual tradition glosses *ji* 既 as *jin* 盡, "are consumed."

12. Cf. *Zuo zhuan* Zhao 21 = 521 B.C., 686, where it is denied that a certain eclipse constitutes a portent—though not because of a general suspicion of such reasoning, but because the alignment of *yin* and *yang* in this case is not irregular.

13. See, in addition to the following, *Zuo zhuan* Zhao 19 = 523 B.C., 674.

14. Cf. Forke, 82.

15. This passage, from the "Hongfan" 洪範, probably dates from the late Warring States period. See e.g. Michael Nylan, *The Shifting Center: The Original "Great Plan" and Later Readings*, Monumenta Serica Monographs (Nettetal: Steyler, 1992).

16. *Yueling* 月令, *Liji* (*Shisan jing* 十三經 [Shanghai: Shangwu, 1914]), 51ff.

17. Cf. e.g. David W. Pankenier, "The Cosmo-political Background of Heaven's Mandate," *Early China* 20 (1995), 121–76.

18. Cf. Marcel Granet, *Fêtes et chansons anciennes de la Chine*, Bibliothèque de l'Ecole des Hautes Etudes, Sciences religieuses 34; Bibliothèque de la Fondation Thiers 39 (Paris: E. Leroux, 1919), 179n.3; and Henri Maspero, *China in Antiquity*, tr. Frank A. Kierman, Jr. (Amherst: University of Massachusetts Press, 1978), 132ff. Maspero also points out that even "the matrimonial union of the common people, like all the rest of their lives, followed the rhythm of the year" (72).

19. The dating of this stratified text is a complicated issue; see e.g. Willard J. Peterson, "Making Connections: 'Commentary on the Attached Verbalizations' of the Book of Change," *Harvard Journal of Asiatic Studies* 42, no. 1 (1982): 71ff.; and Iulian K. Shchutskii, *Researches on the I Ching*, tr. William L. MacDonald and Tsuyoshi Hasegawa with Hellmut Wilhelm (Princeton: Princeton University Press, 1979), 129ff.

20. *Yijing* (*Shisan jing*), 32 (sign 54).

21. *Zhuangzi jishi* 7A.19.632. Cf. *Huainan honglie jijie* 7.219.

22. Despite Graham, *Disputers*, 47; cf. Donald Harper's criticism in the "Warring States, Ch'in, and Han Periods" section of "Chinese Religions—The State of the Field, Part I," *Journal of Asian Studies* 54, no. 1 (1995): 153.

23. Thomé H. Fang, "The World and the Individual in Chinese Metaphysics," in Moore, 242, writes imprecisely that Xunzi was the *only* "one who seemed to be 'fed up' with the value-centric conceptions of Heaven." Xunzi is preceded in this regard by a cohort of personages in the *Zuo zhuan*, of whom we have seen only one or two representative examples.

24. Repeated in *Han Shi waizhuan* 2.4a.

25. Knoblock's note *ad loc.*, III, 301n.51, suggests that *li* 理, "natural order," stands in place of *zhi* 治, "order, govern," the personal name of Tang Emperor Gaozong 高宗 (r. A.D. 650–684)—and hence (ostensibly) a taboo character in Yang Liang's time. But the present edition of *Xunzi* contains innumerable appearances of the character 治.

26. Omitting before *fu* 父 excrescent *ze* 則 (with Wang Niansun and others).

27. *Tian* 田 in this passage may also be construed as a verb, "to hunt," the implication being that hunting at the wrong time of year can damage crops. Commentators do not generally entertain this interpretation.

28. Cf. e.g. Xia, 45; and Dubs, 62; although Eno, 168, notes aptly that the mechanistic conception of Heaven in Xunzi's philosophy has been "overstressed." The contention of Max Weber, *The Religion of China: Confucianism and Taoism*, tr. Hans H. Gerth (New York and London: Macmillan, Free Press, 1951), 147ff., that there was no natural law in traditional Confucian legal thought, is obsolete.

29. *Christianity as Old as the Creation*, 2nd edition (London: N.p., 1732), 5f.

30. *Christianity as Old as the Creation*, 7.

31. *Christianity as Old as the Creation*, 100.

32. *Christianity as Old as the Creation*, 229. The reference is to Numbers 22:22.

33. This component of deism originates in the classical world. Consider the lines of Lucretius (ca. 100–ca. 55 B.C.): "quae bene cognita si teneas Natura uidetur/libera continuo dominis priuata superbis/ipsa sua per se sponte omnia dis agere expers," ("If you keep this well understood, Nature immediately seems, free and uncontrolled by proud masters, herself to drive freely all that is hers, without the gods"), text in T. Lucreti Cari *De rerum natura libri sex*, ed. William Ellery Leonard and Stanley Barney Smith (Madison and London: University of Wisconsin Press, 1942), II.1095–97. Lucretius credits Epicurus (342?–270 B.C.) with having defied the burden of superstition (I.66), and is critical throughout of the popular belief in miracles. For the famous example of the sacrifice of Iphigenia at Aulis, see I.84ff. An epitome of Epicurus's atomism can be found in his lengthy epistle to Herodotus, preserved in Diogenes Laertius, *Lives of Eminent Philosophers*, ed. R.D. Hicks, Loeb Classical Library 185 (Cambridge, Mass.: Harvard University Press, 1925), X.35–83; his conclusion (X.76f.), that celestial portents have a mechanistic explanation and should not be attributed to the commands of willful godheads, is repeated and amplified in his letter to Pythocles (X.84–116) on natural phenomena.

34. *Christianity as Old as the Creation*, 317.

35. *An Enquiry concerning Human Understanding*, in *Enquiries concerning Human Understanding and concerning the Principles of Morals*, ed. L.A. Selby-Bigge, revised by P.H. Nidditch, 3rd edition (Oxford: Clarendon, 1975), X.91. Scholars have long disagreed over the value of this essay, "On Miracles." The classic criticism is C.D. Broad, "Hume's Theory of the Credibility of Miracles," *Proceedings of the Aristotelian Society* 17 (1916–17): 77–94, reprinted in *Human Understanding: Studies in the Philosophy of David Hume*, Wadsworth Studies in Philosophical Criticism, ed. Alexander Sesonske and Noel Fleming (Belmont, Calif., 1965), 86–98, who points out that it is not Hume's best work and does not fit well with the rest of his philosophy. But see also e.g. Antony Flew, *God, Freedom, and Immortality* (Buffalo: Prometheus, 1984), chapter 3; Francis J. Beckwith, *David Hume's Argument Against Miracles: A Critical Analysis* (Lanham, Md.: University Press of America, 1989), as well as Beckwith's "Hume's Evidential/Testimonial Epistemology, Probability, and Miracles," in *Faith in Theory and Practice: Essays on Justifying Religious Belief*, ed. Elizabeth S. Radcliffe and Carol J. White (Chicago and La Salle, Ill.: Open Court, 1993), 117–40; and Robert J. Fogelin, "What Hume Actually Said about Miracles," *Hume Studies* 16, no. 1 (1990), reprinted in Fogelin's *Philosophical Interpretations* (Oxford and New York: Oxford University Press, 1992), 95–101.

36. For more on Tindal, see e.g. Sir Leslie Stephen, *History of English Thought in the Eighteenth Century*, 3rd edition (1902, rpt., New York and Burlingame: Harcourt, Brace & World, Harbinger, 1962), I, 113ff. (= III.iv.43ff.).

37. See Kanaya, "*Junshi* no tenjin no bun ni tsuite"; Ikeda Suetoshi 池田末利, "Chūgoku koyū no shūkyō to in'yō shisō" 中國固有の宗教と陰陽思想,

Shūkyō kenkyū 宗教研究 38 (1965), reprinted in Ikeda's *Chūgoku kodai shūkyōshi kenkyū* 中國古代宗教史研究 (Tokyo: Taikai Daigaku, 1981), 912ff.; Ikeda Suetoshi, "Tendō to temmei (ge)," 天道と天命 (下), *Hiroshima Daigaku Bungakubu kiyō* 廣島大學文學部紀要 29, no. 1 (1970), reprinted in *Chūgoku kodai shūkyōshi kenkyū*, 1004n.36; Itano Chōhachi 板野長八, "Junshi no tenjin no bun to sono ato" 荀子の天人の分とその後, *Hiroshima Daigaku Bungakubu kiyō* 28, no. 1 (1968), 112–34; Eno, 131ff.; and especially Wei Zhengtong, 42ff. A thorough catalogue of occurrences of the word *tian* in the *Xunzi* can be found in Kodama Rokurō 兒玉六郎, "Junshi no ten ni tai suru ichi kōsatsu" 荀子の天に對する一考察, *Shinagaku kenkyū* 支那學研究 33 (1968): 42–49. Some commentators read *tian* as a sort of god; whereas such an interpretation may be justified for the pre-philosophical period—see e.g. Ikeda Suetoshi, "Shaku tei ten" 釋帝天, *Hiroshima Daigaku Bungakubu kiyō* 3 (1952), reprinted in *Chūgoku kodai shūkyōshi kenkyū*, 25–46; Ikeda Suetoshi, "Zokushaku tei ten" 續釋帝天, *Tetsugaku* 哲學 3 (1952), reprinted in *Chūgoku kodai shūkyōshi kenkyū*, 47–63; and Creel, *Origins of Statecraft*, 493–506—by the time of Xunzi not a single philosopher uses the term in reference to a deity. English-language studies of Heaven in Xunzi's philosophy are few. The best work is Eno; see also Edward J. Machle, *Nature and Heaven in the* Xunzi: *A Study of the* Tian lun, SUNY Series in Chinese Philosophy and Culture (Albany, 1993) and the review by Jeffrey Riegel in *China Review International* 1, no. 2 (1994): 202f.

38. This theme is echoed by the Old Testament: cf. e.g. Job 28, and the commentary in Norman H. Snaith, *The Book of Job: Its Origin and Purpose*, Studies in Biblical Theology, Second Series, 11 (Naperville, Ill.: A.R. Allenson, 1968), 97ff.; and Paul Rakita Goldin, "Job's Transgressions," *Zeitschrift für die alttestamentliche Wissenschaft* 108 (1996): 378–90.

Chapter 3

1. E.g. Luo Genze, *Zhuzi kaosuo*, 341; Mou Zongsan, *Xunxue dalue* in *Mingjia yu Xunzi*, 195ff.; Wei Zhengtong, 48; Liu Zijing 劉子靜, *Xunzi zhexue gangyao* 荀子哲學綱要, Renren wenku 1076 (Taipei: Shangwu, 1969), 19f.; Noah Edward Fehl, *Li: Rites and Propriety in Literature and Life* (Hong Kong: Chinese University, 1971), 151 *et passim*; Chen Feilong 陳飛龍, *Xunzi lixue zhi yanjiu* 荀子禮學之研究, Wen shi zhe xue jicheng (Taipei: Wen shi zhe, 1979), 40; Schwartz, 299ff.; and most recently Chad Hansen, *A Daoist Theory of Chinese Thought: A Philosophical Interpretation* (Oxford and New York: Oxford University Press, 1992), 334ff.

2. Two of the best examples are Stanley Jeyaraja Tambiah, *Culture, Thought, and Social Action: An Anthropological Perspective* (Cambridge, Mass., and London: Harvard University Press, 1985), esp. 78ff. and 128ff.; and Herbert Fingarette, *Confucius—The Secular as Sacred* (New York: Harper & Row, 1972), 11ff.

3. *How to Do Things with Words*, ed. J.O. Urmson and Marina Sbisà, 2nd edition, William James Lectures 1955 (Cambridge, Mass.: Harvard University Press, 1975).

4. Austin, 100f.

5. *An Essay Concerning Human Understanding*, ed. Peter H. Nidditch (Oxford: Clarendon, 1975), III.x.17. At issue for Locke were not the consequences that we are concerned with here, but the question of real and nominal essence; cf. J.L. Mackie, *Problems from Locke* (Oxford: Clarendon, 1976), 85ff.

6. I avoid entirely the quagmire of the meaning of the phrase itself. There are notions of meaning, for example, according to which it would be *false* to say that "Gold is malleable" means "I think gold is malleable."

7. This is the essence of Austin's Lecture XI (133–47), the core of his book.

8. *The Gift: The Form and Reason for Exchange in Archaic Societies*, tr. W.D. Halls (London: Routledge, 1990), 3. The "Essai sur le don" first appeared in *Sociologie et anthropologie*, 1950.

9. Mauss, 9.

10. J.L. Mackie, *Ethics: Inventing Right and Wrong* (New York: Penguin, 1977), 115.

11. Strictly speaking, the argument here is imprecise: for both actors will know that on the one hundredth and final dilemma, trustworthiness will have no reward, and hence each will have incentive to deceive the other; and, knowing this, both will deduce that trustworthiness will have no reward on the ninety-ninth dilemma either; and so forth. Cf. R. Duncan Luce and Howard Raiffa, *Games and Decisions: Introduction and Critical Survey* (New York: John Wiley & Sons, 1957), 98ff. But where neither actor knows how many dilemmas there will be, this problem should not arise.

12. This idea of "trust" is a central theme in sociology; see e.g. James S. Coleman, *Foundations of Social Theory* (Cambridge, Mass., and London: Harvard University Press, Belknap Press, 1990), 91ff. and 175ff., with a rigorous mathematical analysis on 747ff. Coleman's results are consistent with our initial findings here: as each actor's trust in the other increases, so does the incentive to be trustworthy himself. Cf. also Anatol Rapoport and Albert Chammah, *Prisoner's Dilemma: A Study in Conflict and Cooperation* (Ann Arbor: University of Michigan Press, 1965), 63ff. A noteworthy recent exploration into the philosophical applications of game theory is John Broome, *Weighing Goods*, Economics and Philosophy (Oxford and Cambridge, Mass.: Basil Blackwell, 1991).

13. Cf. Hobbes, *Philosophical Rudiments concerning Government and Society*, in the second volume of *The English Works*, I.3. I assume here that the *Rudiments* are Hobbes's own translation of his *De cive*, although the attribution is now questioned. Hobbes appears never to have complained of the *Rudiments* as a forgery, although if he did not write them, we cannot be sure that he even knew of them. A.E. Taylor, "The Ethical Doctrine of Hobbes," *Philosophy*, 1938, reprinted in *Hobbes Studies*, ed. K.C. Brown (Cambridge, Mass.: Harvard University Press,

1965), 35, notes one passage where the English translation thoroughly perverts the sense of the Latin original. I shall refer to the *Rudiments*, as is customary, by the name *De cive*.

14. Cf. *De cive*, I.6.

15. *Leviathan*, XIII.60f.

16. John Rawls, *A Theory of Justice* (Cambridge, Mass.: Harvard University Press, Belknap Press, 1971), 269, was one of the first to note the connection between Hobbes's state of nature and the Prisoner's Dilemma.

17. *Leviathan*, XIII.62; cf. *De cive*, I.13.

18. "Avoid" rather than Hobbes's own "[get] themselves out from" (*Leviathan*, XVII.85), because the chaos before the establishment of the Commonwealth is at best a fiction; cf. C.B. Macpherson, *The Political Theory of Possessive Individualism: Hobbes to Locke* (Oxford: Clarendon, 1964), 20. Hobbes insists that a state of War exists among "the savage people in many places of *America*" (*Leviathan*, XIII.63; cf. *De cive*, I.13), which, historically, is probably untrue. There is furthermore the problem of antinomy: if covenants cannot be without sovereigns, nor sovereigns without covenants, the state of nature, once attained, can never be dissolved; cf. Ewin, 107f.

19. Cf. Richard Peters, *Hobbes*, Peregrine Books Y66, 2nd edition (Baltimore: Penguin, 1967), 182ff. Fehl, 167, reminds us that Hobbes's schema of the origin of the Commonwealth is anticipated by the Greek Sophists. Hobbes's debt to ancient Greece is profound and acknowledged; his first publication was a full translation of Thucydides. See e.g. Laurie M. Johnson, *Thucydides, Hobbes, and the Interpretation of Realism* (DeKalb, Ill.: Northern Illinois University Press, 1993). By realism Johnson means not philosophical realism, but realism in international relations, *Realpolitik*.

20. *Leviathan*, XVII.85.

21. *Leviathan*, XVII.87; cf. *De cive* V.6–8.

22. The relevance of game theory to the Hobbesian social contract is made clear in Gregory S. Kavka, *Hobbesian Moral and Political Theory*, Studies in Moral, Political, and Legal Philosophy (Princeton: Princeton University Press, 1986), esp. chs. 2 and 3. See also Jean Hampton, *Hobbes and the Social Contract Tradition* (London: Cambridge University Press, 1986); and David Gauthier, *Morals by Agreement* (Oxford: Oxford University Press, 1986), esp. ch. 6. Ewin, 45f., objects that it is anachronistic to apply game theory to Hobbes.

23. *Leviathan*, XVII.87.

24. Cf. Jacques Maritain, *Man and the State*, Charles R. Walgreen Foundation Lectures (Chicago: University of Chicago Press, 1951), 38ff.

25. *Sociologie et philosophie*, 2nd edition, Bibliothèque de philosophie contemporaine (Paris: Presses Universitaires de France, 1963), 74f.

26. Raymond Aron, *Main Currents in Sociological Thought*, tr. Richard Howard and Helen Weaver (New York: Doubleday, Anchor, 1968–1970), II, 107, for example, answers in the negative. Kant's argument, deriving from the

idea of the *summum bonum*, appears in his *Kritik der praktischen Vernunft*, *Gesammelte Schriften* (Berlin: Preussische Akademie der Wissenschaften, 1902–42), V, 124ff.

27. Johan Huizinga explored the civilizing effects of play, with an argument along similar lines, in his *Homo Ludens: A Study of the Play Element in Culture* (Boston: Beacon, 1950), esp. ch. 3; see also Catherine Garvey, *Play*, The Developing Child (Cambridge, Mass.: Harvard University Press, 1977), esp. chs. 7 and 8, with a completely different method and no apparent knowledge of Huizinga.

28. "Contractarianism" is the recent name for moral theories, like that of Hobbes, which center on contracts. The foremost contemporary texts of contractarianism are Rawls and Gauthier. See also Peter Vallentyne, ed., *Contractarianism and Rational Choice: Essays on David Gauthier's* Morals by Agreement (New York: Cambridge University Press, 1991); Ellen Frankel Paul *et al.*, eds., *The New Social Contract: Essays on Gauthier* (New York and Oxford: Blackwell, 1988); and Charles Fried, *Contract as Promise: A Theory of Contractual Obligation* (Cambridge, Mass., and London: Harvard University Press, 1981). A fuller bibliography appears in Vallentyne, 3n.4.

29. *Les formes élémentaires de la vie religieuse*, 5th edition, Bibliothèque de philosophie contemporaine (Paris: Presses Universitaires de France, 1968), 330f. The influence of this and similar passages in Durkheim is considerable. For example, Susanne K. Langer, *Philosophy in a New Key: A Study in the Symbolism of Reason, Rite, and Art*, 3rd edition (Cambridge, Mass., and London: Harvard University Press, 1957), esp. chs. 5 and 6, approaches ritual from this semiotic point of view: ritual is the expression of the symbolic perception of the universe.

30. Another problem with this line of thinking is that it argues solely out of plausibility. It may be that the "individuals asked themselves in amazement how they could have let themselves be transported so far from their character"; or the individuals may not have perceived their behavior in the assembly to be in any respect discordant with their character in the first place. The individuals might not even think of themselves as possessing a character at all. We simply cannot know *what* they think, or how they regard the assembly and its symbolism.

31. Cf. e.g. Erving Goffman, "Embarrassment and Social Organization," *American Journal of Sociology* 62, no. 3 (1956): 264–74, reprinted in Goffman's *Interaction Ritual: Essays on Face-to-Face Behavior* (Garden City, N.Y.: Doubleday, Anchor Books, 1967), 97–112.

32. It is impossible to formulate this argument without acknowledging Vilfredo Pareto (1848–1923). Pareto's tenet, that our explanations or justifications of what we do need not bear any connection to the actual causes of our doing them, represents the essence of the schism between Paretians and Durkheimians. See Pareto's *Trattato di sociologia generale*, ed. Giovanni Busino, Classici della sociologia (Turin: Unione tipografico-editrice torinese, 1988), 162, 850 *et passim*. Pareto is roundly and uncharitably criticized for his refusal to consider rituals

from the point of view of the participants by Peter Winch, *The Idea of a Social Science and Its Relation to Philosophy* (London: Routledge and Kegan Paul, 1960), 95ff. Of the sociological triumvirate, Pareto, Durkheim, and Max Weber (1864–1920), Pareto is without question the junior member in terms of present fame; but this has as much to do with his unpopular political stance and vitriolic prose as with the merits of his work. The heyday for Pareto studies in America was the 1930's; see e.g. Lawrence J. Henderson, *Pareto's General Sociology: A Physiologist's Interpretation* (New York: Russell & Russell, 1935); and George C. Homans and Charles P. Curtis, Jr., *An Introduction to Pareto* (New York: Knopf, 1934) — long outdated, as the many references to Whitehead and Herbert Dingle attest. Talcott Parsons is one of the most notable sociologists to incorporate Pareto into his own theories; see *The Structure of Social Action: A Study in Social Theory with Special Reference to a Group of Recent European Writers*, 2nd edition (New York: Free Press, 1949), 178–300.

33. Cf. Thomas Nagel, *The View from Nowhere* (Oxford: Oxford University Press, 1986), 62ff.; and the critical reflections in Michael Walzer, *Interpretation and Social Criticism* (Cambridge, Mass., and London: Harvard University Press, 1987), 5ff.

34. This accords with the functionalist line taken by Bronislaw Malinowski in "A Scientific Theory of Culture," published posthumously in *A Scientific Theory of Culture and Other Essays* (Chapel Hill: University of North Carolina Press, 1944), 128ff.

35. Repeated in *Han Shi waizhuan* 1.3b.

36. Repeated in *Han Shi waizhuan* 4.4b and *Shiji* 23.1164. Xunzi's military theory is cited also in *Hanshu* 23.1085f.

37. Omitting excrescent 明 and emending 內 to 固; see comm. *ad loc.*

38. Repeated in *Han Shi waizhuan* 3.22b; Cai Xinfa 蔡信發, *Xinxu shuzheng* 新序疏證, Wenhua Jijinhui yanjiu lunwen 37 (Taipei: Chia Hsin Foundation, 1980), 3.56.

39. For the exploits of Archer Yi, see Marcel Granet, *Danses et légendes de la Chine ancienne*, Bibliothèque de philosophie contemporaine; Travaux de l'Année sociologique (Paris: Librairie Felix Alcan, 1926), I, 376ff.; Wolfram Eberhard, *Lokalkulturen im alten China*, T'oung Pao 37 (supplement, 1942), 125ff.; Eberhard, *The Local Cultures of South and East China*, tr. Alide Eberhard (Leiden: E.J. Brill, 1968), 80ff.; and Birrell, 138ff. There is no shortage of classical references. Though the myths of Yi's demise are manifold, they typically agree that he came to a violent end; see e.g. *Mencius* 4.2.24.1; *Zuo zhuan* Xiang 襄 4 = 569 B.C., 422.

40. Cf. e.g. *Mu tianzi zhuan* 1.4a; *Liezi zhu* 3.32.

41. This is not to say, however, that the idea started with Xunzi; see e.g. *Mencius* 1.1.5.3ff. For two of the few sustained inquiries into Xunzi's military philosophy, see esp. Xu Junru, 151ff., and the more ideologically-minded Hu Yuheng and Li Yu'an, 118ff.

42. Cf. Patricia Buckley Ebrey, *Confucianism and Family Rituals in Imperial*

China: A Social History of Writing about Rites (Princeton: Princeton University Press, 1991), 26ff.

43. Where Xunzi discusses the mechanics of ritualization, he sounds at times much like Durkheim or Langer; e.g. "Sacrifice is the emotion of memory and longing [for the dead]" 祭者志意思慕之情也 (*X* 13.19.249=K 19.11). The institutionalization of communal emotion is the catalyst both here and in Durkheim's *symbolisme*. A.R. Radcliffe-Brown's famous essay, "Religion and Society," in his *Structure and Function in Primitive Society: Essays and Addresses* (Glencoe, Ill.: Free Press, 1952), 157ff., contains probably the earliest and still one of the most insightful comparisons of Xunzi and Durkheim. Recently Robert F. Campany has explored the same topic in "Xunzi and Durkheim as Theorists of Ritual Practice," in *Discourse and Practice*, SUNY Series, Toward a Comparative Philosophy of Religions, ed. Frank Reynolds and David Tracy (Albany, 1992), 197–231; however, Campany fails not only to supersede Radcliffe-Brown, but even to cite him. It is strange that a historian of religion should not give credit to one of Radcliffe-Brown's most renowned works.

44. Whether Hobbes considers human nature to be egoistic has become a Serbonian bog. Kavka, 44ff., summarizes the literature ably; only two or three decades ago, the answer was commonly assumed to be affirmative: e.g. William K. Frankena, *Ethics*, Prentice-Hall Foundations of Philosophy Series (Englewood Cliffs, N.J., 1963), 14. My suspicion is that much of the confusion is due to language. Would a Hobbesian agent forego some material advantage in order to remain, for example, with a loved one? Would an egoist? The answer hinges on the value which the agent ascribes to love; and for both egoists—in the *philosophical* sense—and non-egoists, though the good be not material, its value can be significant. A perfect non-egoist, furthermore, would have to be some sort of automaton, since even non-egoistic behavior, that is to say, the choice of an action which does not lead to the greatest personal good, still represents a function of the ego. In a way the egoism debate represents a reformulation of the question of God's role in Hobbe's system, which fueled a raging dispute in the middle of this century. Is there any reason *in foro interno*, that is, other than the compulsion to self-preservation, for Hobbesian actors to honor their covenants? Today most scholars follow Stuart M. Brown, Jr., "The Taylor Thesis: Some Objections," *The Philosophical Review*, 1959, reprinted in K.C. Brown, 57–71, who notes that Hobbes explicitly rejects the separation of his ethical theory from his psychology, though proponents of both sides find passages from the corpus to support their claims. Brown at one point misapplies Hobbes's discussion of civil government to the *international* arena: "With only a few refinements Hobbes's account of the state of nature can be used to provide reasons why the people of all nations are obliged to submit to a sovereign international government," 67n.25. But, as Hobbes makes clear himself, what is true of *man* in the state of nature is not true of a nation (or, in Hobbes's terms, "city") in the same state; for unlike man, who by his natural limitations cannot protect his acquisitions without civil govern-

ment, nations are blessed with the wherewithal to do so. Most of the important texts on the theism debate are reprinted in K.C. Brown.

45. Cf. Wei Zhengtong, 169ff. The image of deep ponds is echoed in *Han Shi waizhuan* 5.12a.

46. Consider also, in addition to the following, the *caveat* in Ivanhoe, *Confucian Moral Self Cultivation*, 45n.22: "Since Xunzi believes that one can *transform* oneself in fundamental ways, he can avoid certain classic difficulties encountered by thinkers like Hobbes, who offer contractarian ethical philosophies. Since the process of self-cultivation transforms the self and changes the calculus by which one decides what one is to do, Xunzi avoids the set of problems associated with 'prisoner's dilemma' situations."

47. *De cive* I.7. Cf. Kavka, 80ff. The idea of the human urge to self-preservation is anticipated by the Stoics, among others; thus in Cicero's dialogue, *De finibus bonorum et malorum*, M. Cato, the spokesman for the Stoics, says: "Placet his . . . quorum ratio mihi probatur, simul atque natum sit animal (hinc enim est ordiendum), ipsum sibi conciliari et commendari ad se conservandum et ad suum statum eaque quae conservantia sunt eius status diligenda, alienari autem ab interitu iisque rebus quae interitum videantur afferre"—"It is acceptable to those, whose system I approve, that as soon as the animal is born (for here is where we must commence), it is connected to itself and committed to preserving itself, its constitution, and those things which must be esteemed as preserving its constitution; but that it distances itself from destruction and from those things which seem to threaten destruction." Text in M. Tullii Ciceronis *De finibus bonorum et malorum*, ed. H. Rackham, 2nd edition, Cicero XVII; Loeb Classical Library 40 (Cambridge, Mass.: Harvard University Press, 1931), III.v.16. Cf. also Diogenes Laertius, VII.85. Cicero, arguing for the Academics, agrees with Cato thus far, but then appeals, in Graecian manner, to an aretaic imperative: "animadvertamus qui simus ipsi, ut nos quales oportet esse servemus" (IV.x.25)—"we ought to meditate on what we ourselves are, so that we may keep ourselves as we must." Herein he departs completely from anything we might find in Hobbes.

48. Cf. Roetz, 377n.1. Xunzi's tone here is reminiscent of the moralism of Mencius: 孟子曰：魚我所欲也，熊掌亦我所欲也，二者不可得兼，舍魚而取熊掌者也. 生亦我所欲也，義亦我所欲也，二者不可得兼，舍生而取義也 (6.1.10.1): Mencius said: I like fish; I also like bear's paw. [If] I cannot have both at the same time, I discard fish and take bear's paw. I like life; I also like righteousness. [If] I cannot have both at the same time, I discard life and take righteousness.

49. Despite e.g. Heiner Roetz, *Confucian Ethics of the Axial Age: A Reconstruction under the Aspect of the Breakthrough Toward Postconventional Thinking*, SUNY Series in Chinese Philosophy and Culture (Albany, 1993), 226: "It is left unresolved why human reason can be moral for other than utilitarian grounds. We can only presume that, in the final analysis, it is fueled by self-respect." This judgement completely ignores Xunzi's cosmology.

50. On Shen Dao, see p. 120 n.57; see also *Zhuangzi jishi* 10B.33.1088.

51. Cf. Roger T. Ames, *The Art of Rulership: A Study of Ancient Chinese Political Thought* (Honolulu: University of Hawaii Press, 1983; rpt., Albany: State University of New York Press, 1994), 121ff.

52. Consider also the anecdote retold in *Zuo zhuan* Zhao 29 = 513 B.C., 729f. Two generals of Jin levy one *gu* 鼓 (a unit of weight) of iron in order to cast a so-called "Penal Tripod" 刑鼎, that is to say, a vessel inscribed with the penal laws of one Fan Xuanzi 范宣子. Confucius then remarks that the state of Jin will go to ruin because its people will observe the letter of the law instead of being guided by moral principles. For a summary of critical literature on this passage, see Wagner, 57ff., who concludes that it is probably not genuine. Twenty-three years earlier (*Zuo zhuan* Zhao 6 = 536 B.C., 607), Zichan is said to have ordered the penal law of the state of Zheng inscribed on metal; a critic, Shuxiang 叔向, wrote a long epistle with a similar argument, anticipating Confucius. Cf. Graham, *Disputers*, 276.

53. The significance of cooking as a stage in man's cultural evolution is amplified in *Liji*, 80—which is then repeated *verbatim* in the so-called *Kongzi jiayu* 孔子家語: Chen Shike 陳士珂 (fl. 1818), *Kongzi jiayu shuzheng* 疏證, Wanyou wenku, Guoxue jiben congshu (N.p.: Shangwu, 1939), 1.6.26f. Despite e.g. R.P. Kramers, *K'ung tzu chia yü: The School Sayings of Confucius*, Sinica Leidensia 7 (Leiden: E.J. Brill, 1950), I do not believe that anything in the *Kongzi jiayu*, which purports to contain those sayings of Confucius not selected for incorporation into the *Analects*, can be taken without outside confirmation as an authentic document from the Warring States. Kramers concludes that the received text is made up of two interwoven parts: an original pre-Imperial text, and interpolations made by the infamous Wang Su 王肅 (A.D. 195–256)—who is accused of having forged as many as three texts—in order to lend doctrinal support to his own theories. Kramers rejects the possibility that Wang Su may have concocted the entire text because "it presupposes such a diabolical cleverness that it can hardly be considered acceptable" (137). We can say with some confidence, however, that in forging the *Kongcongzi* 孔叢子, Wang Su (or someone in his camp) displayed just the kind of cleverness that Kramers finds it impossible to attribute to him; see esp. Yoav Ariel, *K'ung-ts'ung-tzu: The K'ung Masters' Anthology*, Princeton Library of Asian Translations (Princeton, 1989). Kramers ultimately disagrees with Yan Shigu's contention (in his commentary to *Hanshu* 30.1717) that the *Jiayu* listed in the bibliographical treatise of the *Hanshu* is not the same as that circulating in his time. Yan's testimony must be considered at least as weighty as Wang Su's, and we know from his mischief in connection with the *Kongcongzi* that Wang deliberately chose for his forgeries titles corresponding to lost works from the *Hanshu* bibliography (Ariel, 69). He was crafty indeed. Moreover, of the 320 sections in the received *Kongzi jiayu*, Chen Shike has been able to find textual parallels in other major texts predating Wang Su for 307, or 96 percent. The remaining thirteen sections are: 2.9.60; 2.10.66; 3.11.72; 5.18.127f. (eight

consecutive sections); 5.19.134; and 8.37.213. This means either that Wang Su plagiarized virtually everything (and the other thirteen sections may also have been lifted from texts that are now no longer in existence), or that the *Jiayu* occupied a dominating position in the early Confucian tradition. The question, in other words, is whether Wang stole from everyone, or whether everyone took from a real *Jiayu*. The former is far more likely. First, it should be observed, for what it is worth, that the various sections with parallels in the *Yanzi chunqiu* 晏子春秋 (e.g. 2.9.53f., 4.15.106, etc.—often in the mouth of Confucius rather than Yanzi) seem to be taken from the latter text, rather than *vice versa*, although this probably cannot be proved either way. More conclusive evidence is found at the very beginning of the present text. On two occasions we are told that when Confucius was in office in Lu 魯, the people did not pick up goods left on the highway: 路無拾遺, 1.1.1; and 道不拾遺, 1.1.5. This was a cliché of the late Warring States; it is adduced, for example, in connection with Gongsun Yang 公孫鞅 (d. 338 B.C.) in *Shiji* 68.2231. Nowhere in the *Analects* is there a hint of such encomium. In general the language of the *Jiayu* is not like that of Confucius's day, and if we are to believe the text's pretensions that it is made up of the kind of material from which the *Analects* were chosen, then we would naturally expect the language to conform to what is found in the *Analects* as well. It does not. In particular we may cite the frequency of the term *ru* 儒, "Confucian," which occurs in the *Analects* only once (6.11). Confucius was not concerned with *ru*; he was concerned with *shi* 士, "knights" (i.e. aristocrats, as opposed to farmers and artisans, etc.). *Ru* becomes an important term only after the development of rival schools—that is to say, long after the time when Confucius's disciples would have decided what to include in the *Lunyu* and what in the *Jiayu*. Finally, the overwhelming number of textual parallels throws into doubt Wang Su's entire explanation of how he came to discover the long-lost *Jiayu* and publish it. In his preface (tr. Kramers, 91ff.), Wang tells us that he opposed the exegetical school of Zheng Xuan 鄭玄 (A.D. 127–200) and criticized their views publicly. One day, a certain descendant of Confucius handed him a manuscript of the *Jiayu* which happened to correspond perfectly with Wang Su's own position—like a compass over a circle or an angle-measure over a square. But the fact that some 96 percent of the text could have been found in works extant in Wang Su's day contradicts his implication that the *Jiayu* represented new material confirming the intellectual position to which he had already come.

54. Cf. *X* 6.10.115; *K* 10.3a. Repeated in *Shiji* 23.1161f.

55. Cf. P.J. Ivanhoe, "A Happy Symmetry: Xunzi's Ethical Thought," *Journal of the American Academy of Religion* 59, no. 2 (1991): 309–22.

56. Despite e.g. Liu Zijing, 17.

57. Cf. Schwartz, 301.

58. Cf. *X* 13.19.243.

59. Cf. Derk Bodde, *Chinese Thought, Society, and Science: The Intellectual and Social Background of Science and Technology in Pre-modern China* (Honolulu: University of Hawaii Press, 1991), 197.

60. Cf. e.g. Chen Daqi, 145ff.; Li Deyong, *Xunzi*, 92ff.; Yang Yunru, *Xunzi yanjiu*, 142; Jiang Shangxian 姜尚賢, *Xunzi sixiang tixi* 荀子思想體系, Sixiang congshu (Tainan, 1966), 270ff.; Chen Feilong, 78ff.

61. Cf. *X* 5.9.102f.; K 9.14. I do not cite this passage in full because the importance of hierarchy is not explicit.

62. See Paul Rakita Goldin, "Reflections on Irrationalism in Chinese Aesthetics," *Monumenta Serica* 44 (1996): 177f.

63. This passage, from the "Shundian" 舜典, appears in both the "Old Text" and "New Text" recensions (in the latter case as an appendix to the preceding "Yaodian" 堯典). It is clearly not genuine, but probably not a very late text, either.

64. Cf. also *Mencius* 5.1.4.2, as well as the statements by Bo Zhouli 伯州犁 and Zhao Meng 趙孟 in *Zuo zhuan* Xiang 27 = 546 B.C., 529 and 530, respectively. Chow Tse-tsung, "Early History of the Chinese Word *Shih* (Poetry)," in *Wen-lin: Studies in the Chinese Humanities*, ed. Chow Tse-tsung (Madison: University of Wisconsin Press, 1968), 155, mistakenly gives the year Xiang 27 as 554 B.C.

65. See Chow, 157ff., for some other examples.

66. Text in Legge's "Prolegomena," 34. *Liji*, 184f.—which is the same as *Da Dai Liji* 1.41.7a and *Kongzi jiayu shuzheng* 1.6.25f.—attributes many of the same beneficial affects to ritual 禮 rather than to *wen*.

67. For a thoughtful and more detailed reading of the Great Preface, see Van Zoeren, 95ff. I have discussed the significance of this text in the poetry of Bai Juyi 白居易 (772–846) in "Reading Po Chü-i," *T'ang Studies* 12 (1994): 73ff.

68. Cf. e.g. *Shiji* 24.1206.

69. I follow the emendation of *fang* 方 to *wen* in Stephen Owen, *Readings in Chinese Literary Thought*, Harvard-Yenching Institute Monograph Series 30 (Cambridge, Mass., and London: Harvard University Press, 1992), 50, which evidently goes back to Zheng Xuan.

70. *Liji*, 131; virtually identical to *Shiji* 24.1179.

71. Cf. Liang Qichao, *Xian-Qin zhengzhi sixiang shi* 先秦政治思想史, 3rd edition (Shanghai: Shangwu, 1924), 165f.

72. This idea, curiously popular in recent Chinese commentaries, goes back at least to Chen Daqi, 145. The notion is probably inspired by Xunzi's own statement that ritual has three bases 三本—Heaven and Earth; predecessors and ancestors; and lord and teacher (*X* 13.19.233); cf. Chen Zhengxiong, 83. The three aspects enumerated by Wei Zhengtong, 178, are ethics 道德, politics 政治, and religion 宗教—by which he means not religion in Durkheim's sense, but merely the status of Heaven in people's lives.

Chapter 4

1. Cf. *Han Shi waizhuan* 4.11b.

2. *Zhuangzi jishi* 10B.33.1102.

3. Chen Zhu 陳柱, *Gongsun Longzi jijie* 公孫龍子集解 (Shanghai: Shangwu, 1937), 2.54ff. The discussion between Gongsun Long and Kong Chuan 孔

穿 (312–262 B.C.) over the same issue—which is recorded in *Gongsun Longzi jijie* 1.39ff. and *Kongcongzi* 孔叢子 (*Sibu congkan*), 4.12.72a—is to be rejected as spurious. First, the figure of Gongsun Long cites an apocryphal tale concerning Confucius that is clearly culled from *Shuoyuan* 説苑 (*Sibu congkan*) 24.4a. Second, the misquotation in *Kongcongzi* (白馬為非白馬) is nonsensical and probably indicates the recorder's failure to understand the philosophical issues involved: cf. Hu Daojing 胡道靜, *Gongsun Longzi kao* 考, Renren wenku (Taipei: Shangwu, 1970), 23f.; and Ariel, 36. Third, the *Kongcongzi* was almost certainly forged by Wang Su or an associate (Ariel, 61ff.), and all except *juan* 2 and 3 of *Gongsun Longzi* was forged sometime during or after the fourth century A.D.: see A.C. Graham, "The Composition of the Gongsuen Long Tzyy," *Asia Major* 5, no. 2 (1957): 147–83, reprinted as the first of "Three Studies of Kung-sun Lung," in *Studies*, 126–215. Finally, the entire debate seems to have been inspired by the account in *Lüshi chunqiu jishi* 18.16bf. (appended in the *Kongcongzi* to the debate on the white horse), in which Gongsun Long and Kong Chuan argue over the paradox, "Zang [a typical proper name] has three ears" 臧 [= 臧] 三牙 [= 耳]. Graham's work on the *Gongsun Longzi*, incidentally, appears to be unappreciated in East Asia to this day; thus Li Xianzhong 李賢中, *Xian-Qin mingjia mingshi sixiang tanxi* 先秦名家名實思想探析, Wenshi zhexue jicheng 257 (Taipei, 1992), 60, argues that five-sixths of the text is reliable, yet without citing Graham.

　　Han Feizi jishi 11.32.629 attributes Gongsun Long's paradox to one Ni Yue 兒說 (fl. late 4th cent. B.C.), whose disciple is mentioned in *Lüshi chunqiu jishi* 17.9a as having appeared before "King" Yuan 元 of Song, the Crown Prince who never assumed the throne because Song was conquered by Qi in 285 B.C., during his father's reign. According to the *Han Feizi*, Ni Yue rode a white horse to the border, and was forced to pay duty on his horse, despite his contention that a white horse is not a horse. Ni Yue is mentioned also in *Huainan Honglie jijie* 18.618f.; Gao You 高誘 (ca. 168–212), in his commentary, calls him a "Grand Master of Song" 宋大夫. As Chen Zhu points out (2.47ff.), the paradox had existed before Gongsun Long. Lu Wenchao 盧文弨 (1717–1796), in his commentary on the same passage in *Lüshi chunqiu*, quoting from the *Xinlun* 新論 of Huan Tan 桓譚 (ca. 43 B.C.–A.D. 28)—now lost—recites the same story that the *Han Feizi* tells of Ni Yue, but with Gongsun Long as the protagonist. Incidentally, Lu cannot be referring to the well known fragment preserved in Li Fang 李昉 *et al.*, *Taiping yulan* 太平御覽 (*Sibu congkan*) 464.5a (quoted, for example, in Graham, *Studies*, 157), since he clearly mentions the incident at the border, which is absent from that account. Timoteus Pokora, *Hsin-lun (New Treatise) and Other Writings by H'uan T'an (43 B.C.–28 A.D.)*, Michigan Papers in Chinese Studies 20 (Ann Arbor, 1975), 124, has found the right passage in an edition of the *Bai-Kong Liutie* 白孔六帖 in the library of Beijing University—which he calls "fragment 135B" in his new redaction. Pokora (xii) also dates the completed *Xinlun* to the last three years of Huan Tan's life.

　　The attribution of the tale to Ni Yue is more likely, in accordance with the principle of *difficilior lectio*: Gongsun Long was far more widely known. This

means that a pseudo-hagiography of Gongsun Long had begun to arise as early as the beginning of the present era. The many conflicting reports of Gongsun Long's life and teachings paint a tangled picture. *Shiji* 67.2219 (= *Kongzi jiayu shuzheng* 9.227), for example, lists one Gongsun Long as a disciple of Confucius, and places the year of his birth at 498 B.C. Some commentators even suggest that this Gongsun Long is the famous dialectician (e.g. *Shiji* 74.2349); but—if we are to believe any of the other sources—this is impossible. *Shiji* 76.2370, for example, records that the dialectician Gongsun Long was a favored client of Zhao Sheng 趙勝, Lord Pingyuan 平原君 (d. 250 B.C.), which squares with the *Lüshi chunqiu* and *Kongcongzi/Gongsun Longzi* accounts. However, here Zou Yan 鄒衍 (305–240 B.C.?), rather than Kong Chuan, is credited with having refuted Gongsun Long; Zou's argument is preserved in Liu Xiang's *Bielu* 別錄, a fragment of which is in turn preserved in Pei Yin's 裴駰 fifth-century commentary (*Shiji ibid.*). Moreover, *Lüshi chunqiu jishi* 18.3bf. records a discussion between Gongsun Long and King Hui[wen] of Zhao 趙惠 [文] 王 (r. 298–265 B.C.), in which Gongsun Long urges the king to devote himself to disarmament and universal love 兼愛. In *Lüshi chunqiu jishi* 18.24bf., Gongsun Long attempts to persuade King Zhao of Yan 燕昭王 (r. 311–279 B.C.) to adopt a similar pacifism. *Lüshi chunqiu jishi* 13.15a, furthermore, seems to refer to both 18.16bff. and 18.24bf. The Gongsun Long of the *Lüshi chunqiu* (and possibly *Shiji*) therefore, active between 298 and 279 B.C., was clearly a Later Mohist, and could not have been a Confucian born in 498 B.C. Some scholars avoid the problem by assuming that there were (at least) two men named Gongsun Long, one who lived in the fifth century B.C. and one who lived in the third: cf. e.g. Tan Jiefu 譚戒甫, *Gongsun Longzi xingming fawei* 形名發微 (Beijing: Kexue, 1957), 11; and He Qimin 何啓民, *Gongsun Long yu Gongsun Longzi*, Zhongguo xueshu zhuzuo jiangzhu weiyuanhui congshu 34 (Taipei, 1967), esp. 21ff. But the fact remains that, aside from the *Gongsun Longzi* itself, there is not a single Warring States text that ascribes the white-horse paradox to Gongsun Long. Classical references to Gongsun Long are collected in Xu Fuguan, *Gongsun Longzi jiangshu* 講疏 (Taichung: Sili Donghai daxue, 1966), 53–72.

Perhaps Gongsun Long's name was used long after his death as a convenient paragon, a disciple of Confucius, to whom one might attribute any clever argument one desired. Thus *Liezi zhu* 4.48, another forged text, ascribes seven other spurious paradoxes to Gongsun Long.

4. *Zhuangzi jishi* 10B.33.1105f.

5. *Ming shi* 名實, text in A.C. Graham, *Later Mohist Logic, Ethics and Science* (Hong Kong: Chinese University Press, 1978), 470ff. There are other paradoxes in *Ming shi* not included here.

6. Other paradoxes mentioned in *Xunzi ibid.* include a second version of (3) and a shattered version of (19). It should be pointed out, however, that Xunzi's corrupt version of (19)—入乎耳山乎口 ("It enters the ear, mountains from mouths")—is not beyond reconstruction: it derives from the same source as Sima Biao's 司馬彪 (d. A.D. 306) commentary on (19) in *Zhuangzi jishi* 10B.33.1108:

呼 於 一 山 , 一 山 皆 應 , 一 山 之 聲 入 於 耳 , 形 與 聲 並 行 , 是 山 猶 有 口 也 ("If you call in a mountain, all the mountains respond; the sound from a mountain enters the ear. The shape and the sound move together; this is like the mountain's having a mouth."). In some editions, the text is emended to read 山 出 口 ("Mountains emerge from mouths"). Joseph Needham, *Science and Civilisation in China* (Cambridge: Cambridge University Press, 1954–), II, 196f., interprets 山 出 口 to mean that mountains are called "mountains" by our mouths; Needham takes 山 有 口 in Sima Biao's commentary to refer to volcanoes. According to Graham, *Later Mohist Logic*, 311f., on the other hand, a mountain may be said to descend out of a hole (= mouth) in the sky rather than rise up from the earth.

7. Drawn from the commentaries in *Zhuangzi jishi*, especially those of Sima Biao and Li Yi 李 頤 (365–420); Hu Shih, *The Development of the Logical Method in Ancient China* (Shanghai: Oriental Book Company, 1928), 112ff.; Fung, I, 197ff.; Bernard S. Solomon, "The Assumptions of Hui-tzu," *Monumenta Serica* 28 (1969), 1–40; and Graham, *Disputers*, 78ff.

8. In H. Diels and W. Kranz, *Die Fragmente der Vorsokratiker*, 10th edition (Berlin: Weidmann, 1960), 29 B 2. Cf. also Jonathan Barnes, *The Presocratic Philosophers*, revised edition, The Arguments of the Philosophers (Boston: Routledge & Kegan Paul, 1982), 238f.

9. But see Graham, *Disputers*, 79.

10. Cf. Hu Shih, 113, who argues that "the paradoxes, like those of Zeno the Eleatic, are directed to prove a monistic theory of the universe." Zhang Binglin 章 炳 麟, "Guogu lunheng" 國 故 論 衡, *Zhangshi congshu* 章 氏 叢 書 (Shanghai: Zhejiang Tushuguan, 1936), 192ff., suggests that the paradoxes are intended to illustrate the illusory nature of spatial and temporal distinctions.

11. Compare Zeno's paradox of motion, in Diels and Kranz, 29 B 4.

12. Needham, II, 197, proposes that the annihilation of the intervening states may bring about a situation in which Qi and Qin are made adjacent.

13. Cf. Li Xianzhong, 95f. Marc Lange, "Hui Shih's Logical Theory of Descriptions: A Philosophical Reconstruction of Hui Shih's Ten Enigmatic Arguments," *Monumenta Serica* 38 (1988/89), 95–114, suggests that the ten paradoxes constitute a coherent theory of descriptions, incorporating a criticism of inductive reasoning. Ralf Moritz, *Hui Shi und die Entwicklung des philosophischen Denkens im alten China*, Schriften zur Geschichte und Kultur des alten Orients 12 (Berlin: Akademie-Verlag, 1973), analyzes in unimaginative Marxist terms the ten paradoxes and other material attributed to Hui Shi—whereupon he announces: "[Die Lehre des Hui Shi] erweist sich als eine subjektivistisch-theoretische, dabei noch logisch-widersprüchliche, Konstruktion. Ihr Ergebnis ist die Auffassung von einer in sich zusammengefallenen Welt" (148). Hui Shi cannot be considered Mohist, Moritz continues, because the principle of universal love represents the laudable Mohist attempt, "die sozialen Widersprüche [zu] eliminieren"; Hui Shi, on the other hand, merely "flüchtet sich in einen inkonsequenten Relativismus" (149). This counts for Moritz as a weighty charge: relativism is of course the arch-enemy

of all ideology. Perhaps in a freer Europe scholars will no longer feel compelled to stigmatize thinkers of the past from within a framework as bankrupt and anti-intellectual as that of the Akademie der Wissenschaften der deutschen demokratischen Republik.

14. See also Mou Zongsan, "Hui Shi yu bianzhe zhi tu zhi guaishuo" 惠施與辯者之徒之怪說, *Dongfang wenhua* 東方文化 (1967), reprinted in *Mingjia yu Xunzi*, esp. 3ff.

15. Cf. John R. Searle, *Speech Acts* (Cambridge: Cambridge University Press, 1969), 73ff.

16. The literature on this paradox has mushroomed in recent years. The best alternative explanation is that of Graham, *Disputers*, 85ff., who argues that Gongsun Long was following the Later Mohist technique of differentiating mutually pervasive qualities (e.g. "being horse" and "being white"). Thus what "is horse" and "is white" is not the same as what "is horse." See also Graham, "Three Studies of Kung-sun Lung"; Mou Zongsan, "Gongsun Long zhi mingli" 公孫龍之名理, *Minzhu pinglun* 民主評論 (1963), reprinted in *Mingjia yu Xunzi*, esp. 99ff.; Zhiming Bao, "Abstraction, *Ming-shi* and Problems of Translation," *Journal of Chinese Philosophy* 14, no. 4 (1987): 419–44, esp. 425ff.; Ernstjoachim Vierheller, "Object Language and Meta-Language in the Gongsun-long-zi," *Journal of Chinese Philosophy* 20, no. 2 (1993): 181–210; Thierry Lucas, "Hui Shih and Kung Sun Lung an Approach from Contemporary Logic [*sic*; no colon]," *Journal of Chinese Philosophy* 20, no. 2 (1993): 211–55; Klaus Butzenberger, "Some General Remarks on Negation and Paradox in Chinese Logic," *Journal of Chinese Philosophy* 20, no. 3 (1993): 313–48; and Kirill Ole Thompson, "When a 'White Horse' Is Not a 'Horse,'" *Philosophy East and West* 45, no. 4 (1995): 481–99. Chad Hansen, *Language and Logic in Ancient China*, Michigan Studies on China (Ann Arbor, 1983), 61, misreads the argument about yellow horses. He dismisses it as a fallacy:

Yellow horses are horses.
Yellow horses are not white horses.
Therefore white horses are not horses.

But this is not what Gongsun Long is saying. Yellow horses satisfy the condition "horse" but not the condition "white horse"; thus "white horse" and "horse" have different senses. Hansen's solution to the paradox involves treating all Chinese nouns as "mass nouns," a move inspired by W.V. Quine's study of Japanese nouns in "Ontological Relativity," in Quine's *Ontological Relativity and other essays*, The John Dewey Essays in Philosophy 1 (New York: Columbia University Press, 1969), 36ff. A judicious consideration of Hansen is Christoph Harbsmeier, "The Mass Noun Hypothesis and the Part-Whole Analysis of the White Horse Dialogue," in Rosemont, *Chinese Texts*, 49–66.

17. It is perhaps in this way that we are to interpret the enigmatic saying of Chrysippus (ca. 279–ca. 206 B.C.): "If you say something, it comes out of your

mouth; now you say wagon, so a wagon comes out of your mouth" (Diogenes Laertius, VII.187).

18. These explanations are drawn from the same sources as those of Hui Shi's paradoxes. Paradoxes (17), (22), (24), (25), (31), and (48) are excluded from this list because I do not find any explanations convincing. (22) and (48) are probably garbled. (32) is not a paradox at all, although it is counter-intuitive.

19. See W.V. Quine's classic taxonomy of paradoxes in "Paradox," *Scientific American* 206 (1962), reprinted as "The Ways of Paradox" in Quine's *The Ways of Paradox and Other Essays*, revised edition (Cambridge, Mass., and London: Harvard University Press, 1976), 1–18. Graham has pointed out that some of the Later Mohist paradoxes involve idioms with special meanings; e.g. (34), where shi ren 事 人, "serving people," has the specific sense of "serving a husband": *Disputers*, 151. But the paradoxes work even without considering idiomatic meanings. Thus Huo in (34) serves her parents not because they are simply people, but because they are her parents. In other words, the fact that she serves her parents does not imply that she would serve anyone.

20. *Meaning and Necessity*, 2nd edition (Chicago: University of Chicago Press, 1956), sect. 31.

21. This famous example is from Bertrand Russell, "On Denoting," *Mind* 14 (1905): 479–93, reprinted in *Readings in Philosophical Analysis*, ed. Herbert Feigl and Wilfrid Sellars (New York: Appleton-Century-Crofts, 1949), 103–15.

22. The *locus classicus* is "Über Sinn und Bedeutung," *Zeitschrift für Philosophie und philosophische Kritik* 100 (1892), 25–50 (translated in Feigl and Sellars, 85–102), but the subject occupied Frege in many of his writings. Frege's foremost interpreter is now Michael Dummett; see e.g. his "Sense and Reference" and "Some Theses of Frege's on Sense and Reference," in *Frege: Philosophy of Language*, 2nd edition (Cambridge, Mass.: Harvard University Press, 1981), 81–151 and 152–203, respectively; as well as "Frege's Distinction between Sense and Reference," in *Truth and Other Enigmas*, 116–44; and more recently "Sense without Reference," in *Origins of Analytical Philosophy* (Cambridge, Mass.: Harvard University Press, 1993), 57–75. Russell proposed his own solution to the paradox of the name relation. Alonzo Church, "Intensionality and the Paradox of the Name Relation," in *Themes from Kaplan*, ed. Joseph Almog, John Perry, and Howard Wettstein (Oxford and New York: Oxford University Press, 1989), 151–65, adds his own reflections to Frege's and Russell's solutions.

23. To illustrate how critical this distinction between sense and reference can be, consider the argument in Willard Van Orman Quine, "On What There Is," in *From a Logical Point of View*, 1–19; see also Quine's *Methods of Logic*, 4th edition (Cambridge, Mass.: Harvard University Press, 1982), 259ff. Failing to distinguish sense and reference leads to the absurd conclusion that all words refer to objects which actually exist (e.g. "God" must exist). A given name has sense; therefore it must have reference (if sense and reference are not distinct). Quine

refers to this notion as "Plato's Beard," since it has persisted for centuries in dulling Occam's Razor. *Reductio ad absurdum*: the phrase "round square cupola at Berkeley" has sense. It cannot possibly have reference.

24. For an informative perspective on (46), see Quine, *Methods of Logic*, 294ff., who observes that "the Apostles are twelve, but not in the sense in which we say they are pious; for we attribute piety, but not twelveness, to each."

25. Hui Shi's close friend Zhuangzi is known for having once used the Dialecticians' technique against them:

莊子與惠子遊於濠梁之上．莊子曰：鯈魚出遊從容，是魚之樂也．惠子曰：子非魚，安知魚之樂？......莊子曰：......我知之濠上也．

Zhuangzi and Huizi [= Hui Shi] were walking on the bridge over the river Hao. Zhuangzi said: "The minnows are swimming out so carefree, this is the joy of fish." Huizi said: "You are not a fish, from where do you [get] the knowlege of the joy of fish?". . . Zhuangzi said: ". . . I know it over the Hao" (*Zhuangzi jishi* 6B.17.606f.).

Huizi asked "where" Zhuangzi knew; and Zhuangzi answered: he knew from on top of the bridge. But that is not quite the answer Huizi was expecting.

G.J. Warnock discussed a similar issue in a completely different idiom: how should one who sees a fox answer when asked whether he knows that it is a fox? See his "Seeing," *Proceedings of the Aristotelian Society* 55 (1954–55): reprinted in *Perceiving, Sensing, and Knowing*, ed. Robert J. Swartz (Garden City, N.Y.: Doubleday, Anchor Books, 1965), 52.

26. *Canons* A 94, text in Graham, *Later Mohist Logic*, 343.

27. *Ming shi* 9; text in Graham, *Later Mohist Logic*, 478.

28. Cf. the Stoic "syllogism" that pain is no evil, as argued by Cato in the Ciceronian *De finibus* III.viii.29. For Cicero's response, see IV.xix.52f.: the premise is fallacious and the conclusion unedifying.

29. See also Graham, *Later Mohist Logic*, 20f. and n.53. The "Chengfa" 成法 section of the *Shi da jing* 十大經, excavated at Mawangdui 馬王堆 in 1973, the Yellow Emperor remarks: "Cunning people will arise, using wisdom with eloquent dialectics; can I not stop them by some method?" 猾民將生，佞辯用智，不可法組 [= 沮]? His minister, Li Mu 力黑 [= 牧 or 默], answers: the Yellow Emperor can put an end to sophism by establishing the connection between names and reality. Text in *Mawangdui Hanmu boshu* 漢墓帛書 (Beijing: Wenwu, 1980), 72. Li Xueqin 李學勤, "Mawangdui boshu Jingfa Dafen ji qita" 馬王堆帛書經法大分及其他, *Daojia wenhua yanjiu* 3 (1993): 274–82, argues trenchantly that the title of the text known as *Shi da jing* or *Shiliu jing* should be merely *Jing*, i.e. *Canons*, and that *shi da* refers to ten important instructions given in the last chapter of that text, previously thought to be untitled; as it is too early to tell whether his view will become generally accepted, I still refer to the text as *Shi da jing* (*Canon of the Ten Great* [*Matters*]). Gao Zheng 高正, "Boshu 'Shisi jing' zhengming" 帛

書十四經正名, *Daojia wenhua yanjiu* 3 (1993): 283–84, suggests unconvincingly that the disputed character should be read *si* 四, since the text contains fourteen chapters with titles.

30. Knoblock, III, 115f., considers various arguments for and against the supposition that this passage was interpolated by Xunzians. In any case, there can be no serious doubt that the rectification of names represented an important issue for many philosophers other than Xunzi—especially the Later Mohists. See also e.g. *Lüshi chunqiu jishi*, 2.19af. and 16.28aff., for other references to the idea.

31. Consider also the oft-cited story of one Mr. He 和氏 who presented an uncut piece of jade before his king. When the jade expert reported that it was a stone, the king was incensed at what he supposed to be deception in Mr. He, and summarily amputated his left foot. After the king's death, Mr. He presented his jade to the successor, who promptly cut off Mr. He's right foot for the same reason. Mr. He then wept until he bled, and informed the king's emissary that he was crying not for the loss of his limbs, but because 夫寶玉而題之以石,貞士而名之以誑—"a precious jade is referred to as a stone; a loyal vassal is dubbed a villain," *Han Feizi jishi* 4.13.238; repeated in *Xinxu shuzheng* 5.138f. and alluded to in *Lunheng jijie* 15.307, in addition to many other texts. Cf. also Eric Henry, "The Motif of Recognition in Early China," *Harvard Journal of Asiatic Studies* 47, no. 1 (1987): 8. One of the most hackneyed examples of the trope, that a king 王 is so only if he acts like a king, is echoed in the West by St. Isidore of Seville (d. A.D. 636): "Reges a regendo vocati. . . . Recte igitur faciendo regis nomen tenetur, peccando amittitur" ("Kings are so called by ruling. . . . Therefore the name of king is held by acting correctly, and is lost by sinning")—*Etymologiae* 9.3.4; text in San Isidoro de Sevilla, *Etimologías*, ed. Jose Oroz Reta and Manuel-A. Marcos Casquero, Biblioteca de Autores Cristianos 433 (Madrid: La Editorial Católica, 1982), I, 764. For a typical Chinese formulation, consider the fragment attributed to Shen Buhai 申不害 (d. 337 B.C.): "The lord is honored because he commands. If his commands are not carried out, then there is no lord" 君之所以尊者令,令不行是無君也; text in Herrlee G. Creel, *Shen Pu-hai: A Chinese Political Philosopher of the Fourth Century B.C.* (Chicago and London: University of Chicago Press, 1974), 358, fragment (7).

32. See John Makeham, *Name and Actuality in Early Chinese Thought*, SUNY Series in Chinese Philosophy and Culture (Albany, 1994), 57ff., for a discussion of Xunzi in the broad context of early Chinese theories of naming.

33. Knoblock's note *ad loc.*, III, 336n.27, contains two errors: he reads "*jiu suan*" for *sa suan* 洒酸 (evidently mistaking 洒 for 酒), and speaks of "*shan*" 扇 in Yang Liang's commentary where the text has *lou* 漏.

34. The many commentarial emendations suggested for *pi* 鈹 are unwarranted; the word means "needle," hence "aciform," or "sharp."

35. For a survey of Xunzi's insights into linguistics, see William S-Y. Wang, "Language in China: A Chapter in the History of Linguistics," *Journal of Chinese*

Linguistics 17, no. 2 (1989): 186ff. Xunzi later adds that names may still have an inherent goodness 善: if they are "straight, easy, and not at odds with [what they designate]" 徑易而不拂, then they are good names. The argument is somewhat baffling, and commentators have been at a loss to explain how this does not represent a contradiction of the arbitrariness principle that Xunzi has just expounded: e.g. Ch'ien, 151; and Tang Junyi, *Daolun pian*, 160f. Long Yuchun, "Xunzi Zhengming pian zhongyao yuyan lilun chanshu" 荀子正名篇重好語言理論闡述, *Guoli Taiwan Daxue wen shi zhe xuebao* 國立臺灣大學文史哲學報 18 (1969), reprinted in Long's *Xunzi lunji*, 107–26, argues with some persuasiveness that words can be said to be "good" only *with respect to each other*; that is to say, the names of objects are absolutely arbitrary, but from the point of view of speakers, pairs of words may seem aptly named if they share both semantic and phonological similarities. If we are to accept this hypothesis, then we must recognize that Xunzi anticipates not only the arbitrariness theory of Saussure, but *also the non-arbitrariness theory* of Roman Jakobson, which is articulated in e.g. "Quest of the Essence of Language," *Diogenes* 51 (1966), reprinted in Jakobson's *On Language*, ed. Linda R. Waugh and Monique Monville-Burston (Cambridge, Mass., and London: Harvard University Press, 1990), 407–21. It is particularly in this second accomplishment that Xunzi's originality is to be found; for a well-known Warring States story illustrates Saussure's idea by telling of a man who asked for jade and got a rat (a homonym in a different dialect) instead. See e.g. *Zhuangzi jishi* 10B.33.1107n.6; *Shizi* 尸子 (*Sibu beiyao* 四部備要 ed.), B.7b; *Zhanguo ce*, 5.201f.; and the discussion in A.C. Graham, "'Being' in Western Philosophy Compared with *Shih/Fei* and *Yu/Wu* in Chinese Philosophy," in *Studies*, 338n.32. None of the above, it should be noted, are certifiably Warring States texts; for the *Shizi* is often regarded as forged. See e.g. Zhang Xitang, "*Shizi* kaozheng" 尸子考證, *Gushi bian*, IV, 646–53; Jin Dejian 金德建, "*Shizi* zuozhe yu *Erya*" 尸子作者與爾雅, *Gushi bian*, VI, 306–13. Graham, *Disputers*, 495, considers it a text from the late 3rd cent. B.C.

36. *Philosophical Investigations*, tr. G.E.M. Anscombe, 3rd edition (Oxford: Basil Blackwell, 1968), II.xi, p. 197. Wittgenstein's distinction between two modes of perception goes back to that made by Witelo (fl. 1268–1277), an admirer of Alhazen (ca. 965–1039), between perception *a uisu solo simpliciter* and *cum ratione et distinctione*: *Perspectiva*, III.60; text in Clemens Baeumker, *Witelo: Ein Philosoph und Naturforscher des XIII. Jahrhunderts*, 2nd edition, Beiträge zur Geschichte der Philosophie und Theologie des Mittelalters 3.2 (Munster: Aschendorff, 1991), 143. Thus Witelo maintains that images such as light and color are grasped by the *uisus* alone, whereas the conception of the similarity of two forms requires reason. Cf. Baeumker, 623f.; and Umberto Eco, *Art and Beauty in the Middle Ages*, tr. Hugh Bredin (New Haven and London: Yale University Press, 1986), 68f.

Witelo is, of course, building upon foundations laid by Aristotle, who sets forth a similar argument in *De Anima*, ed. Sir David Ross (Oxford: Clarendon,

1961), 426b8–29: the judgment that white and sweet are different kinds of sensible qualities is made by the *koinē aisthēsis*, or common sense, because both sensations must be apperceived by the same faculty. Cf. G. Verbeke, "Doctrine du pneuma et entéléchisme chez Aristote," *Aristotle on mind and the senses*, ed. G.E.R. Lloyd and G.E.L. Owen, Proceedings of the Seventh Symposium Aristotelicum, Cambridge Classical Studies (Cambridge, 1978), 212n.46; and Deborah K.W. Modrak, *Aristotle: The Power of Perception* (Chicago and London: University of Chicago Press, 1987), 65.

37. In the idiom of contemporary philosophy, one of the most influential essays on this matter is G.N.A. Vesey, "Seeing and Seeing As," *Proceedings of the Aristotelian Society* 56 (1955–56), reprinted in Swartz, 68–83. Vesey does not even consider apperception a separate act at all: he distinguishes between our judgment of an object to be what it looks like, and the object's appearance itself. The point is that (from our point of view) the object's appearance is phenomenal rather than intellectual. Naturally, without an observer, an object has no particular "look" about it, just as a taste is not inherently pleasant or unpleasant.

38. Xunzi borrows many items of Later Mohist vocabulary in this passage (cf. Makeham, 57; and Graham, *Later Mohist Logic*, 63); for the translations of these terms, I rely directly on Graham, *Later Mohist Logic*, 167ff., since a justification of each rendering would result only in a repetition of what Graham has done. Thus *lunyi yi* (and not *lun yiyi*) 論一意 means not "propound one idea" but "sort ideas into one."

39. Xunzi's concept of the Way bears significant resemblance to the naturalism of the excavated Huang-Lao texts; see e.g. Yu Mingguang 余明光, "Xunzi sixiang yu Huang-Lao zhi xue" 荀子思想與黃老之學, *Daojia wenhua yanjiu* 6 (1995): 160–74.

40. Some scholars suppose that being an absolutist does not necessarily disqualify one from also being a relativist. Peter Gardner, "Ethical Absolutism and Education," in *Ethics*, ed. A. Phillips Griffiths, Royal Institute of Philosophy Supplement 35 (Cambridge: Cambridge University Press, 1993), 79, for example, remarks: "The [relativist] claim that different people hold different moral views may be perfectly compatible with absolutism." The critical difference between absolutism and relativism, for Gardner, involves ideas about truth. Relativists allegedly hold that the truth of a statement depends on a society's conventions, while absolutists are committed to at most one truth in a set of logically incompatible statements. But this is a rigid understanding of relativism. W.V. Quine's relativism, for example, still allows for only one "fact of the matter," as though he were what Gardner would call an absolutist. See e.g. Quine's "Things and Their Place in Theories," in *Theories and Things* (Cambridge and London: Harvard University Press, Belknap Press, 1981), 21ff. Thus Gardner transmogrifies the relativism that Quine takes to be an epistemological attitude into the belief that different ontologies can be equally "true." But the distinction between truth and evidential support is critical to Quine's philosophy as it informs the difference

between the underdetermination of theory by observation on the one hand, and the indeterminacy of translation on the other; cf. Roger F. Gibson, Jr., "Translation, Physics, and Facts of the Matter," in *The Philosophy of W. V. Quine*, ed. Lewis Edwin Hahn and Paul Arthur Schilpp, The Library of Living Philosophers 18 (La Salle, Ill.: Open Court, 1986), 139–54. The most famous critic to have confused the issue is Richard Rorty, in "Indeterminacy of Translation and Truth," *Synthese* 23 (1972): 443–62, and again in *Philosophy and the Mirror of Nature* (Princeton: Princeton University Press, 1979), 192ff.

41. On Zhuangzi's relativism, see e.g. Chad Hansen, "A *Tao* of *Tao* in *Chuang-tzu*," in *Experimental Essays on Chuang-tzu*, ed. Victor H. Mair, Asian Studies at Hawaii 29 ([Honolulu], 1983), 24–55; Philip J. Ivanhoe, "Zhuangzi on Skepticism, Skill, and the Ineffable Dao," *Journal of the American Academy of Religion* 61, no. 4 (1993): 639–54; and Philip J. Ivanhoe, "Was Zhuangzi a Relativist?" in Kjellberg and Ivanhoe, 196–214.

42. *Zhuangzi jishi* 1B.2.63ff.

43. Cf. Kuang-ming Wu, *The Butterfly as Companion: Meditations on the First Three Chapters of the* Chuang Tzu, SUNY Series in Religion and Philosophy (Albany, 1990), 249f.; Graham, *Studies*, 336ff.; and Graham, *Disputers*, 179. In spite of his criticism of Mohism, Zhuangzi appropriates here at least one Mohist technical term: *yin* 因, "depend [on]," a frequent relation between concepts in Later Mohist logic.

44. Cf. Liu Xiang's observation: "He pled that the Way of the King is very easy to practice" 陳王道甚易行 (*X* 20.32.367).

45. The *Xunzi bian* appears in *Jiexiao xiansheng wenji* 節孝先生文集, in *Yingyin Wenyuan'ge Siku quanshu* 景印文淵閣四庫全書 (Taipei: Shangwu, 1983), vol. 1101, 29.1a–6a = 930–32; it is also cited *in toto*, with Huang Baijia's commentary, in *Song-Yuan xue an*, 1.32ff.

46. Recently Kai-wing Chow, *The Rise of Confucian Ritualism in Late Imperial China: Ethics, Classics, and Lineage Discourse* (Stanford: Stanford University Press, 1994), 195, argues that some thinkers of the very late Imperial period — notably Ling Tingkan 凌廷堪 (1757–1809) — attempted to rehabilitate Xunzi for his supremacy "in the knowledge of ancient ritual propiety." This was, however, precisely the reason why Xunzi was criticized no less vigorously by figures such as Tan Sitong 譚嗣同 (1864–1898), who believed that his ritualism "had for centuries restrained and oppressed the Chinese people" (Kai-wing Chow, 228).

47. Here a legacy of Western political thought has given us a paradigm with which to compare the thought of Xunzi. Xunzi's relation between the Way and ritual mirrors that laid out between *aequitas* ("equity") and *lex* ("law") in the political philosophy of John of Salisbury (ca. A.D. 1115–1180):

Porro aequitas, ut juris periti asserunt, rerum convenientia est, quae cuncta coaequiparat ratione, et in paribus rebus paria jura desiderat, in omnes aequabilis, tribuens unicuique quod suum est. Lex vero ejus interpres est,

utpote cui aequitatis et justitiae voluntas innotuit. . . . Princeps tamen legis nexibus dicitur absolutus, non quia et iniqua liceant, sed quia is esse debet, qui non timore poenae, sed amore justitiae aequitatem colat, reipublicae procuret utilitatem, et in omnibus, aliorum commoda privatae praeferat voluntati.

Further, equity, as those expert in the law claim, is the conformity of things, which compares everything with reason, and which requires the same rules in the same affairs, equitable with regard to everyone, allotting to each what is his. The law, indeed, is its mediator, inasmuch as the will of justice and equity have become known to it. . . . However, the prince is said to be unfettered by the binds of law, not because even iniquities are permitted [to him], but because he should be one who cultivates equity not through fear of punishment but through love of justice, who takes care of the well-being of the republic, and in all matters prefers the advantage of others to his personal desire.

Text in Ioannis Saresberiensis episcopi Carnotensis *Policratici sive De nugis curialium et vestigiis philosophorum libri VIII*, ed. Clemens C.I. Webb (Oxford, 1909; rpt., Frankfurt: Minerva, 1965), IV.ii.

John of Salisbury's political ideal is *aequitas*, or equity among citizens, which represents his vision of justice. *Lex*, the law, is the *interpres*, or mediator, of equity, but *not equity itself*. The law is a means by which equity may be instituted. The prince is free to depart from the law where he considers it vital to the promotion of equity; he retains, in other words, the power of amercement. The prince is set free of the law in order that he not lose sight of his primary directive, the establishment of *aequitas* on earth. The *content* of *aequitas* is by no means the same as that of Xunzi's Way; but John's law and Xunzi's ritual stand in analogous position with respect to the two philosophers' supreme ideals. Cf. Cary J. Nederman, "A Duty to Kill," *Review of Politics* 50, no. 3 (1988): 386n.50; and Richard H. and Mary A. Rouse, "John of Salisbury and the Doctrine of Tyrannicide," *Speculum* 42.4 (1967), 701f.

48. Cf. Vincent Y.C. Shih, "Hsüntzu's Positivism," *Qinghua xuebao* 4, no. 2 (1964): 171ff.

Bibliography

I. Pre-Imperial and Early Imperial Works in Chinese

Note: Classical Chinese texts from the middle and modern periods appear in Section II. For more information on most of these texts, consult Michael Loewe, ed., *Early Chinese Texts*, Early China Special Monographs Series 2 (Berkeley, 1993). Radically different theories regarding many of these texts can be found in E. Bruce Brooks's review of Loewe in *Sino-Platonic Papers* 46 (1994): 1–74. Since some of the texts listed here are now thought to have been forged, there will be some items in Section II that actually antedate certain titles in Section I.

CHUCI 楚辭 (*Lyrics of Chu*). Hong Xingzu 洪興祖. *Chuci zhangju buzhu* 章句 補注. Ed. Chen Zhi 陳直. In *Chuci zhu bazhong* 楚辭注八種. Zhongguo wenxue mingzhu. Taipei: Shijie, 1989. Text attributed to Qu Yuan 屈原 (3rd cent. B.C.) and others, originally compiled by Wang Yi 王逸 (fl. A.D. 120). Later commentary by Hong Xingzu (1090–1155).

CHUNQIU ZUOZHUAN 春秋左傳 (*Springs and Autumns, Zuo Commentary*). James Legge. *The Chinese Classics*. 5 volumes in 4. N.d.; rpt., Taipei: SMC Publishing, 1992. Vol. 5: *The Ch'un Ts'ew with the Tso Chuen*. Attributed ceremonially to Confucius 孔丘 (551–479 B.C.), with commentary attributed to Zuo Qiuming 左丘明 (fl. 5th cent. B.C.), but dating probably to the fourth century or later.

DA DAI LIJI 大戴禮記 (*Record of Rites of Dai the Elder*). *Sibu congkan* 四部叢刊. Compilation attributed to Dai De 戴德 (fl. 1st cent. B.C.), but probably dating to a time two or three centuries later. Commentary by Lu Bian 盧辯 (fl. 519–557).

FAYAN 法言 (*Model Sayings*). *Sibu beiyao* 四部備要. Text by Yang Xiong 揚雄 (53 B.C.–A.D. 18).

FENGSU TONGYI 風俗通義 (*Comprehending the Meaning of Traditions*). Wang Liqi 王利器. *Fengsu tongyi jiaozhu* 校注. Beijing: Zhonghua, 1981; rpt., Taipei: Mingwen, 1982. Text by Ying Shao 應劭 (d. A.D. 195).

GONGSUN LONGZI 公孫龍子. Chen Zhu 陳柱. *Gongsun Longzi jijie* 集解. Shanghai: Shangwu, 1937. Attributed to Gongsun Long (fl. early 3rd cent. B.C.), but most chapters were forged several centuries later.

GUANZI 管子. Dai Wang 戴望. *Guanzi jiaozheng* 校正. In *Guanzi Shangjun shu* 商君書. Zhongguo sixiang mingzhu. Taipei: Shijie, 1990. Miscellaneous

anthology redacted by Liu Xiang 劉向 (79–8 B.C.) and named after Guan Zhong 管仲 (d. 645 B.C.), though most of its contents date from the time of the academy at Jixia. Commentary by Yin Zhizhang 尹知章(d. A.D. 718), but sometimes attributed to Fang Xuanling 方玄齡 (578–648). Later commentary by Dai Wang (1783–1863).

GUOYU 國語 (*Speeches of the States*). Shanghai: Guji, 1978; rpt., Taipei: Liren, 1981. Anthology attributed to Zuo Qiuming, containing materials from the fourth and possibly late fifth centuries B.C. Certainly not written by the same author as the *Zuo zhuan*. Commentary by Wei Zhao 韋昭 (A.D. 204–273).

HAN FEIZI 韓非子. Chen Qiyou 陳奇猷. *Han Feizi jishi* 集釋. 2 volumes. Zhongguo sixiang mingzhu. Beijing: Zhonghua, 1958; rpt., Taipei: Shijie, 1991. Text by Han Fei (d. 233 B.C.), a student of Xunzi. Thought by some to contain later accretions, by others to be largely authentic. The Shijie edition includes Chen's *Han Feizi jishi bu* 補 of 1961.

HAN SHI WAIZHUAN 韓詩外傳 (*External Commentary to the Han Odes*). *Sibu congkan*. Heterogeneous collection of anecdotes illustrating principles in the *Odes*. Attribution to Han Ying 韓嬰 (fl. mid-2nd cent. B.C.) not easily refuted—although Han certainly borrowed freely from older material.

HANSHU 漢書 (*Book of Han*). Beijing: Zhonghua, 1962. Compiled by Ban Gu 班固 (A.D. 32–92), continuing the work of his father, Ban Biao 班彪 (A.D. 3–54). Some sections completed after Ban Gu's death by his sister Ban Zhao 班昭 (48?–116?), with the assistance of Ma Xu 馬續 (fl. 116–141).

HEGUANZI 鶡冠子 (*Master of the Pheasant Cap*). Lu Dian 陸佃. *Heguanzi jie* 解. In *Heguanzi deng niansan zhong* 等廿三種. Zengding Zhongguo xueshu mingzhu, Series 1; Zengbu Zhongguo sixiang mingzhu 12. Taipei: Shijie, 1979. Text attributed to the mysterious teacher of General Pang Xuan 龐煖 (fl. 242 B.C.), and of unclear provenance. Commentary by Lu Dian (1042–1102).

HUAINANZI 淮南子. Liu Wendian 劉文典. *Huainan honglie jijie* 淮南鴻烈集解. Ed. Feng Yi 馮逸 and Qiao Hua 喬華. 2 volumes. Xinbian Zhuzi jicheng, Series 1. Beijing: Zhonghua, 1989. Miscellany compiled at the court of Liu An 劉安, Prince of Huainan (d. 122 B.C.). Commentary by Gao You 高誘 (ca. 168–212).

KONGCONGZI 孔叢子 (*Masters of the Kong Clan*). *Sibu congkan*. Attributed to Kong Fu 孔鮒 (264–208 B.C.), an eighth-generation descendant of Confucius; now widely believed to be a forgery by Wang Su 王肅 (A.D. 195–256).

KONGZI JIAYU 孔子家語 (*School Sayings of Confucius*). Chen Shike 陳士珂. *Kongzi jiayu shuzheng* 疏證. Wanyou wenku, Guoxue jiben congshu (N.p.: Shangwu, 1939). A spurious work purporting to consist of those Confucian sayings not included in the *Analects*. It was "discovered" by Wang Su, and few scholars accept it as genuine. The edition by Chen Shike (fl. 1818) lists parallels in other texts.

LAOZI 老子. Ma Xulun 馬敘倫. *Laozi jiaogu* 校詁. Beijing: Guji, 1956. The

provenance of the *Laozi* has been the subject of countless inquiries. Final form dates probably to the third century B.C., with older vestiges.

LIEZI 列子. Zhang Zhan 張湛. *Liezi zhu* 注. Zhongguo sixiang mingzhu. Taipei: Shijie, 1992. Attributed to Lie Yukou 列禦寇 (fl. 4th cent. B.C.?), although almost certainly forged in the third or fourth century A.D., with the apparent collaboration of the "commentator" Zhang Zhan (fl. A.D. 4th cent.).

LIJI 禮記 (*Book of Rites*). *Shisan jing* 十三經 (Shanghai: Shangwu, 1914). Compilation attributed—almost certainly falsely—to Dai Sheng 戴聖 at the turn of our era. Received text may have been transmitted by Cao Bao 曹襃 (d. A.D. 102).

LUNHENG 論衡 (*Discourses Weighed*). Liu Pansui 劉盼遂. *Lunheng jijie* 集解. 2 volumes. Zhongguo sixiang mingzhu. Beijing: Guji, 1957; rpt., Taipei: Shijie, 1990. Rationalist, satirical text authored by Wang Chung 王充 (A.D. 27–ca. 100).

LUNYU 論語 (*Analects*). Legge, vol. 1: *Confucian Analects, the Great Learning, and the Doctrine of the Mean*. Sayings of Confucius said to have been collected by his students after his death. The text, however, contains different layers from different pens, some possibly from after the establishment of the Empire. The title dates from Imperial times.

LÜSHI CHUNQIU 呂氏春秋 (*Springs and Autumns of Mr. Lü*). Xu Weiyu 許維遹. *Lüshi chunqiu jishi* 集釋. 3 volumes. Zengding Zhongguo xueshu mingzhu, Series 1; Zengbu Zhongguo sixiang mingzhu 19. Beijing: Guoli Qinghua Daxue, 1935; rpt., Taipei: Shijie, 1988. Philosophical encyclopedia commissioned by Lü Buwei 呂不韋 (d. 235 B.C.); preface dated 239 B.C. Undisputedly pre-Imperial, but the whole of the text is not easily datable.

MENGZI 孟子 (*Mencius*). Legge, vol. 2: *The Works of Mencius*. Alleged to be the discourses of Mencius 孟軻 (372–289 B.C.), though its quotations are always to be taken *cum grano salis*. Redacted by Zhao Qi 趙岐 (d. A.D. 201).

MU TIANZI ZHUAN 穆天子傳 (*Biography of Mu, Son of Heaven*). *Sibu beiyao*. A fantastical text, purporting to be a biography of Mu, the mad fifth king of Zhou (r. 1001–947 B.C., according to the traditional chronology); found in ca. A.D. 281 in a tomb dating to 296 B.C. The last third of the received text may have undergone some adulteration.

SHENZI 慎子. P.M. Thompson. *The Shen-tzu Fragments*. Oxford: Oxford University Press, 1979. Fragments attributed to the thinker Shen Dao 慎到 (fl. 310 B.C.). There are no bibliographical or textual reasons to doubt their authenticity.

SHI DA JING 十大經 (*Ten Great Canons*). *Mawangdui Hanmu boshu* 馬王堆漢墓帛書. Beijing: Wenwu, 1980. One of four anonymous texts excavated at Mawangdui in 1973. Of disputed date and origin; probably from the very late pre-Imperial or early Imperial period.

SHIJI 史記 (*Records of the Historian*). Beijing: Zhonghua, 1959. Epoch-making historical work by Sima Qian 司馬遷 (145–86 B.C.), continuing the project

of his father, Sima Tan 談 (d. 110 B.C.). Chu Shaosun 褚少孫 (104?–30 B.C.?) added some passages after Sima Qian's death. Some sections are of questionable veracity, and other sections may have been lost very early and reconstructed still in Classical times.

SHIJING 詩經 (*Book of Odes*). Legge, vol. 4: *The She King of the Book of Poetry.* Songs purportedly from Chou times. The transmission of this text is a subject fit for an entire monograph.

SHIZI 尸子. *Sibu beiyao.* Text attributed to Shi Jiao 尸佼 (fl. 4th cent. B.C.). May well have been forged.

SHUJING 書經 (*Book of Documents*). Legge, vol. 3: *The Shoo King or Book of Historical Documents.* Supposed documents and speeches from the earliest period of recorded history in China. Contains a genuine core, mixed with materials dating down to the Warring States period. Legge's text includes both the "Old Text" 古文 and "New Text" 今文 traditions, which is unfortunate, as the "Old Text" chapters are now known to have been a forgery of the first millennium A.D. (The culprit may have been Mei Ze 梅賾 [fl. 317–322].) Some care has been taken here to cite only passages that appear in both recensions.

SHUOYUAN 説苑 (*Garden of Sayings*). *Sibu congkan.* Anthology compiled by Liu Xiang from a morass of texts in the Imperial Library. The contents date from the late Warring States and early Han periods, though they are often set in earlier times.

WU YUE CHUNQIU 吳越春秋 (*Springs and Autumns of Wu and Yue*). Wanyou wenku. Shanghai: Shangwu, 1937. Compiled by Zhao Ye 趙曄 (fl. A.D. 40). Received text may be the compilation of Huangfu Zun 皇甫尊 (fl. A.D. seventh century), and is in any case probably perverted.

XINXU 新序 (*Newly Arranged [Anecdotes]*). Cai Xinfa 蔡信發. *Xinxu shuzheng* 疏證. Wenhua Jijinhui yanjiu lunwen 37. Taipei: Chia Hsin Foundation, 1980. Anthology much like *Shuoyuan*, likewise edited by Liu Xiang. *Xinxu* may not have been the original title; rather, it might mean merely "a new arrangment" [of *Shuoyuan*].

XUNZI 荀子. Wang Xianqian 王先謙. *Xunzi jijie* 集解. Zhongguo sixiang mingzhu. Beijing: Guji, 1954; rpt., Taipei: Shijie, 1992. Text attributed to Xun Kuang 荀況 (ca. 310–ca. 210 B.C.).

YIJING 易經 (*Book of Changes*). *Shisan jing.* Many-layered divinatory text of uncertain date, with a skeleton dating to the first half of the first millennium B.C. Most of the appendices, though attributed ceremonially to Confucius, date to the late third and early second centuries B.C.

ZHANGUO CE 戰國策 (*Intrigues of the Warring States*). 2 volumes. Shanghai: Guji, 1978; rpt., Taipei: Liren, 1990. Compiled by Liu Xiang. Amusing anthology of anecdotes from the Warring States, with no pretensions to historicity. Commentaries by Yao Hong 姚宏 (d. 1146) and Bao Biao 鮑彪 (1106–1149); the Shanghai Guji edition includes the contributions of Huang

Peilie 黃丕烈 (1763–1825) to the Yao edition and of Wu Shidao 吳師道 (1283–1344) to the Bao edition.

ZHUANGZI 莊子. Guo Qingfan 郭慶藩. *Zhuangzi jishi* 集釋. Ed. Wang Xiaoyu 王孝魚. Xinbian Zhuzi jicheng, Series 1. Beijing: Zhonghua, 1961. Attributed to Zhuang Zhou 莊周 (d. ca. 320 B.C.). Few scholars disagree that the so-called "inner chapters" are genuine; the rest is now believed to have congealed in the first century B.C., perhaps at the court of Liu An. Collected explanations by Guo Qingfan (1844-1896).

II. *Other Sources in East Asian Languages*

Note: This section includes representative works only. It is not possible to cite every Chinese and Japanese study of Xunzi. For the sake of concision, pieces by the same author in one book are represented collectively by the title of the anthology. Contributions to collaborative volumes receive their own entries, but where these are reprinted or revised, the original bibliographical data are omitted here. Sources are alphabetized by character; thus e.g. "Yuheng" 玉衡 comes before "Yuanyi" 元儀.

CAI Yuanpei 蔡元培. *Zhongguo lunlixue shi* 中國倫理學史. Zhongguo wenhua shi congshu, 2nd series. Shanghai: Shangwu, 1937.

CHEN Daqi 陳大齊. *Xunzi xueshuo* 荀子學說. Xiandai guomin jiben zhishi congshu, 2nd series. Taipei: Zhongguo wenhua chuban shiye weiyuanhui, 1954.

CHEN Dengyuan 陳登元. *Xunzi zhexue* 荀子哲學. Guoxue xiao congshu. Shanghai: Shangwu, 1930.

CHEN Feilong 陳飛龍. *Xunzi lixue zhi yanjiu* 荀子禮學之研究. Wen shi zhe xue jicheng. Taipei: Wen shi zhe, 1979.

CHEN Li 陳澧. *Dongshu dushu ji* 東塾讀書記. Shanghai: Shangwu, 1930.

CHEN Zhengxiong 陳正雄. *Xunzi zhengzhi sixiang yanjiu* 荀子政治思想研究. Yungho: Wenjin, 1980.

CHENG Zhaoxiong 程兆熊. *Xunzi jiangyi* 荀子講義. Hong Kong: Ehu, 1963.

DAI Zhen 戴震. *Mengzi ziyi shuzheng* 孟子字義疏證. Beijing: Zhonghua, 1961.

DU Guoxiang 杜國庠. *Du Guoxiang wenji* 杜國庠文集. Beijing: Renmin, 1962.

FENG Youlan 馮友蘭. "*Daxue* wei Xunxue shuo" 大學為荀學說. *Gushi bian*, IV, 175–83.

FU Sinian 傅斯年. *Xing ming guxun bianzheng* 性命古訓辨證. 2 volumes. Shanghai: Shangwu, 1947.

GAO Zheng 高正. "Boshu 'Shisi jing' zhengming" 帛書十四經正明. *Daojia wenhua yanjiu* 道家文化研究 3 (1993): 283–84.

GUO Moruo 郭沫若. *Shi pipan shu* 十批判書. Guo Moruo wenji, series 1, no. 2. N.p.: Qunyi, 1946.

———. *Jinwen congkao* 金文叢考. Beijing: Renmin, 1954.

———. *Qingtong shidai* 青銅時代. Beijing: Kexue, 1957.

HAN Yu 韓愈. *Han Changli wenji jiaozhu* 韓昌黎文集校注. Ed. Ma Qichang 馬其昶. Shanghai: Guji, 1986.

HE Qimin 何啓民. *Gongsun Long yu Gongsun Longzi* 公孫龍與公孫龍子. Zhongguo xueshu zhuzuo jiangzhu weiyuanhui congshu 34. Taipei, 1967.

HU Daojing 胡道靜. *Gongsun Longzi kao* 公孫龍子考. Renren wenku. Taipei: Shangwu, 1970.

HU Jiacong 胡家聰. "Lun Rujia Xun Kuang sixiang yu Daojia zhexue de guanxi" 論儒家荀況思想與道家哲學的關係. *Daojia wenhua yanjiu* 6 (1995): 175–82.

HU Shi 胡適. *Zhongguo zhexueshi dagang* 中國哲學史大綱. 2 volumes. Beijing daxue congshu. Shanghai: Shangwu, 1931.

HU Yuheng 胡玉衡 and Li Yu'an 李育安. *Xun Kuang sixiang yanjiu* 荀況思想研究. Henan: Zhongzhou, 1983.

HU Yuanyi 胡元儀. *Xun Qing biezhuan* 荀卿別傳. Reprinted in Wang Xianqian, *Xunzi jijie*, kaozheng 考證 B.25–38.

HUANG Zongxi 黃宗羲, *et al. Song-Yuan xue an* 宋元學案. Guoxue jiben congshu. Shanghai: Shangwu, 1936.

IKEDA Suetoshi 池田末利. *Chūgoku kodai shūkyōshi kenkyū* 中國古代宗教史研究. Tokyo: Taikai Daigaku, 1981.

ITANO Chōhachi 板野長八. "Junshi no tenjin no bun to sono ato" 荀子の天人の分とその後. *Hiroshima Daigaku Bungakubu kiyō* 廣島大學文學部紀要 28, no. 1 (1968): 112–34.

JIANG Kuizhong 姜奎忠. *Xunzi xing shan zheng* 荀子性善證. N.p.: Xiangqiao shu, 1926.

JIANG Ronghai 姜榮海. "Shen Dao ying shi Huang-Lao sixiangjia" 慎到應是黃老思想家. *Beijing Daxue xuebao* 北京大學學報 1 (1989): 110–16.

JIANG Shangxian 姜尚賢. *Xunzi sixiang tixi* 荀子思想體系. Sixiang congshu. Tainan, 1966.

JIN Dejian 金德建. "*Shizi* zuozhe yu *Erya*" 尸子作者與爾雅. *Gushi bian*, VI, 306–13.

KANAYA Osamu 金谷治. "*Junshi* no bunkengaku teki kenkyū" 荀子の文獻學的研究. *Nihon gakushiin kiyō* 日本學士院紀要 9, no. 1 (1951): 9–33.

——. "Junshi no tenjin no bun ni tsuite" 荀子の天人の分について. *Shūkan tōyōgaku* 集刊東洋學 24 (1970): 1–14.

KODAMA Rokurō 兒玉六郎. "Junshi no ten ni tai suru ichi kōsatsu" 荀子の天に對する一考察. *Shinagaku kenkyū* 支那學研究 33 (1968): 42–49.

KONG Fan 孔繁. *Xun Kuang* 荀況. Xi'an: Renmin, 1975.

LI Cunshan 李存山. "*Neiye* deng si pian de xuezuo shijian he zuozhe" 內業等四篇的學作時間和作者. *Guanzi xuekan* 管子學刊 1987, no. 1: 31–37.

LI Deyong 李德永. *Xunzi* 荀子. Shanghai: Renmin, 1959.

——. "Daojia lilun siwei dui Xunzi zhexue tixi de yingxiang" 道家理論思維對荀子哲學體系的影響. *Daojia wenhua yanjiu* 1 (1992): 249–64.

L<small>I</small> Fang 李昉, *et al*., eds. *Taiping yulan* 太北御覽. *Sibu congkan*.

L<small>I</small> Fengding 李鳳鼎. "Xunzi chuanjing bian" 荀子傳經辨. *Gushi bian*, IV, 136–40.

L<small>I</small> Xianzhong 李賢中. *Xian-Qin mingjia mingshi sixiang tanxi* 先秦名家名實思想探析. Wenshi zhexue jicheng 257. Taipei, 1992.

L<small>I</small> Xueqin 李學勤. "Mawangdui boshu Jingfa Dafen ji qita" 馬王堆帛書經法大分及其他. *Daojia wenhua yanjiu* 3 (1993): 274–82.

L<small>IANG</small> Qichao 梁啓超. "Xun Qing ji *Xunzi*" 荀卿及荀子. *Gushi bian*, IV, 104–14.

———. *Xian-Qin zhengzhi sixiang shi* 先秦政治思想史. 3rd edition. Shanghai: Shangwu, 1924.

L<small>IANG</small> Qixiong 梁啓雄. *Xunzi jianshi* 荀子柬釋. Shanghai: Shangwu, 1936.

L<small>IU</small> Zijing 劉子靜. *Xunzi zhexue gangyao* 荀子哲學綱要. Renren wenku 1076. Taipei: Shangwu, 1969.

L<small>ONG</small> Yuchun 龍宇純. *Xunzi lunji* 荀子論集. Taipei: Xuesheng, 1987.

L<small>U</small> Ji 陸機. *Maoshi caomu niaoshou chongyu shu* 毛詩草木鳥獸蟲魚疏. *Yingyin Wenyuan'ge Siku quanshu* 景印文淵閣四庫全書, LXX.

L<small>U</small> Jiuyuan 陸九淵. *Lu Jiuyuan ji* 陸九淵集. Beijing: Zhonghua, 1980.

L<small>UO</small> Genze 羅根澤. "Xun Qing youli kao" 荀卿遊歷考. *Gushi bian*, IV, 123–36.

———. *Zhuzi kaosuo* 諸子考索. Beijing: Renmin, 1958.

L<small>UO</small> Genze 羅根澤 *et al*., eds. *Gushi bian* 古史辨. Beiping: Jingshan shushe, 1926–37.

L<small>UO</small> Guang 羅光. *Zhongguo zhexue sixiang shi* 中國哲學思想史. Taipei: Xuesheng, 1978.

M<small>OU</small> Zongsan 牟宗三. *Mingjia yu Xunzi* 名家與荀子. Xinya Yanjiusuo congkan. Taipei: Xuesheng, 1979.

Ō<small>GATA</small> Toru 大形徹. "*Kakkanshi*—fukyū no kokka o gensō shita inja no hon" 鶡冠子——不朽の幻想した隠者の本. *Tōhō shūkyō* 東洋宗教 59 (1982): 43–65.

Q<small>IAN</small> Mu 錢穆. "Xun Qing kao" 荀卿攷. *Gushi bian*, IV, 115–23.

———. *Xian-Qin zhuzi xinian* 先秦諸子繫年. 2nd edition. Canghai congshu. Hong Kong: Hong Kong University Press, 1956; rpt., Taipei: Dongda, 1990.

R<small>AO</small> Bin 饒彬. *Xunzi yiyi jishi* 荀子疑義輯釋. Taipei: Lantai, 1977.

R<small>UAN</small> Tingzhuo 阮廷焯. *Xunzi jiaozheng* 荀子斠證. Yuexiu shanfang congshu. Taipei, 1959.

———. "*Xunzi* tongkao" 荀子通考. *Dalu zazhi* 大陸雜志 34 (1967): 241–48.

T<small>AKEUCHI</small> Yoshio 武内義雄. *Kanshi no Shinjutsu to Naigyo* 管子の心術と内業. *Shinagaku* 支那學, supplement 10 (1958).

T<small>AN</small> Jiefu 譚戒甫. *Gongsun Longzi xingming fawei* 公孫龍子形名發微. Beijing: Kexue, 1957.

T<small>ANG</small> Junyi 唐君毅. *Zhongguo zhexue yuanlun* 中國哲學原論. *Yuanxing pian* 原性篇. Hong Kong: Xinya, 1968.

——. *Zhongguo zhexue yuanlun. Daolun pian* 導論篇. 2nd edition. Hong Kong: Xinya, 1974.

WANG Fuzhi 王夫之. *Zhuangzi jie* 莊子解. Beijing: Zhonghua, 1961.

WANG Niansun 王念孫. *Dushu zazhi* 讀書雜志. Jiangsu: Guji, 1985.

WANG Zhong 汪中. *Jiangdu Wangshi congshu* 江都汪氏叢書. Shanghai: Zhongguo shudian, 1925.

WEI Zhengtong 韋政通. *Xunzi yu gudai zhexue* 荀子與古代哲學. Renren wenku 68/69. Taipei: Shangwu, 1966.

XIA Zhentao 夏甄陶. *Lun Xunzi de zhexue sixiang* 論荀子的哲學思想. Shanghai: Renmin, 1979.

XIANG Rengdan 向仍旦. *Xunzi tonglun* 荀子通論. Fuzhou: Fujian jiaoyu, 1987.

XIONG Gongzhe 熊公哲. *Xunzi jinzhu jinyi* 荀子今注今譯. Taipei: Shangwu, 1975.

XU Fuguan 徐復觀. *Zhongguo renxing lun shi* 中國人性論史. Taichung: Sili Donghai daxue, 1963.

——. *Gongsun Longzi jiangshu* 公孫龍子講疏. Taichung: Sili Donghai daxue, 1966.

XU Ji 徐積. *Jiexiao xiansheng wenji* 節孝先生文集. *Yingyin Wenyuange Siku quanshu* 景印文淵閣四庫全書, vol. 1101. Taipei: Shangwu, 1983.

XU Junru 許鈞儒. *Xunzi zhexue* 荀子哲學. Changyan congshu. Taipei, 1971.

YAN Lingfeng 嚴靈峰. *Xunzi jicheng* 荀子集成. Taipei: Chengwen, 1977.

YANG Yunru 楊筠如. *Xunzi yanjiu* 荀子研究. Renren wenku 42/43. Shanghai, 1931; rpt., Taipei: Shangwu, 1966.

YOU Guo'en 游國恩. "Xun Qing kao" 荀卿考. *Gushi bian*, IV, 94–104.

YU Jiaju 余家菊. *Xunzi jiaoyu xue* 荀子教育學. Shanghai: Zhonghua, 1935.

YU Mingguang 余明光. "Xunzi sixiang yu Huang-Lao zhi xue" 荀子思想與黃老之學. *Daojia wenhua yanjiu* 6 (1995): 160–74.

ZHANG Binglin 章炳麟. *Zhangshi congshu* 章氏叢書. Shanghai: Zhejiang Tushuguan, 1936.

ZHANG Dainian 張岱年. *Zhongguo zhexue dagang* 中國哲學大綱. Beijing: Zhongguo Shehui Kexue Yuan, 1982.

——. "*Guanzi* de 'Xinshu' deng pian fei Song Yin zhuzuo kao" 管子的心術等篇非宋尹著作考. *Daojia wenhua yanjiu* 2 (1992): 320–26.

ZHANG Heng 張亨. *Xunzi jiacuo zi pu* 荀子假錯字譜. Wenshi congkan. Taipei: Guoli Taiwan Daxue Wenxue Yuan, 1963.

ZHANG Xitang 張西堂. "*Shizi* kaozheng" 尸子考證. *Gushi bian*, IV, 646–53.

——. "*Xunzi* zhenwei kao" 荀子真偽考. *Shixue jikan* 史學集刊 3 (1936): 165–236.

ZHAO Jihui 趙吉惠. "Lun Xunxue shi Jixia Huang-Lao zhi xue" 論荀學是稷下黃老之學. *Daojia wenhua yanjiu* 4 (1994): 103–17.

ZHU Xuan 朱玄. "*Meng Xun* shu shi kao ji Meng Xun liezhuan shuzheng" 孟荀書十考及孟荀列傳疏證. *Guowen Yanjiusuo jikan* 國文研究所集刊 10 (1966): 69-216.

III. Works in Western Languages of All Periods

Note: Collaborative volumes are treated as in Section II above.

ALLINSON, Robert E. "A Hermeneutic Reconstruction of the Child in the Well Example." *Journal of Chinese Philosophy* 19, no. 3 (1992): 297–308.

ALMOG, Joseph, John Perry, and Howard Wettstein, eds. *Themes from Kaplan.* Oxford and New York: Oxford University Press, 1989.

AMES, Roger T. *The Art of Rulership: A Study of Ancient Chinese Political Thought.* Honolulu: University of Hawaii Press, 1983; rpt., Albany: State University of New York Press, 1994.

———. "The Mencian Conception of *Ren xing*: Does it Mean 'Human Nature'?" In Rosemont, *Chinese Texts*, 143–75.

ARIEL, Yoav. *K'ung-ts'ung-tzu: The K'ung Family Master's Anthology.* Princeton Library of Asian Translations. Princeton, 1989.

ARISTOTLE. *De Anima.* Ed. Sir David Ross. Oxford: Clarendon, 1961.

ARON, Raymond. *Main Currents in Sociological Thought.* Tr. Richard Howard and Helen Weaver. 2 volumes. New York: Doubleday, Anchor, 1968–70.

[AUGUSTINUS, St. Aurelius]. *Oeuvres de Saint Augustin.* Bibliothèque Augutinienne. Paris: Desclee de Brouwer, 1941–.

AUSTIN, J.L. *How to Do Things with Words.* Ed. J.O. Urmson and Marina Sbisà. 2nd edition. William James Lectures, 1955. Cambridge, Mass.: Harvard University Press, 1975.

BAEUMKER, Clemens. *Witelo: Ein Philosoph und Naturforscher des XIII. Jahrhunderts.* 2nd edition. Beiträge zur Geschichte der Philosophie und Theologie 3.2. Munster: Aschendorff, 1991.

BAO, Zhiming. "Abstraction, *Ming-Shi* and Problems of Translation." *Journal of Chinese Philosophy* 14, no. 4 (1987): 419–44.

BARNES, Jonathan. *The Presocratic Philosophers.* Revised edition. The Arguments of the Philosophers. Boston: Routledge & Kegan Paul, 1982.

BAXTER, William H. *A Handbook of Old Chinese Phonology.* Trends in Linguistics Studies and Monographs 64. Berlin and New York: Mouton de Gruyter, 1992.

BECKWITH, Francis J. *David Hume's Argument Against Miracles: A Critical Analysis.* Lanham, Md.: University Press of America, 1989.

———. "Hume's Evidential/Testimonial Epistemology, Probability, and Miracles." In Radcliffe and White, 117–40.

BIRRELL, Anne. *Chinese Mythology: An Introduction.* Baltimore and London: Johns Hopkins University Press, 1993.

BLOOM, Irene. "Mencian Arguments on Human Nature (*Jen-hsing*)." *Philosophy East and West* 44, no. 1 (1994): 19–53.

———. "Human Nature and Biological Nature in Mencius." *Philosophy East and West* 47, no. 1 (1997): 21–32.

BODDE, Derk. *Chinese Thought, Society, and Science: The Intellectual and Social*

Background of Science and Technology in Pre-Modern China. Honolulu: University of Hawaii Press, 1991.

BROAD, C.D. "Hume's Theory of the Credibility of Miracles." In Sesonske and Fleming, 86–98.

BROOME, John. *Weighing Goods*. Economics and Philosophy. Oxford and Cambridge, Mass.: Basil Blackwell, 1991.

BROWN, K.C., ed. *Hobbes Studies*. Cambridge, Mass.: Harvard University Press, 1965.

BROWN, Stuart M., Jr. "The Taylor Thesis: Some Objections." In K.C. Brown, 57–71.

BUTZENBERGER, Klaus. "Some General Remarks on Negation and Paradox in Chinese Logic." *Journal of Chinese Philosophy* 20, no. 3 (1993): 313–48.

CAMPANY, Robert F. "Xunzi and Durkheim as Theorists of Ritual Practice." In Reynolds and Tracy, 197-231.

CARNAP, Rudolf. *Meaning and Necessity*. 2nd edition. Chicago: University of Chicago Press, 1956.

CHAN, Wing-tsit. *The Way of Lao Tzu*. The Library of Liberal Arts. Indianapolis and New York: Bobbs-Merrill, 1963.

———. "Syntheses in Chinese Metaphysics." In Moore, 132–48.

CH'EN, Ch'i-yün. *Hsün Yüeh and the Mind of Late Han China: A Translation of the* Shen-chien *with Introduction and Annotations*. Princeton Library of Asian Translations. Princeton, 1980.

CH'IEN, Edward T. *Chiao Hung and the Restructuring of Neo-Confucianism in Late Ming*. Neo-Confucian Studies. New York: Columbia University Press, 1986.

CHIN, Ann-Ping, and Mansfield Freeman. *Tai Chen on Mencius: Explorations in Words and Meaning*. New Haven: Yale University Press, 1990.

CHING, Julia. *Mysticism and kingship in China: The heart of Chinese wisdom*. Cambridge studies in religious traditions. Cambridge, 1997.

CHOW, Kai-wing. *The Rise of Confucian Ritualism in Late Imperial China: Ethics, Classics, and Lineage Discourse*. Stanford: Stanford University Press, 1994.

CHOW Tse-tsung, ed. *Wen-lin: Studies in the Chinese Humanities*. Madison: University of Wisconsin Press, 1968.

CHURCH, Alonzo. "Intensionality and the Paradox of the Name Relation." In Almog *et al.*, 151–65.

CICERO, [M. Tullius]. *De finibus bonorum et malorum*. Ed. H. Rackham. 2nd edition. Cicero XVII; Loeb Classical Library 40. Cambridge, Mass.: Harvard University Press, 1931.

CLARK, Stephen R.L. *Aristotle's Man: Speculations upon Aristotelian Anthropology*. New York: Oxford University Press, 1975.

COLEMAN, James S. *Foundations of Social Theory*. Cambridge, Mass., and London: Harvard University Press, Belknap Press, 1990.

CREEL, Herrlee G. *Chinese Thought from Confucius to Mao Tse-tung*. Chicago: University of Chicago Press, 1953.

———. *The Origins of Statecraft in China*. Chicago and London: University of Chicago Press, 1970.

———. *Shen Pu-hai: A Chinese Political Philosopher of the Fourth Century B.C.* Chicago and London: University of Chicago Press, 1974.

CRUMP, James I., Jr. *Intrigues: Studies of the Chan-kuo Ts'e*. Ann Arbor: University of Michigan Press, 1964.

CUA, A[ntonio] S. "The conceptual aspect of Hsün Tzu's philosophy of human nature." *Philosophy East and West* 27, no. 4 (1977): 373–90.

———. "The quasi-empirical aspect of Hsün-Tzu's philosophy of human nature." *Philosophy East and West* 28, no. 1 (1980): 3–20.

———. "Hsün-tzu and the Unity of Virtues." *Journal of Chinese Philosophy* 14, no. 4 (1987): 381–400.

DEFOORT, Carine. *The Pheasant Cap Master (He guan zi): A Rhetorical Reading*. SUNY Series in Chinese Philosophy and Culture. Albany, 1997.

DIELS, H., and W. Kranz. *Die Fragmente der Vorsokratiker*. 10th edition. Berlin: Weidmann, 1960.

DIOGENES Laertius. *Lives of Eminent Philosophers*. Ed. R.D. Hicks. Loeb Classical Library 185. Cambridge, Mass.: Harvard University Press, 1925.

DUBS, Homer H. *Hsüntze: The Moulder of Ancient Confucianism*. Probsthain's Oriental Series 15. London, 1927.

———. "Mencius and Sun-dz on Human Nature." *Philosophy East and West* 6 (1956): 213–22.

DUMMETT, Michael. *Frege: Philosophy of Language*. 2nd edition. Cambridge, Mass.: Harvard University Press, 1981.

———. *Origins of Analytical Philosophy*. Cambridge, Mass.: Harvard University Press, 1993.

DURKHEIM, Emile. *Sociologie et philosophie*. 2nd edition. Bibliothèque de philosophie contemporaine. Paris: Presses Universitaires de France, 1963.

———. *Les formes élémentaires de la vie religieuse*. 5th edition. Bibliothèque de philosophie contemporaine. Paris: Presses Universitaires de France, 1968.

DUYVENDAK, J.J.L. "Hsün-tzu on the Rectification of Names." *T'oung Pao* 23 (1924): 221–54.

———. "Notes on Dubs' Translation of *Hsün Tzu*." *T'oung Pao* 26 (1929): 73–95.

DWORKIN, Ronald. *Law's Empire*. Cambridge, Mass.: Harvard University Press, Belknap Press, 1986.

EBERHARD, Wolfram. *Lokalkulturen im alten China*. *T'oung Pao* 37 (supplement, 1942).

———. *The Local Cultures of South and East China*. Tr. Alide Eberhard. Leiden: E.J. Brill, 1968.

EBREY, Patricia Buckley. *Confucianism and Family Rituals in Imperial China: A*

Social History of Writing about Rites. Princeton: Princeton University Press, 1991.

ECO, Umberto. *Art and Beauty in the Middle Ages*. Tr. Hugh Bredin. New Haven and London: Yale University Press, 1986.

ENO, Robert. *The Confucian Creation of Heaven: Philosophy and the Defense of Ritual Mastery*. SUNY Series in Chinese Philosophy and Culture. Albany, 1990.

EWIN, R.E. *Virtues and Rights: The Moral Philosophy of Thomas Hobbes*. Boulder: Westview, 1991.

FANG, Thomé. "The World and the Individual in Chinese Metaphysics." In Moore, 238–63.

FEHL, Noah Edward. Li: *Rites and Propriety in Literature and Life*. Hong Kong: Chinese University, 1971.

FEIGL, Herbert, and Wilfrid Sellars, eds. *Readings in Philosophical Analysis*. New York: Appleton-Century-Crofts, 1949.

FINGARETTE, Herbert. *Confucius—The Secular as Sacred*. New York: Harper & Row, 1972.

FLEW, Antony. *God, Freedom, and Immortality*. Buffalo: Prometheus, 1984.

FLEW, Antony, ed. *Logic and Language*. First and Second Series. Garden City, N.Y.: Doubleday, Anchor Books, 1965.

FOGELIN, Robert J. *Philosophical Interpretations*. Oxford and New York: Oxford University Press, 1992.

FORKE, Alfred. *The World-Conception of the Chinese: Their Astronomical, Cosmological and Physico-Philosophical Speculation*. Probsthain's Oriental Series 14. London, 1925.

———. *Geschichte der alten chinesischen Philosophie*. Hamburg: Friederichsen, 1927.

FRANKENA, William K. *Ethics*. Prentice-Hall Foundations of Philosophy Series. Englewood Cliffs, N.J., 1963.

FREGE, Gottlob. "Über Sinn und Bedeutung." *Zeitschrift für Philosophie und philosophische Kritik* 100 (1892): 25–50.

FRIED, Charles. *Contract as Promise: A Theory of Contractual Obligation*. Cambridge, Mass., and London: Harvard University Press, 1981.

FUNG Yu-lan [= Feng Youlan]. *A History of Chinese Philosophy*. Tr. Derk Bodde. 2nd edition. 2 volumes. Princeton: Princeton University Press, 1952–1953.

GARDNER, Peter. "Ethical Absolutism and Education." In Griffiths, 77–94.

GARVEY, Catherine. *Play*. The Developing Child. Cambridge, Mass.: Harvard University Press, 1977.

GAUTHIER, David. *Morals by Agreement*. Oxford: Oxford University Press, 1986.

GIBSON, Roger F., Jr. "Translation, Physics, and Facts of the Matter." In Hahn and Schilpp, 139–54.

GOFFMAN, Erving. *Interaction Ritual: Essays on Face-to-Face Behavior*. Garden City, N.Y.: Doubleday, Anchor Books, 1967.

GOLDIN, Paul Rakita. "Some Old Chinese Words." *Journal of the American Oriental Society* 114, no. 4 (1994): 628–31.

———. "Reading Po Chü-i." *T'ang Studies* 12 (1994): 57–96.

———. "Job's Transgressions" *Zeitschrift für die alttestamentliche Wissenschaft* 108 (1996): 378–90.

———. "Reflections on Irrationalism in Chinese Aesthetics." *Monumenta Serica* 44 (1996): 167–89.

GRAHAM, A.C. *Two Chinese Philosophers: The Metaphysics of the Brothers Ch'eng*. 1958; rpt., La Salle, Ill.: Open Court, 1992.

———. *Later Mohist Logic, Ethics and Science*. Hong Kong: Chinese University Press, 1978.

———. *Disputers of the Tao: Philosophical Argument in Ancient China*. La Salle, Ill.: Open Court, 1989.

———. "A Neglected Pre-Han Philosophical Text: *Ho-kuan-tzu*." *Bulletin of the School of Oriental Studies* 52, no. 3 (1989): 497–532.

———. *Studies in Chinese Philosophy and Philosophical Literature*. SUNY Series in Chinese Philosophy and Culture. Albany, 1990.

———. *Unreason within Reason: Essays on the Outskirts of Rationality*. La Salle, Ill.: Open Court, 1992.

GRANET, Marcel. *Fêtes et chansons anciennes de la Chine*. Bibliothèque de l'Ecole des Hautes Etudes, Sciences religieuses 34; Bibliothèque de la Fondation Thiers 39. Paris: E. Leroux, 1919.

———. *Danses et légendes de la Chine ancienne*. 2 volumes. Bibliothèque de philosophie contemporaine; Travaux de l'Année sociologique. Paris: Felix Alcan, 1926.

GRAYLING, A.C. *The Refutation of Scepticism*. La Salle, Ill.: Open Court, 1985.

———. *Berkeley: The Central Arguments*. La Salle, Ill.: Open Court, 1986.

GRIFFITHS, A. Phillips, ed. *Ethics*. Royal Institute of Philosophy Supplement 35. Cambridge: Cambridge University Press, 1993.

HAHN, Lewis Edwin, and Paul Arthur Schilpp, eds. *The Philosophy of W. V. Quine*. The Library of Living Philosophers 18. La Salle, Ill.: Open Court, 1986.

HALL, David L., and Roger T. Ames. *Thinking Through Confucius*. SUNY Series in Systematic Philosophy. Albany, 1987.

———. *Anticipating China: Thinking through the Narratives of Chinese and Western Culture*. Albany: State University of New York Press, 1995.

HAMPTON, Jean. *Hobbes and the Social Contract Tradition*. London: Cambridge University Press, 1986.

HANSEN, Chad. *Language and Logic in Ancient China*. Michigan Studies on China. Ann Arbor, 1983.

———. "A *Tao* of *Tao* in Chuang-tzu." In Mair, *Experimental Essays*, 24–55.

———. *A Daoist Theory of Chinese Thought: A Philosophical Interpretation*. Oxford and New York: Oxford University Press, 1992.

———. "Qing (Emotions) 情 in Pre-Buddhist Chinese Thought." In Marks and Ames, 181–211.

HARBSMEIER, Christoph. "The Mass Noun Hypothesis and the Part-Whole Analysis of the White Horse Dialogue." In Rosemont, *Chinese Texts*, 49–66.

HARPER, Donald. "Warring States, Ch'in, and Han Periods." *The Journal of Asian Studies* 54, no. 1 (1995): 152–60.

HART, H.L.A. *The Concept of Law*. Clarendon Law Series. Oxford, 1961.

HATTORI, U. "Confucius' Conviction of his Heavenly Mission." *Harvard Journal of Asiatic Studies* 1.1 (1936): 96–108.

HAWKES, David. *The Songs of the South: An Ancient Chinese Anthology of Poems by Qu Yuan and other Poets*. 2nd edition. New York: Penguin, 1985.

HENDERSON, Lawrence J. *Pareto's General Sociology: A Physiologist's Interpretation*. New York: Russell & Russell, 1935.

HENRY, Eric. "The Motif of Recognition in Early China." *Harvard Journal of Asiatic Studies* 47.1 (1987): 1–30.

HIGHTOWER, James Robert. "The *Han Shih wai chuan* 韓詩外傳 and the *San chia Shih* 三家詩." *Harvard Journal of Asiatic Studies* 11, nos. 3/4 (1948): 241–310.

——. *Han Shih wai chuan: Han Ying's Illustrations of the Didactic Application of the* Classic of Songs. Harvard-Yenching Institute Monograph Series 11. Cambridge, Mass., 1952.

[HOBBES, Thomas]. *The English Works of Thomas Hobbes*. Ed. Sir William Molesworth. 11 volumes. London: John Bohn, 1839–45.

HOBBES, Thomas. *Leviathan*. Ed. C.B. Macpherson. New York: Penguin, 1968.

HOMANS, George C., and Charles P. Curtis. *An Introduction to Pareto*. New York: Knopf, 1934.

HSIAO, Kung-chuan. *A History of Chinese Political Thought*. Vol. I: *From the Beginnings to the Sixth Century A.D.* Tr. F.W. Mote. Princeton Library of Asian Translations. Princeton, 1979.

HU Shih. *The Development of the Logical Method in Ancient China*. Shanghai: Oriental Book Company, 1928.

HUCKER, Charles O. *A Dictionary of Official Titles in Imperial China*. Stanford: Stanford University Press, 1985.

HUIZINGA, Johan. *Homo Ludens: A Study of the Play Element in Culture*. Boston: Beacon, 1950.

HUME, David. *A Treatise of Human Nature*. Ed. L.A. Selby-Bigge, revised by P.H. Nidditch. 2nd edition. Oxford: Clarendon, 1978.

——. *Enquiries concerning Human Understanding and concerning the Principles of Morals*. Ed. L.A. Selby-Bigge, revised by P.H. Nidditch. 3rd edition. Oxford: Clarendon, 1975.

ISIDORO de Sevilla, San. *Etimologías*. Ed. Jose Oroz Reta and Manuel-A. Marcos Casquero. 2 volumes. Biblioteca de Autores Cristianos 433/4. Madrid: La Editorial Católica, 1982.

IVANHOE, P[hilip] J. "Thinking and Learning in Early Confucianism." *Journal of Chinese Philosophy* 17, no. 4 (1990): 473–94.

——. "A Happy Symmetry: Xunzi's Ethical Thought." *Journal of the American Academy of Religion* 59, no. 2 (1991): 309–22.

———. *Confucian Moral Self Cultivation*. The Rockwell Series Lectures 3. New York: Peter Lang, 1993.

———. "Zhuangzi on Skepticism, Skill, and the Ineffable Dao." *Journal of the American Academy of Religion* 61, no. 4 (1993): 639–54.

———. "Human Nature and Moral Understanding in Xunzi." *International Philosophical Quarterly* 34, no. 2 (1994): 167–76.

———. "Was Zhuangzi a Relativist?" In Kjellberg and Ivanhoe, 196–214.

JAKOBSON, Roman. *On Language*. Ed. Linda R. Waugh and Monique Monville-Burston. Cambridge, Mass., and London: Harvard University Press, 1990.

JOHN of Salisbury. *Policratici sive De nugis curialium et vestigiis philosophorum libri VIII*. Ed. Clemens C.I. Webb. 2 volumes. Oxford, 1909; rpt., Frankfurt: Minerva, 1965.

JOHNSON, Laurie M. *Thucydides, Hobbes, and the Interpretation of Realism*. DeKalb, Ill.: Northern Illinois University Press, 1993.

KANT, Immanuel. *Gesammelte Schriften*. 22 volumes. Berlin: Preussische Akademie der Wissenschaften, 1902–42.

KARLGREN, Bernhard. "The Early History of the Chou Li and Tso Chuan Texts." *Bulletin of the Museum of Far Eastern Antiquities* 3 (1931): 1–59.

KAVKA, Gregory S. *Hobbesian Moral and Political Theory*. Studies in Moral, Political, and Legal Philosophy. Princeton: Princeton University Press, 1986.

KJELLBERG, Paul, and Philip J. Ivanhoe, eds. *Essays on Skepticism, Relativism, and Ethics in the* Zhuangzi. SUNY Series in Chinese Philosophy and Culture. Albany, 1996.

KNOBLOCK, John H. "The Chronology of Xunzi's Works," *Early China* 8 (1982–83): 29–52.

———. *Xunzi: A Translation and Study of the Complete Works*. 3 volumes. Stanford: Stanford University Press, 1988–1994.

KRAMERS, R.P. *K'ung tzu chia yü: The School Sayings of Confucius*. Sinica Leidensia 7. Leiden: E.J. Brill, 1950.

KUHN, Thomas S. *The Structure of Scientific Revolutions*. 2nd edition. Chicago: University of Chicago Press, 1970.

KULLER, Janet A.H. "The 'Fu' of the *Hsün Tzu* as an Anti-Taoist Polemic." *Monumenta Serica* 31 (1974–75): 205–18.

———. "Anti-Taoist Elements in Hsün Tzu's Thought and their Social Relevance." *Asian Thought and Society* 3.7 (1978): 53–67.

LANCIOTTI, Lionello. "Sword Casting and Related Legends in China, Part 1." *East and West* 6, no. 2 (1955): 106–14.

LANGE, Marc. "Hui Shih's Logical Theory of Descriptions: A Philosophical Reconstruction of Hui Shih's Ten Enigmatic Arguments." *Monumenta Serica* 38 (1988/89): 95–114.

LANGER, Susanne K. *Philosophy in a New Key: A Study in the Symbolism of Reason, Rite, and Art*. 3rd edition. Cambridge, Mass., and London: Harvard University Press, 1957.

LAU, D.C. "Theories of Human Nature in *Mencius* and *Shyuntzyy*." *Bulletin of the School of Oriental and African Studies* 15, no. 3 (1953): 541–65.

———. *Lao Tzu Tao Te Ching*. New York: Penguin, 1963.

———. "On Mencius' Use of the Method of Analogy in Argument." *Asia Major* 10 (1963): 173–94.

———. *Mencius*. New York: Penguin, 1970.

LENK, Hans, and Gregor Paul, eds. *Epistemological Issues in Classical Chinese Philosophy*. SUNY Series in Chinese Philosophy. Albany, 1993.

LEYS, Simon, tr. *The Analects of Confucius*. New York and London: Norton, 1997.

LI Shuyou. "On Characteristics of Human Beings in Ancient Chinese Philosophy." *Journal of Chinese Philosophy* 15, no. 3 (1988): 221–54.

LLOYD, G.E.R., and G.E.L. Owen, eds. *Aristotle on mind and the senses*. Proceedings of the Seventh Symposium Aristotelicum. Cambridge Classical Studies. Cambridge, 1978.

LOCKE, John. *An Essay Concerning Human Understanding*. Ed. Peter H. Nidditch. Oxford: Clarendon, 1975.

LUCAS, Thierry. "Hui Shih and Kung Sun Lung an Approach from Contemporary Logic." *Journal of Chinese Philosophy* 20, no. 2 (1993): 211–55.

LUCE, R. Duncan, and Howard Raiffa. *Games and Decisions: Introduction and Critical Survey*. New York: John Wiley & Sons, 1957.

LUCRETIUS Carus, T. *De rerum natura libri sex*. Ed. William Ellery Leonard and Stanley Barney Smith. Madison and London: University of Wisconsin Press, 1942.

MACDONALD, Margaret. "The Philosopher's Use of Analogy." In Flew, 85–106.

MACHLE, Edward J. "The Mind and the 'Shen-ming' in Xunzi." *Journal of Chinese Philosophy* 19, no. 4 (1992): 361–86.

———. *Nature and Heaven in the* Xunzi: *A Study of the Tian lun*. SUNY Series in Chinese Philosophy and Culture. Albany, 1993.

MACKIE, J.L. *Problems from Locke*. Oxford: Clarendon, 1976.

———. *Ethics: Inventing Right and Wrong*. New York: Penguin, 1977.

MACPHERSON, C.B. *The Political Theory of Possessive Individualism: Hobbes to Locke*. Oxford: Clarendon, 1964.

MAIR, Victor H. *Tao Te Ching: The Classic Book of Integrity and the Way*. New York: Bantam, 1990.

MAIR, Victor H., ed. *Experimental Essays on Chuang-tzu*. Asian Studies at Hawaii 29. [Honolulu], 1983.

MAKEHAM, John. *Name and Actuality in Early Chinese Thought*. SUNY Series in Chinese Philosophy and Culture. Albany, 1994.

MALINOWSKI, Bronislaw. *A Scientific Theory of Culture and Other Essays*. Chapel Hill: University of North Carolina Press, 1944.

[MARCUS AURELIUS Antoninus]. *The Communings with Himself of Marcus Aurelius Antoninus, Emperor of Rome, Together with his Speeches and Sayings*. Ed. C.R. Haines. Revised edition. Loeb Classical Library 58. Cambridge, Mass., and London: Harvard University Press, 1930.

MARITAIN, Jacques. *Man and the State*. Charles R. Walgreen Foundation Lectures. Chicago: University of Chicago Press, 1951.

MARKS, Joel, and Roger T. Ames, eds. *Emotions in Asian Thought: A Dialogue in Comparative Philosophy*. Albany: State University of New York Press, 1995.

MASPERO, Henri. "Le Roman de Sou Ts'in." *Etudes Asiatiques* 2 (1925): 127–41.

———. *Mélanges posthumes sur les religions et l'histoire de la Chine*. Publications du Musée Guimet, Bibliothèque de Diffusion 57–60. 3 volumes. Paris: Civilisations du Sud, 1950.

———. *China in Antiquity*. Tr. Frank A. Kierman, Jr. Amherst: University of Massachusetts Press, 1978.

MAUSS, Marcel. *The Gift: The Form and Reason for Exchange in Archaic Societies*. Tr. W.D. Halls. London: Routledge, 1990.

MEI, Tsu-lin. "Notes on the Morphology of Ideas in Ancient China," in *The Power of Culture: Studies in Chinese Cultural History*, ed. Willard T. Peterson *et al.* Hong Kong: The Chinese University Press, 1994, 37–46.

MEI, Y.P. "Hsün Tzu's Theory of Education." *Qinghua xuebao* 青華學報 2, no. 2 (1961): 361–79.

MODRAK, Deborah K.W. *Aristotle: The Power of Perception*. Chicago and London: University of Chicago Press, 1987.

MOORE, Charles A., ed., with the assistance of Aldyth V. Morris. *The Chinese Mind: Essentials of Chinese Philosophy and Culture*. Honolulu: University of Hawaii Press, East-West Center Press, 1967.

MORITZ, Ralf. *Hui Shi und die Entwicklung des philosophischen Denkens im alten China*. Schriften zur Geschichte und Kultur des alten Orients 12. Berlin: Akademie-Verlag, 1973.

MUNRO, Donald J. *The Concept of Man in Early China*. Stanford: Stanford University Press, 1969.

NAGEL, Thomas. *The View from Nowhere*. Oxford: Oxford University Press, 1986.

NEDERMAN, Cary J. "A Duty to Kill." *The Review of Politics* 50, no. 3 (1988): 365–89.

NEEDHAM, Joseph, *et al. Science and Civilisation in China*. 7 volumes. Cambridge: Cambridge University Press, 1954–.

NIVISON, David Shepherd. "Mencius and Motivation." In Rosemont and Schwartz, 417–32.

———. "Hsun Tzu and Chuang Tzu." In Rosemont, *Chinese Texts*, 129–42.

———. *The Ways of Confucianism: Investigations in Chinese Philosophy*. Ed. Bryan W. Van Norden. Chicago and La Salle, Ill.: Open Court, 1996.

OWEN, Stephen. *Readings in Chinese Literary Thought*. Harvard-Yenching Institute Monograph Series 30. Cambridge, Mass., and London: Harvard University Press, 1992.

PANKENIER, David W. "The Cosmo-political Background of Heaven's Mandate." *Early China* 20 (1995): 121–76.

PARETO, Vilfredo. *Trattato di sociologia generale*. Ed. Giovanni Busino. 4 volumes. Classici della Sociologia. Turin: Unione tipografico-editrice torinese, 1988.

PARSONS, Talcott. *The Structure of Social Action: A Study in Social Theory with Special Reference to a Group of Recent European Writers.* 2nd edition. New York: Free Press, 1949.

PAUL, Ellen Frankel, *et al.*, eds. *The New Social Contract: Essays on Gauthier.* New York and Oxford: Basil Blackwell, 1988.

PEERENBOOM, R.P. "*Heguanzi* and Huang-Lao Thought." *Early China* 16 (1991): 169–86.

———. *Law and Morality in Ancient China: The Silk Manuscripts of Huang-Lao.* SUNY Series in Chinese Philosophy and Culture. Albany, 1993.

PETERS, Richard. *Hobbes.* Peregrine Books Y66. 2nd edition. Baltimore: Penguin, 1967.

PETERSON, Willard J. "Making Connections: 'Commentary on the Attached Verbalizations' of the Book of Change." *Harvard Journal of Asiatic Studies* 42, no. 1 (1982): 67–116.

POKORA, Timotheus [sic; should be "Timoteus"]. *Hsin-lun (New Treatise) and Other Writings by H'uan T'an (43 B.C.–28 A.D.).* Michigan Papers in Chinese Studies 20. Ann Arbor, 1975.

QUINE, W[illard] V[an Orman]. *Ontological Relativity and other essays.* The John Dewey Essays in Philosophy 1. New York: Columbia University Press, 1969.

———. *The Ways of Paradox and Other Essays.* Revised edition. Cambridge, Mass., and London: Harvard University Press, 1976.

———. *From a Logical Point of View: 9 Logico-Philosophical Essays.* 2nd edition, revised. Cambridge, Mass., and London: Harvard University Press, 1980.

———. *Theories and Things.* Cambridge, Mass., and London: Harvard University Press, Belknap Press, 1981.

———. *Methods of Logic.* 4th edition. Cambridge, Mass.: Harvard University Press, 1982.

RADCLIFFE, Elizabeth S., and Carol J. White, eds. *Faith in Theory and Practice: Essays on Justifying Religious Belief.* Chicago and La Salle, Ill.: Open Court, 1993.

RADCLIFFE-BROWN, A.R. *Structure and Function in Primitive Society: Essays and Addresses.* Glencoe, Ill.: Free Press, 1952.

RAPHALS, Lisa. "Skeptical Strategies in the *Zhuangzi* and *Theaetetus.*" In Kjellberg and Ivanhoe, 26–49.

RAPOPORT, Anatol, and Albert Chammah. *Prisoner's Dilemma: A Study in Conflict and Cooperation.* Ann Arbor: University of Michigan Press, 1965.

RAWLS, John. *A Theory of Justice.* Cambridge, Mass.: Harvard University Press, Belknap Press, 1971.

REYNOLDS, Frank, and David Tracy, eds. *Discourse and Practice.* SUNY Series, Toward a Comparative Philosophy of Religions. Albany, 1992.

RICHARDS, I.A. *Mencius on the Mind: Experiments in Multiple Definition.* International Library of Psychology Philosophy and Scientific Method. New York: Harcourt, Brace, 1932.

RICKETT, W. Allyn. *Kuan-Tzu: A Repository of Early Chinese Thought. A Translation and Study of Twelve Chapters.* Hong Kong: Hong Kong University Press, 1965.

ROETZ, Heiner. *Mensch und Natur im alten China: Zum Subjekt-Objekt-Gegensatz in der klassischen chinesischen Philosophie, zugleich eine Kritik des Klischees vom chinesischen Universalismus.* Europäische Hochschulschriften, Reihe 20, Band 136. Berne: Peter Lang, 1984.

——. *Confucian Ethics of the Axial Age: A Reconstruction under the Aspect of the Breakthrough Toward Postconventional Thinking.* SUNY Series in Chinese Philosophy and Culture. Albany, 1993.

RORTY, Richard. "Indeterminacy of Translation and Truth." *Synthese* 23 (1972): 443–62.

——. *Philosophy and the Mirror of Nature.* Princeton: Princeton University Press, 1979.

ROSEMONT, Henry, Jr. "State and Society in the *Hsün Tzu*: A Philosophical Commentary." *Monumenta Serica* 29 (1970–71): 38–78.

ROSEMONT, Henry, Jr, ed. *Chinese Texts and Philosophical Contexts: Essays Dedicated to Angus C. Graham.* Critics and Their Critics 1. La Salle, Ill.: Open Court, 1991.

ROSEMONT, Henry, Jr., and Benjamin I. Schwartz, eds. *Studies in Classical Chinese Thought. Journal of the American Academy of Religion* 47, no. 3, Thematic Issue S (1979).

ROTH, Harold D. "Psychology and Self-Cultivation in Early Taoistic Thought." *Harvard Journal of Asiatic Studies* 51, no. 2 (1991): 599–650.

——. "Who Compiled the *Chuang Tzu?*" In Rosemont, *Chinese Texts*, 79–128.

ROUSE, Richard H. and Mary A. "John of Salisbury and the Doctrine of Tyrannicide." *Speculum* 42, no. 4 (1967): 693–709.

RUSSELL, Bertrand. "On Denoting." *Mind* 14 (1905): 479–93.

SAGART, Laurent. "L'infixe -r- en chinois archaïque." *Bulletin* 88, no. 1 (1993): 261–93.

DE SAUSSURE, Ferdinand. *Cours de linguistique générale.* 5th edition. Paris: Payot, 1955.

SAUSSY, Haun. *The Problem of a Chinese Aesthetic.* Meridian, Crossing Aesthetics. Stanford: Stanford University Press, 1993.

SCHIPPER, Kristofer. *The Taoist Body.* Tr. Karen C. Duval. Berkeley: University of California Press, 1993.

SCHWARTZ, Benjamin I. *The World of Thought in Ancient China.* Cambridge, Mass., and London: Harvard University Press, Belknap Press, 1985.

SESONSKE, Alexander, and Noel Fleming, eds. *Human Understanding: Studies in the Philosophy of David Hume.* Wadsworth Studies in Philosophical Criticism. Belmont, Calif., 1965.

SHCHUTSKII, Iulian K. *Researches on the I Ching.* Tr. William L. MacDonald and Tsuyoshi Hasegawa with Hellmut Wilhelm. Princeton: Princeton University Press, 1979.

SHIH, Vincent Y.C. "Hsüntzu's Positivism." *Qinghua xuebao* 4, no. 2 (1964): 152–74.

SHUN, Kwong-loi. "Mencius and *Jen-hsing.*" *Philosophy East and West* 47, no. 1 (1997): 1–20.

SIDGWICK, Henry. *The Methods of Ethics.* 7th edition. Chicago: University of Chicago Press, 1962.

SIM, Luke J., S.J., with James T. Bretzke, S.J. "The Notion of 'Sincerity' (*Ch'eng*) in the Confucian Classics." *Journal of Chinese Philosophy* 21, no. 2 (1994): 179–212.

SIVIN, Nathan. "On the Word 'Taoist' as a Source of Perplexity: With Special Reference to the Relations of Science and Religion in China." *History of Religions* 17 (1978): 303–30.

———. *Traditional Medicine in Contemporary China.* Science, Medicine, & Technology in East Asia 2. Ann Arbor: Center for Chinese Studies, University of Michigan, 1987.

SNAITH, Norman H. *The Book of Job: Its Origin and Purpose.* Studies in Biblical Theology, Second Series 11. Naperville, Ill.: A.R. Allenson, 1968.

SOLOMON, Bernard S. "The Assumptions of Hui-tzu." *Monumenta Serica* 28 (1969): 1–40.

STEPHEN, Sir Leslie. *History of English Thought in the Eighteenth Century.* 3rd edition. 2 volumes. 1902; rpt., New York and Burlingame: Harcourt, Brace & World, Harbinger, 1962.

SWARTZ, Robert J., ed. *Perceiving, Sensing, and Knowing.* Garden City, N.Y.: Doubleday, Anchor Books, 1965.

TAMBIAH, Stanley Jeyaraja. *Culture, Thought, and Social Action: An Anthropological Perspective.* Cambridge, Mass., and London: Harvard University Press, 1985.

TAYLOR, A.E. "The Ethical Doctrine of Hobbes." In K.C. Brown, 35–55.

THOMPSON, Kirill Ole. "When a 'White Horse' Is Not a 'Horse.'" *Philosophy East and West* 45, no. 4 (1995): 481–99.

TILLMAN, Hoyt Cleveland. *Ch'en Liang on Public Interest and the Law.* Monographs of the Society for Asian and Comparative Philosophy 12. Honolulu: University of Hawaii Press, 1994.

TINDAL, Matthew. *Christianity as Old as the Creation.* 2nd edition. London: N.p., 1732.

TU Wei-ming. *Humanity and Self-Cultivation: Essays in Confucian Thought.* Berkeley: Asian Humanities Press, 1979.

———. *Centrality and Commonality: An Essay on Confucian Religiousness.* SUNY Series in Chinese Philosophy and Culture. Revised edition. Albany, 1989.

TUCK, Richard. *Hobbes.* Past Masters. Oxford: Oxford University Press, 1989.

TURNER, Karen. "War, Punishment, and the Law of Nature in Early Chinese Concepts of the State." *Harvard Journal of Asiatic Studies* 53, no. 2 (1993): 285–324.

VALLENTYNE, Peter, ed. *Contractarianism and Rational Choice*: *Essays on David Gauthier's* Morals by Agreement. New York: Cambridge University Press, 1991.

VANDERMEERSCH, Léon. *La formation du Légisme*: *Recherche sur la constitution d'une philosophie politique caractéristique de la Chine ancienne*. Publications de l'Ecole Française d'Extrême-Orient 56. Paris, 1965.

VAN NORDEN, Bryan W. "Mengzi and Xunzi: Two Views of Human Agency." *International Philosophical Quarterly* 32, no. 2 (1992): 161–84.

——. "Hansen on Hsün-Tzu." *Journal of Chinese Philosophy* 20, no. 3 (1993): 365–82.

VAN ZOEREN, Steven. *Poetry and Personality*: *Reading, Exegesis, and Hermeneutics in Traditional China*. Stanford: Stanford University Press, 1991.

VERBEKE, G. "Doctrine du pneuma et entéléchisme chez Aristote." In Lloyd and Owen, 191–214.

VESEY, G.N.A. "Seeing and Seeing As." In Swartz, 68–83.

VIERHELLER, Ernstjoachim. "Object Language and Meta-Language in the Gongsun-long-zi." *Journal of Chinese Philosophy* 20, no. 2 (1993): 181–210.

WAGNER, Donald B. "The Language of the Ancient Chinese State of Wu." *East Asian Institute Occasional Papers* 6 (1990): 161–76.

——. *Iron and Steel in Ancient China*. Handbuch der Orientalistik; vierte Abteilung: China, neunter Band. Leiden: E.J. Brill, 1993.

WALEY, Arthur. *Three Ways of Thought in Ancient China*. London: George Allen & Unwin, 1939.

WALZER, Michael. *Interpretation and Social Criticism*. Cambridge, Mass., and London: Harvard University Press, 1987.

WANG, William S-Y. "Language in China: A Chapter in the History of Linguistics." *Journal of Chinese Linguistics* 17, no. 2 (1989): 183–222.

WARNOCK, G.J. "Seeing." In Swartz, 49–67.

WEBER, Max. *The Religion of China*: *Confucianism and Taoism*. Tr. Hans H. Gerth. New York and London: Macmillan, Free Press, 1951.

WELCH, Holmes. *Taoism*: *The Parting of the Way*. Revised edition. Boston: Beacon Press, 1965.

WINCH, Peter. *The Idea of a Social Science and Its Relation to Philosophy*. London: Routledge and Kegan Paul, 1960.

WITTGENSTEIN, Ludwig. *Philosophical Investigations*. Tr. G.E.M. Anscombe. 3rd edition. Oxford: Basil Blackwell, 1968.

WU, Kuang-ming. *The Butterfly as Companion*: *Meditations on the First Three Chapters of the* Chuang Tzu. SUNY Series in Religion and Philosophy. Albany, 1990.

YEARLEY, Lee H. "Hsün Tzu on the Mind: His Attempted Synthesis of Confucianism and Taoism." *Journal of Asian Studies* 39, no. 3 (1980): 465–80.

Index of Names
and Subjects

Index Locorum

Xunzi 荀子